Learning To See

An Artist's View on Contemporary Artists From Artschwager To Zakanitch

By Bruce Helander

Edited by Susan Hall

Foreword by Bonnie Clearwater, Introduction by Gilbert Brownstone, Essay by

Designed by Daniel Ellis of Look Interactive & Mel Abfier of StarGroup Int

Published by StarGroup International

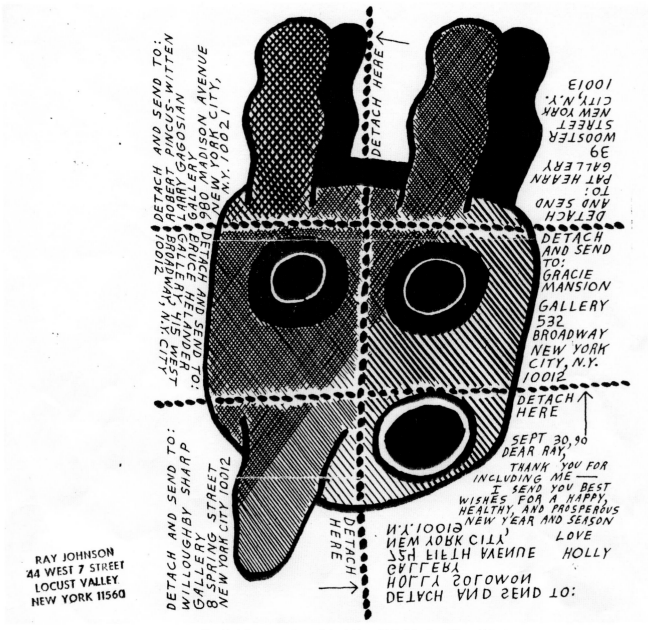

Ray Johnson, New York Correspondence School, *Flyer, 1990*, Collection of Bruce Helander

All correspondence concerning this publication should be sent to:
StarGroup International, Inc.
(561) 547-0667 • www.stargroupinternational.com

Library of Congress Cataloging-in-Publication Data pending

FIRST EDITION

ISBN 978-1-884886-88-1

Jacket (back) center illustration: poster fragment detail for London Underground ca. 1938, Collection of Claudia Helander.
Helander Studio, Inc. (561) 655-0504 • helander@bellsouth.net • www.brucehelander.com
©2008 Bruce Helander

Table of Contents

Reviews List

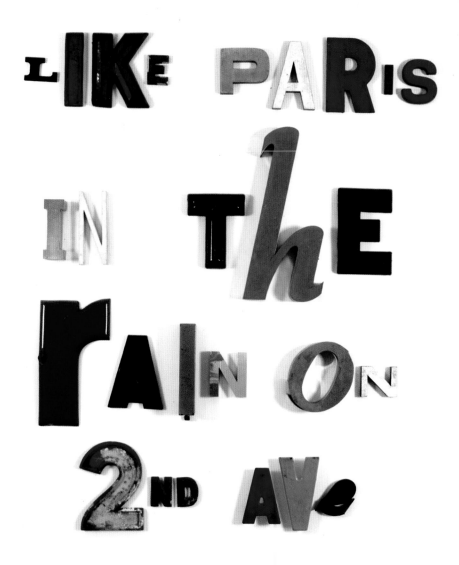

Jack Pierson, *Like Paris in the Rain on Second Avenue,* 1993, plastic, iron, steel, chrome and paint, 66 7/8 in. x 58 in. x 3 in., 169.9 cm x 147.3 cm x 7.6 cm. © 2008 Jack Pierson. Courtesy Cheim & Read, New York

(see page 116)

Jack Pierson, the unofficial late night letterman of the art world, has made his mark with sign fragments that spin phrases and quotes into readable wall assemblages.

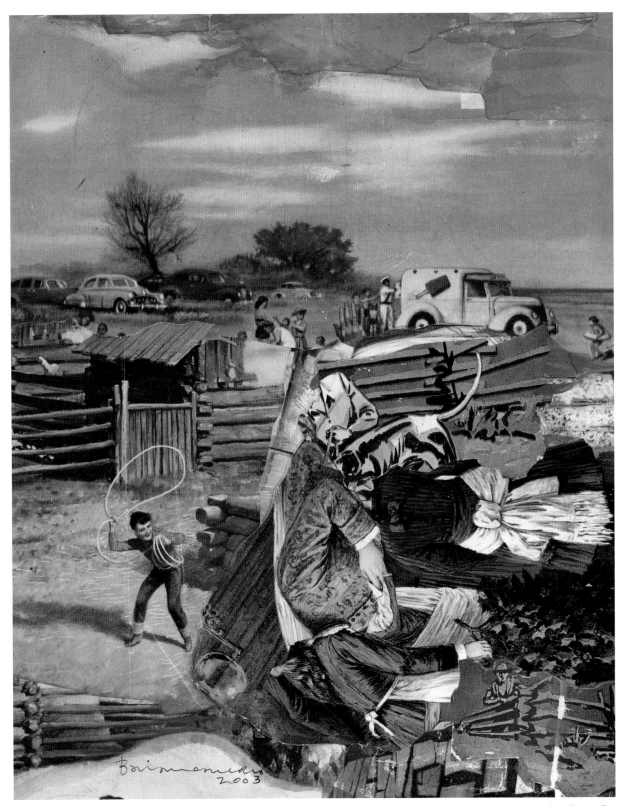

Bruce Helander, *Don't Fence Me In (Kansas), 2003,* paper collage on museum board, 9 1/2 in. x 7 1/2 in., Collection of Donna Long, Palm Beach, FL

Foreword by Bonnie Clearwater

Bruce Helander is an artist, an art educator and a critic. As a collagist, he designs jazzy kaleidoscopic designs from vintage printed-paper. These riotous images combine snippets of art historical references, cartoons, advertisements and text printed in a variety of decorative typefaces.

Helander has a special flair for design and a heightened sensitivity to printed matter. Although his method of collaging is to cut (or tear) and paste, the end result is a seamless passage of color and form. He brings a similar approach to art criticism by drawing on his extensive knowledge of art history and popular culture and turning an experienced objective eye towards the subject at hand.

Helander is in the business of creating images. His elegant sentences are the textual equivalent to the graceful lines meandering through his collages. He can turn a phrase as cleverly as he splices an array of printed patterns in his artwork. As in his collages, form supports the content of these essays. In his criticism, he has no hidden agenda or ideology. As an artist, lover of art, and educator, he simply aims to spread his enthusiasm for art to his readers in order to heighten their joy and ultimately their understanding of visual culture. Although these articles and reviews are of ephemeral exhibitions, this anthology preserves the experience of these events for posterity.

Bonnie Clearwater is the Executive Director and Chief Curator of the Museum of Contemporary Art (MOCA) in North Miami, Florida. She is the former Executive Director of the Lannan Foundation Art Programs in Los Angeles, the former Director of the Lannan Museum in Lake Worth, Florida and was Curator of the Mark Rothko Foundation.

Introduction by Gilbert Brownstone

To introduce Bruce Helander's assemblage of art reviews is not only a pleasure because he is a close friend, but more so because of how much I enjoy reading these reviews. His lucid, unobtuse and often very amusing writing is what is so badly needed in the art world today.

Bruce doesn't write for an exclusive group of intellectuals whose motto, too often, seems to be to do what is necessary in order not to facilitate the comprehension and appreciation of art by the general public. But after all, isn't the function of art criticism to help us understand and appreciate art?

Bruce doesn't use the jargon of "academia," not because he doesn't know it (Bruce was the youngest dean in the history of the prestigious Rhode Island School of Design), but because he is before anything else an artist, and if I may add a damned good one, too, and therefore knows how to explain his work and the work of others. He also had an important art gallery and was an exceptional art dealer, so he can explain that media in a way everyone can understand and appreciate it.

Bruce's reviews read like an irresistible novel. His introductory one-liners have become legendary. How can one resist reading on after such titles as In the Name of the Father (The Smith Family, Tony, Kiki and Seton), Good Grooming (Red Grooms at the Norton Museum of Art), Dutch Boy Paints (Willem de Kooning at L&M Arts), Fine Dining (Jim Dine), The Tin Man (Tony Berlant, whose cut-tin collage is on the cover), Horse Sense (Deborah Butterfield) and Sit (William Wegman). These are just some of my favorites: take your pick.

Gilbert Brownstone, a noted collector and independent curator, is the former director of the Picasso Museum (Paris).

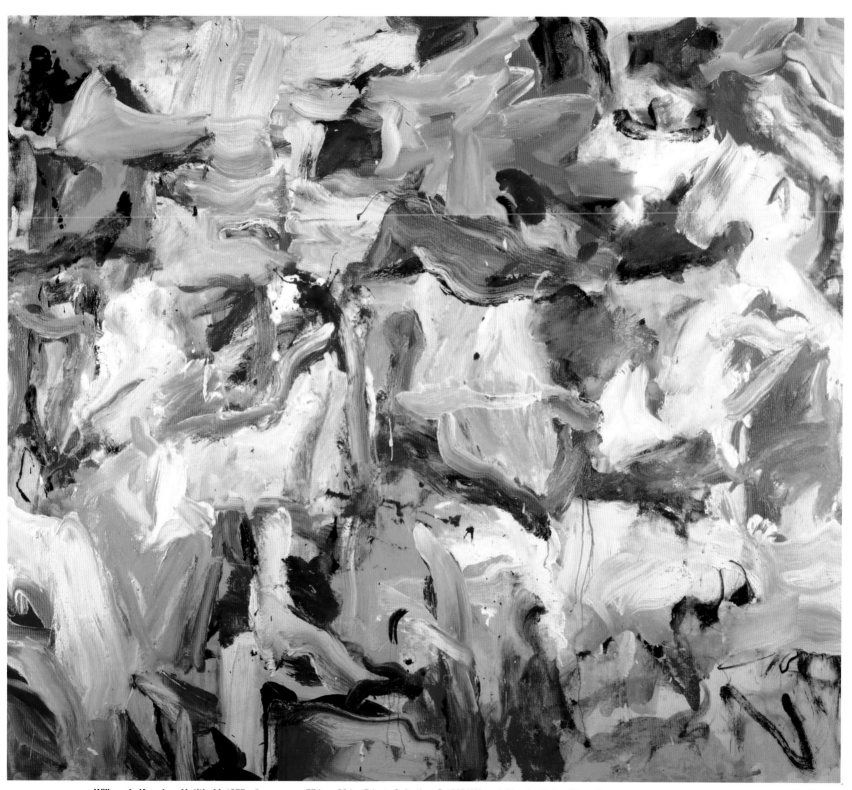

Willem de Kooning, *Untitled I*, 1977, oil on canvas, 77 in. x 88 in., Private Collection, © 1993 Willem de Kooning/Artists Rights Society. Courtesy of L&M Arts, New York

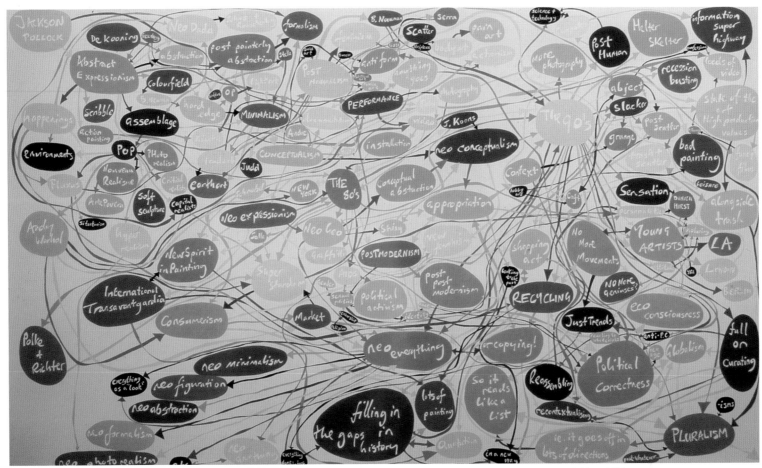

Peter Davies, *What Goes Around Comes Around-Jackson Pollock Text Painting, 2001,* acrylic on canvas, 78 in. x 132 in.
© Peter Davies. Courtesy Gagosian Gallery.

Peter Davies charts the evolution and major influence of the art world's past development with wit and whimsy in an ingenious interconnecting highway cloverleaf of gray-blue cartoon bubbles… a kind of controlled, golf course splatter shaped design oddly relating to Jackson Pollock's attempts at inventing and controlling surface chaos. Here the dizzying chart of the art universe roughly follows the rich blood lines and family tree of key developments, styles and "isms" that has had a direct influence on many of the artists reviewed here. In this madcap Rube Goldberg flow chart, de Kooning and Pollock point their virgin arrows into a crowded sky. -- B.H.

Helander Introduction by William Warmus

Bruce Helander creates at a time when some say that chaos and anarchy are poised to triumph. But Helander is not so sure that chaos always equates with disaster and he is comfortable with anarchy. In his delightful lovely soothing collages, he assuages our fears and shows us a way to live with, and even at times enjoy, chaos, and pandemonium, and bedlam, and all the other stuff that the world's media drag onto our breakfast table every morning.

He, Helander, has accomplished this by melding realism and abstraction. Helander the abstractionist sought a way to release the tensions and pressures that chaos creates and that classical abstraction so accurately represented, as for example in Jackson Pollock's major canvases. Once you are in a great tumultuous Pollock, there is no way out. Helander found the exit; or rather he collaged in an exit. He also collaged in the viewer, dragged along all the viewer's possessions, glued them back into the space of the abstract picture. He did more. Helander pumped in a healthy atmosphere in which to breathe (by poetically brushing in exactly the right amount of paint to create that atmosphere) and he constructed a humane space (outlined by the terrifically sensuous and literally edgy cut edges of each collaged part) in which to move around and release pent up anxiety. Helander transplanted heart and lungs into a style of painting that had become all eyes and brain and neurotic in the process. His collages emerge from abstract painting as if squirted from a tube of paint: Paint that coats and edges and accents a chaotic world of scissored and knifed statues, and teddy bears, and beds and violins, and on and upward.

Helander's comfort with the chaotic also makes him an excellent and uplifting writer of art reviews, among the precious few artists who consistently write about their peers. He reviews, not as a journalist who studied writing, but as an artist who studied art and whose work is in over fifty museum collections, including the Whitney Museum of American Art, the Guggenheim, Metropolitan Museum of Art and the Los Angeles County Museum of Art. His style suggests and requires a daily awareness of the collage aesthetic all around us, a world where, in his words, "you start to see things as multifaceted……built up with layers…..whether it is a ripped paper billboard, a new fashion design, or something run over many times in the road." Eventually Helander used his unique collage perspective to invent a way of looking at (and articulating) how pictures come together--just like a collage. In Dutch Boy Paints, Helander takes the reader from the first imaginary stroke and shows us how de Kooning builds on that, as if we are looking over the Dutch Boy's shoulder. Many in the art world enjoy his writing because, like collage, it has understandable components, the basic structure is clear and, most importantly, each essay is a

readable respite from the torrent of incomprehensible jargon or shameless hype published every day in the art press.

Helander has a fairly remarkable academic background. He received his MFA from the prestigious Rhode Island School of Design (RISD) and later became the Provost there—1976—when he was twenty-nine years old. His experiences were valuable and unusual (he wasn't much older than many of the graduate students) and they became the bricks and mortar for building a sensible career as a writer. Helander left RISD with a burning desire to publish a national art magazine, and so became publisher of Art Express, where he hired some of the nation's finest art writers. But he secretly did not care for what several of the prestigious academic critics submitted, finding their writing too dense and technical. And when, in an effort to improve the quality of the writing, he announced that the magazine would increase its pay to ten cents a word, the reviews got longer, but not better. So he became a de facto reviewer of reviewers, sorting out what he really enjoyed from what was bad or confusing. "I let some reviewers go and finally let the magazine go as well, but those were formative days that gave me everything I needed to become an informed art writer… and because I have a collage lifestyle, this swirling, crazy schedule I keep continues feeding into the opportunity to work, discover new artists and think on my own, with my own rock solid opinions."

Helander feels fortunate to have then explored a career as an art dealer and an artist at the same time, mounting over 400 museum and gallery exhibits during fifteen years, from surveys of the work of Ken Noland to Dale Chihuly installations. "I got to meet and work with these legendary creatures, be in their studios, discuss art over dinner and share opinions. My gallery was in Palm Beach as well as in SoHo on West Broadway in New York City, and I searched south Florida down Alligator Alley for the artists who lived there, including Rauschenberg, Chamberlain, Rosenquist, Poons and Olitski. As a dealer, you are forced every day, every hour to articulate to visitors what they are seeing or answer questions that require straight talk and clear responses." -- all experiences that fed into his writing.

The critic Henry Geldzahler enjoying his favorite pastime at Helander's Palm Beach home (1993)

The famous New York art dealer Ivan Karp, who discovered many of the artists Helander represented, from Robert Rauschenberg to Andy Warhol, taught him a great deal about the fine art of talking about art. "I listened to him for hours; we worked with each other for ten years. He got his vocabulary from working with Leo Castelli. Then came my friendship with the former Metropolitan Museum of Art curator Henry Geldzahler, who stayed with me when he was in Palm Beach and would talk the night away about art writing… he encouraged

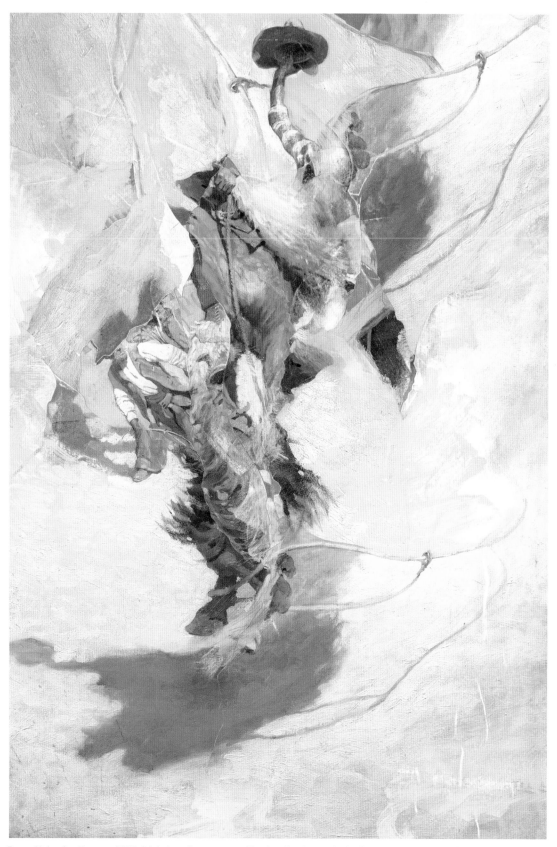

Bruce Helander, *Bronco,* 2007**,** Original acrylic on canvas with printed background, 59 1/2 x 39 1/2 in., Alshroogi Collection, Bahrain, UAE

Larry Poons, *Untitled,* 2007, oil on canvas. Courtesy Bernard Jacobson Gallery, London

\mathcal{O}n the Fast Track, 1987

Larry Poons considering the next round at the Moroso Motorcycle Track, West Palm Beach, Florida. Poons' painting method in his winter home in the Florida Keys was to take a giant roll of prepared canvas and unwind it in a large circle under a tent, where he would go round and round like a racetrack, "throwing" acrylic paint until the entire roll was saturated with layers of colorful dripping pigment. At the end of the winter the roll would be shipped off to his Broadway studio to be cut in appropriate sections.

Photograph by Bruce Helander

me. He showed me how a good review is built. Most art reviews are painfully long and are unnecessarily complicated: you have to know how to wrap it up, when it's time to stop."

For me, as a writer and curator who spends much of his time in front of a computer thinking and typing, a visit to Bruce's studio in West Palm Beach is a sheer delight because it is so sensual. The collages are laid out on tables and easels for viewing, and Bruce and I pour over them with the interest of archaeologists who have just unearthed treasures, but ones we need to decipher. I'm a diver and can't help comparing the experience of viewing a Helander collage to the experience of diving on a coral reef. At first, it all seems chaotic and there is too much activity. But after a while a dreamy floating quality takes hold and unifies the vista. Underwater, dramatic scenes compose themselves spontaneously as schools of fish (or are they fields of color?) and seaweed and coral and rays of sunlight all drift together for an instant, only to disappear the next. This adds to the surreal quality, but also forces you to swim on ahead, in hopes of spotting the next drama. The same holds for Helander's writing as well as his art. I leave his studio or read his reviews with the thought that chaos is perhaps simply a stage in the progression of the human spirit, and that the optimism inherent in all of Helander's work is a remedy for any brand of pessimism that threatens to diminish our humanity.

William Warmus is a writer and art critic who lives near Ithaca, New York. Warmus was a curator at the Corning Museum of Glass and later an advisor to the estate of the critic Clement Greenberg. He is the author of a dozen books, including biographies of Dale Chihuly, Louis C. Tiffany and Rene Lalique.

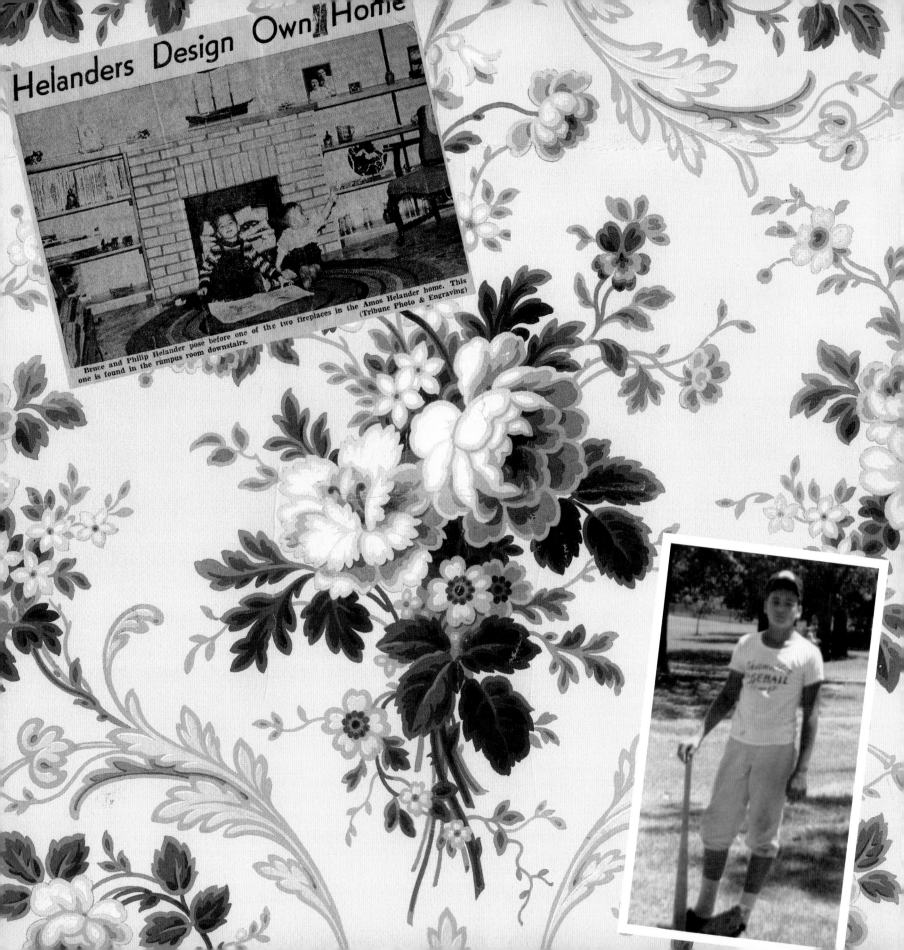

Helanders Design Own Home

Bruce and Philip Helander pose before one of the two fireplaces in the Amos Helander home. This one is found in the rumpus room downstairs.
(Tribune Photo & Engraving)

Amos Helander, 1957, Great Bend, Kansas

Carmen Helander, 1950, Great Bend, Kansas

Out of the Ballpark by Bruce Helander

I was a kid from Kansas, born in a place called Great Bend, which was situated on the edge of a big bend in the Arkansas River that sliced through the geographical center of the continental United States. However, it was definitely not the creative center of anything, rather, an uninteresting, safe haven in which to grow up, smack dab in the middle of nowhere: fervently religious, Republican, conservative, reactionary, backward and dry. Not exactly the most ideal ingredients for encouraging free thinking or abstract thought, or attracting imaginative people that might have a prayer of shaking things up at bit. Wheat and oil were the commodities that drove this small town economy, and people didn't really pay attention to much else. The brightly lit high school football games were about the only events that brought a little competitive excitement to the dismal night life there. Most people had a backyard tornado cellar, just like the one Dorothy unsuccessfully headed for in The Wizard of Oz, but no one ever seemed to move away but me. For a young artist it was restrictive in its simplicity and offered no creative inspiration or direction: maybe that's why they called it the Plains. With a lack of culture, other than one movie theatre, and, this is stretching it, Sunday drag races just outside of town, one needed to generate your own inventive environment out·of curiosity or boredom. You needed to make your own independent observations about life without the advantages of a metropolitan arena that would, I assumed, be filled with working artists, innovative galleries and museum retrospectives. At the suggestion of my mother, a creative housewife and skilled decorator who had attended the Rhode Island

School of Design during the Second World War and who lovingly supported me, I subscribed to a correspondence art school far from the Midwest that would evaluate my drawings and give me a sense of direction and ambition. My mom was a kind of Isadora Duncan type, who loved to get dressed up, often in unique clothes she had made, to dance the night away at the Petroleum Club with my handsome, stylish, Swedish father, who had a collection of 200 hand-painted silk neckties and liked constructing eccentric and witty surroundings like a wagon wheel fence with a huge horseshoe as an entryway to our house.

After wandering about as an adolescent in the heart of the wheat belt without finding anything of aesthetic substance, I realized one day, quite by accident and to my surprise, an inherently lovely natural expansive design that opened my eyes and my horizons and made me recognize that there was a big world out there, full of marvelous things to discover. A family friend invited me for a spin in a small Beechcraft bi-plane (manufactured in nearby Wichita) that allowed me a perfect aerial view of my surroundings, at once giving me a stunning perspective on the innate beauty of an engaging sequence of man-made patterns that seemed to go on forever. Just under my nose, or rather just above my head, all this time, was a landscape filled with odd shapes and parallel lines, crop circles in deep greens, with patches of harmonic and complementary burnt umber, all coming together as a huge, living Cubist canvas that was exhilarating and unforgettable. From that day forward, I was able to make the connection between something you instinctively know (but haven't realized) and a bonafide real life abstract visual statement on a large scale, which united my natural interests to become a preoccupation that continued into my college education and beyond.

So, while I certainly had a nose for being creative, I needed to explore other things. At the age of fifteen, thinking I might have a chance at going somewhere in professional baseball, I traveled gladly to nearby Oklahoma for a couple of summers at the Chandler Baseball Camp. The soil was even different—a kind of deep cadmium orange that would stain your white uniform as a permanent souvenir of a third base slide. The potential career exploration was, however, short-lived, as boredom set in during the second season and I found myself literally lost out in left field, observing the night games as a participant, voyeur, historian and radio commentator. From a darkened outfield, it was satisfying to examine the color variances between the bright lights, blue sky and emerald green grass surrounding a large diamond-shape carved out of dirt. When the action got started, I conducted an impromptu monologue from an imaginary press box. I started

Bruce Helander as a young cowboy, Lindsborg, Kansas. Backdrop: Aerial view of Barton County, Kansas.

to analyze everything with a clever description. I practiced my introductions and sharpened my delivery like a wind up from the pitcher's mound by talking into my leather catcher's mitt. This was the very beginning of my fascination with looking and investigating and documenting what I saw. It was great practice for my future as a writer and an artist, and it was a bit of enjoyable theatre that I created on my own. I did remain involved in sports, as there wasn't much else to do after school; I was a track star, a pole vaulter, an archer who miraculously almost always hit the bull's eye and a sprinter. I excelled in varsity football and basketball. I was very fast on my feet. My high school yearbook picture has the nickname "Flash" next to it, with coiffed hair and a quote that said, "Art isn't the only place you need a good line!"

Later in life, I was fortunate to have a friendship with Curt Gowdy, the legendary sportscaster. Along with his daughter, Cheryl, we would occasionally discuss reviews that I was currently preparing and he would always comment that art reviews have a direct relationship to calling a game. You need to know the game well, the players involved, the history surrounding the sport and the art of the game. Curt once remarked to me that "You're good at describing pictures in a frame and I'm good at describing pitchers on the mound." Essentially, we both decided that to be really successful making observations for others, you need to describe a circumstance that brings your own character and perceptions and excitement into a clear picture for the listener or the reader. These particular skills were especially important to Mr. Gowdy's early success in the days of pre-TV sportscasting. The same practical skills persuaded me to always put my critical thoughts about art down on paper (I always carried a reporter's notepad in my back pocket) as cryptic clues that eventually developed into a post-modern collage style of writing.

I had already developed a pretty accurate perspective on the important players of the art world after six years as an art student in New England and as an art college administrator, magazine editor and publisher and art dealer in New York City and Palm Beach. By then I knew a lot of

OUTDOORS

Staff photos by DEBORAH COLEMAN

Curt Gowdy, a former baseball announcer and the host of 'The American Sportsman,' enjoys the pre-induction cocktail party with his daughter, Cheryl Gowdy, and friend Bruce Helander.

Curt Gowdy, Cheryl Gowdy,
Bruce Helander
Photo by Deborah Coleman
Palm Beach Post.
Used with permission.

respected artists personally, so the unique combination of eccentric interests and distinctive encounters I had gave me at least a clear direction, if not professional confidence, to do more than just make notes to myself. I also had the distinct advantage of reading and contemplating published reviews by other writers on my own work as an artist. Eventually, I was hired to write for a variety of publications that offered me great satisfaction and a paycheck, and to my surprise, subscribers liked what I had to say.

Learning to See, the title of this book, ended up as an appropriate catch-all that bound together in chapters all of my past experiences that helped fine tune my vision and the analytical sense of style that make up this meandering journey my life is on. Contemporary art reviews are not really a subject that a majority of Americans care anything about, perhaps preferring the finals of a mindless NASCAR race, a ball game or a popular TV soap opera. But for those who do care, and dare to learn more about art and how it fits into a certain context, my writing tries to bring an inquisitive conclusion with a bit of wit and logical, compelling conclusions meant to reinforce others' perceptions and have a good time while doing so.

New art is something you must seek out—it's not always convenient to see (like clicking on your

favorite cable channel) and it's not always noticeable from the street, except perhaps for a simple description on a discreet sign or banner out front. There is a famous scene in the movie Jurassic Park, where a main character stares intently at a glass of water and sees it start to vibrate. As the miniature ripples start to get bigger and come at faster intervals and the ground begins to shake, you know something really powerful is coming around the corner, pronto. Art usually doesn't vibrate outside a defined perimeter (except for the neon works of Dan Flavin) or comes out to grab your attention on the street like a hungry dinosaur on a mission. It offers no warning; no danger and no religious affiliation to persuade you to enter its pearly gates. Instead, you must search for this elusive beast in order to sharpen your visual perception in the world of art, hunting for shows through announcements, advertisements or by word of mouth. These pre-planned journeys assist in developing an informed personal opinion that confidently eliminates the bad and embraces the good.

Jed Perl, a highly respected critic, once put the necessity of "looking" into a realistic context in one of his reviews, which directly relates to my continued exploration and motivation and is an important component for us all to consider as we continue our quest for images that are inventive and meaningful. In a 1990 essay titled "Successes," for The New Criterion (edited by Hilton Kramer), Perl wrote: "Anyone with even a tangential connection to the art world has some story about the day he or she went to ten or fifteen galleries and saw nothing of interest. I will not be the one to cast doubt on those experiences—since I've had them myself, in spades. If you go to the galleries you know that the ratio of valuable work to work that's utterly without value is pretty scary (I include among the valuable work anything that seems authentic, even if I don't feel anything for it). I'm not sure, however, that the situation is quite so scary as it sometimes seems. I suspect that there's as much good work being done in New York City as there ever was. What has increased (geometrically) is the number of galleries showing bad art and the number of artists doing bad work: the process of sifting through it grows more tedious all the time. Nevertheless, we cheat ourselves if we don't sift through it, because every once in a while an engaging artist who we're unfamiliar with appears, and if we're not there for those experiences, what is it all about?" I am proud to say that the artist he was talking about was yours truly. Often in the business of writing as a regular contributing art critic, there are inevitable assignments that must be covered whether I'm interested or not, so I try to make the best of it by searching for the positive visual elements in order to carve out something meaningful. The choice of going

Lady on a Dock, found thrift shop painting, Budapest, Hungary, is a wonderful example of a classic naïve painting that gently and unintentionally stretches out proportions, but still retains dignity and a sense of seriousness, which brings an experienced viewer a bit of simple pleasure. © Collection of Michael Price, North Palm Beach, Florida.

after other appealing alternative exhibitions is not always available. Nevertheless, you see a great deal in between and surrounding the trips you make in the context of your job, and if you didn't attempt the extra effort and don't "sift through it," you miss the boat and lose your edge.

Art reviews are complicated progress reports that in my case require a personal, subjective and informative summary of an artist's work you may not even be familiar with. Learning to See is not really an A to Z book encompassing all aspects of contemporary art; although the list of artists is roughly alphabetical, it is not meant to be an examination of trends or categories. The previously published reviews in the pages ahead are a compilation of many years covering exhibitions, mostly in the southeast where I am based. There are, however, plenty of exceptions where I have traveled far beyond my geographical circle to cover something of extreme interest. In my writing, I like to keep it simple and direct, beginning with something that might not immediately connect with the subject of the review, which offers the reader a pleasant, innocuous introduction, then continue perhaps with some oddly related history that soon comes to the point. Then I like to dissect the images into reference points, intersecting visual common denominators that make up the recognizable and logical progression of an artist's style.

I don't really have preferences, as long as the work does something for me. For my money, the most important artists of our generation are Pablo Picasso and Willem de Kooning, with Andy Warhol a distant third. Just about everybody who makes art pays homage to this trio; the latter two are discussed at length in separate chapters.

I always look forward to examining all forms of creativity that come my way and I have no prejudices in that department. However, as a collage artist and painter, I have more of a connected interest to two-dimensional works and assemblage. I am always waiting to see the latest efforts by Damien Hirst and Jeff Koons, who often combine painting and sculpture; I consider them to be among the top artistic inventors of our time, and they make art a serious business as well—and why not? I'm also absolutely fascinated with John Currin, who has transformed the figure into a dramatic, ironic, duplicitous balancing act between sensuality and innocence and exaggeration and directness. Not since Thomas Eakins has there been another contemporary painter with such a completely idiosyncratic voice, except perhaps for Botero that has separated their work from all other figure-oriented paintings. I'm intrigued with the exquisite, painted, cut-out silhouettes of African-American artist, Kara Walker (recently shown at the Whitney), perhaps the most important and stirring body of art produced by any American in the last decade.

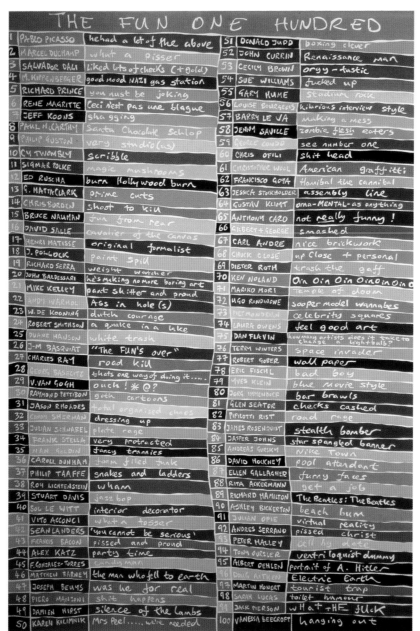

Peter Davies,
The Fun One Hundred
(Pink Top Version), 2000,
acrylic on canvas,
72 in. x 48 in.
© Peter Davies.
Courtesy Gagosian Gallery.

Peter Davies' chatty exhibition in 2003 at the Gagosian Gallery in London was an original and historic retrospective of images and ideas utilizing large hand-painted charts of text, evolutionary lists and aesthetic diagrams that etched in canvas one person's opinions of the universal art world both past and present. The letter perfect charts incorporate art about art, or in this case art by an artist about art on the back of an oversized envelope like a betting sheet at a horse race as information. Part Jenny Holzer, Richard Prince and Ed Ruscha, part grocery list, these humorous depictions and controversial line-ups create art out of informed views and subjective hearsay in the precious pecking order of art. In The Fun One Hundred (Pink Top Version), Davies fashions himself as a veteran beauty pageant judge, determining who is the most "fun." This colorful checkerboard text is reminiscent of a Monopoly board game that lists a property and defines what smile you get. NOTE: while it's a fun ticket for a carnival of laughs, what's so funny about Richard Serra, Donald Judd, Carl Andre...I'd much prefer taking Jeff Koons, Paul McCarthy, Martin Mull, Richard Prince, Jenny Holzer, Mike Kelley and Tony Oursler on a trip to the Laugh Factory any day. -- B.H.

I am especially encouraged and intrigued by the newest trend of artists applying their work to fashion, "art couture:" Levi's painted jeans by Damien Hirst and lately, Andy Warhol, Takashi Murakami and Richard Prince for Louis Vuitton, Todd Oldham for any object worn or sat on, Tracey Emin for Longchamp and London artist Julie Verhoeven for Mulberry bags (and of course, "Bruce Helander for Nicole Miller" neckties!)

But, I'm also interested in "unsophisticated" pictures, especially authorless discoveries from secondhand stores or unschooled artists, who have no agenda (and will never receive notice) but that of creating something they alone enjoy, without regard to where it ends up or if someone else likes it.

In 1989 I was asked to appraise a collection of dusty paintings stacked like a hermit's library in every room of a dilapidated house. I discovered from my first foot in the door a treasure trove of gloriously genuine primitive works on board that, like Jed Perl's comments, make it all worth it. When the artist, Carrie Mueller, was seventy years old, she stopped by early at night school to pick up her son, who was studying accounting practices. While waiting, she went into a small art class, where the teacher offered her the opportunity to sit with the students. She had never had a paint brush in her hands, but always loved art. Using a magazine illustration for inspiration, she finished a small picture within an hour to her amazement and that of the teacher; her work was off kilter but fascinating and unique. She loved the initial experience and began painting on her own, every day, in private, without a single exhibition, for the next twenty years. I decided to find her. She was on her death bed, blind and weak, at a nearby care center. While visiting her, I held her hands as I told her what a wonderful, unusual talent she had and that I was flabbergasted at her natural ability. With tears in her eyes, she told me with a smile that my observations were comforting music to her ears. It was the first time she had ever received a professional comment about her work—it had hardly ever been seen—and the next week she passed away. So keep your eyes open, as there are discoveries to be made outside of exhibition environments—and try without prejudice to not let anything pass you by. Forty-odd reviews have been reprinted here about works that have been a joy to discover, digest, research, abstract and write about. It has been a pleasure to share my descriptive thoughts on style in print, originally conceived from a baseball mitt—where a metaphorical hand-sewn curve ball full of spin and energy finally hits a designated target—this time from a show to a notepad to a computer screen to printers somewhere in Asia.

Carrie Mueller, *Sabbath at Beth Shalom, Elkin Park* (Last building designed by Frank Lloyd Wright), 1982, oil on board, 20 in. x 24 in. © Collection of Bruce Helander

Helander Kitchen, Historic Grandview Heights, West Palm Beach. Photo by Sargent Architectural Photography

*W*ith notes in hand, Helander's kitchen becomes a habitual private sanctuary where he can avoid all interruptions, except for a teakettle's whistle. The phones are off the hook, radios turned off and doors shut. Surrounded by the objects he loves, Helander sits at the small wooden table, which is just big enough, transcribing his initial exhibition notes to an outline on paper before it is typed up for the computer. -- *Susan Hall*

Richard Artschwager

SHADES OF GRAY

Richard Artschwager's retrospective at the Museum of Contemporary Art in North Miami, which coincided with his eightieth birthday, augments his position as one of the most consistent and intriguing living contemporary artists of our time. The 'art' in Artschwager isn't just the first three letters of his famous name, but a kind of psychic all-over assimilation of everything that the artist feels compelled to document.

Richard Artschwager, like so many great artists, did not fit the mold his parents expected him to follow. One day he decided to become an artist and the next day he made his first painting. He never looked back. Visual artists have an intuitive searching spirit that seems perfectly logical to develop. Artschwager's mother, who had studied studio art, encouraged his aspirations and in many ways opened the young boy's eyes to a changing landscape that ranged from New Mexico to Munich. In 1942, during his sophomore year as a Cornell University science student, World War II interrupted his studies. These events indirectly centered his vision through photographs he would take of the impact of the war on everyday life.

After World War II, he returned to New York City to study at Amedee Ozenfant's art school, where he discovered that everything to express in art seemed to be already covered by others. But Artschwager was determined to find and invent a singular, recognizable style unique to picture making. The searching emotional experiences recorded by his camera in Europe and the discovery of a certain sympathy and inquisitiveness for newspaper photographs laid a natural groundwork for developing his pictorial references. His creative attraction to found photographs and newspaper clippings of people and architecture allowed him to successfully combine distant sentiment and personal observation. He ground these into a swirling industrial surface made of Celotex—a rigid compound board formed from sugar cane fiber. The coarse textural repeat patterns of Celotex offered the artist the opportunity to create an impression of a magnified halftone abstracted line, which could comfortably distance itself from the original printed source.

It's also interesting to note here that Andy Warhol, a gifted illustrator, first began translating his interest in newspaper clippings of celebrities and tragedies onto canvas. Warhol's slightly off-registered reproductions became an indelible signature, as did Celotex surfaces for Artschwager. Of the available commercial patterns, the swirl design — a favorite of Artschwager's — is reminiscent of the brushstrokes in Van Gogh's Starry Night. The deliberate harmonious combination of a textured repetitive design supported the artist's candid portraits of life with a mysterious, convincing grace. Ordinary voyeuristic views of a fancy living room tempered with the artist's all over multiple dot applications become subtly intriguing and starkly beautiful. A simple bowl of peaches seems to fit nearly perfectly on top of a circular grid that adds a convincing rhythmic three-dimensional quality. The painting articulated with an understated black and white color scheme exposes one piece of fruit painted in tones of violet. These devices of segregating a relatively small segment of a painting with one color on a gray background becomes an odd focal point, like the young girl with the red dress in Schindler's List.

Dinner (Two), 1986, is another black and white painting of a pair of dinner plates with highly abstracted utensils. One plate comes alive with an orange fried egg shape that is unsettling. In Untitled (Fire), 1988, the ominous destruction by fire of a towering high-rise building eerily predates September 11th, and seems remarkably fresh. The anguish of a viewer to this scene is amplified, not just from the outside horror but by the unmistakable fright and compassion for the occupants assumed to be trapped hopelessly in an impossible situation. Artschwager will often pick an anonymous structure or select a single window that shades the secrets of everyday life.

Although his signature paintings are clearly based on photographic sources from as early as the 1960s, they seem conventionally perceived as natural in subject and conceptual in strategy. The exhibition at MOCA took a rather unique approach by zeroing in on emotional content and psychological associations. Empty rooms and loneliness, desolate landscapes devoid of people or an empty jeep in the wilderness, headlights focused on nothingness, are uncomfortable images that we can relate to, but do not want to participate in.

Artschwager's straightforward head and shoulder portraits take full advantage of the textural patterns that lay just under the painted surface. His painting of George W. Bush is a handsome rendition of the world's most powerful man, portrayed without visual clues to his state of mind. His modest Self-Portrait, 2003, is also plain and straightforward without an agenda. Here the artist presents himself as unassuming but dignified, with a bright green background that allows his silhouette to leap out from the frame. This is no ordinary portrait, for it combines the vision and intellectual curiosity that the artist has formulated all his life. In the self-portrait, his technique, his textured surface, his image and his spirited composition are all rolled into one haunting statuesque image.

Perhaps the essence of Artschwager's appealing portraits is his inherent neutralized stand for the individuals he portrays in his paintings, whether he is familiar with them or not. Artschwager, the "late bloomer" who had no time to lose, has shown us that a serious lifetime of investigation into people and places has permanently captured our imagination and fired-up our passions for convincing explorations of life.

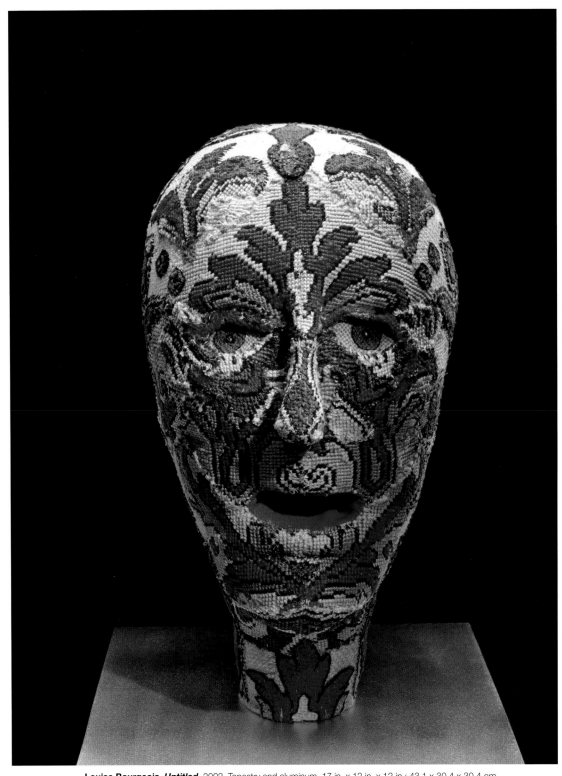

4

Louise Bourgeois, *Untitled,* 2002**,** Tapestry and aluminum, 17 in. x 12 in. x 12 in.; 43.1 x 30.4 x 30.4 cm.
Collection of the artist, courtesy Cheim & Read, New York. Photo: Christopher Burke

Louise Bourgeois
A STITCH IN TIME

For thousands of years a meandering river of coincidences and primal instincts brought people together to challenge the overwhelming odds of basic survival. As they continued to sharpen their skills, they developed methods of communication, from languages to decorative embellishment, that they were able to pass down as new cultures spread in all directions. These twists of fate, which brought disparate groups and individual family members together, produced offspring who inherited the talents and daily influences of their biological parents. Often in art history two parents with specific goals and creative interests have a remarkable effect on their children, from the workplace during the day to the dinner table at night.

Louise Bourgeois' parental dominance, both good and bad, has followed her career almost all her life. She was born three years before the beginning of World War I. Her early childhood was unsettled, because she and her mother traveled about to follow her father in the military. After the war, her parents worked in a tapestry factory, and much of the conversation concerned hard work, technique and style. These three subjects would become important common denominators in developing the artist's vocation and have remained identifiable even as she has lived into her 90s. While lineage and parental guidance are important components, they need to be linked with a productive environment and a meaningful education. Bourgeois attended school at the Lycee Fenelon in Paris and majored in philosophy, then continued at the Sorbonne. Her mother died when she was only eight years old. Bourgeois was so grief-stricken that she found refuge in the subject of geometry, which was logical, predictable and systematic and provided a world of desperately needed order for her. Later, she studied art with post-cubist Ozenfant and Leger and lived the life of the Bohemian on the Left Bank of Paris while commuting from her house. At every turn something strongly reinforced the direction of her career. In 1937 she became a tour guide at the Louvre; in 1938 she married Robert Goldwater, an American art historian whom she was with until his death in 1973. She loved nurturing children, and raised three sons of her own in New York City.

Louise Bourgeois has continued her artistic practice for the better part of a century. The art has remained surprisingly innovative, sometimes shocking, and she has conveniently and deliberately removed herself from labels of surrealism, abstract expressionism, minimalism and conceptual art. Her exhibition at the Museum of Contemporary Art (MOCA) in North Miami presented an extraordinary collection of objects and an eclectic selection of the artist's graphic pieces.

Bourgeois' work offers an overview of her life's complicated forces and the experiences that have literally been woven into her art like the carpets she repaired as a child. She created a group of life-size busts in sewn fabric and a series of cell-like vitrines housing surrealist scenes, as well as totemic fabric figures. The grief over her mother's early death and the traumatic triangle of relationships between her father, mother and governess (who, much to her chagrin, ironically became the father's mistress) continued to surface throughout her career.

Louise Bourgeois has been a pioneer in utilizing installation as a way of engaging audiences in the experience

of her art. Her 3-D documentaries, like installations from a book, allow her to share her camouflaged pain from the mysterious recreations of her memory. The visual evidence presented in this show points back to all former influences to create a polished, sympathetic and completely resolved repertoire that is charged with brilliance and invention. These qualities, particularly over the last two decades, have produced astonishing projects that have propelled the artist to remarkable critical achievement. Upon her arrival in New York, in her basement, she began making sculpture for the first time. As the sculptural work found its direction, and the demands for larger space became overwhelming, she moved to a warehouse in Brooklyn, where the legitimate birth of her installation art took place.

It was here that she explored in depth through metaphor aspects of human disappointment and discomfort, whether physical, emotional or psychological. In one haunting example of an artist's background sifting into their work, Untitled (2002), a tapestry covering an aluminum skull shape, Bourgeois confronts the viewer with a hypnotic dialogue with her past. The head shape is literally tattooed with a decorative ceremonial mask that sweeps under the woven rug the pain just below the surface. The face cries out to share the hardships of life. Its lonely stare reaches into the dark for help as a lipless mouth makes communication impossible. The dehumanization of sex and love and the drama of betrayal and transgression are further explored by a red-lipped racetrack-shaped mouth opening that seems to be reminiscent of a 42nd Street blow-up doll. Scary as this face is, it is also uncanny in its symmetry and naturally constructed beauty. In this piece, Bourgeois' family history, her father's job as a dealer and restorer of tapestry and the hatred, betrayal and transgression she held onto, is all ironically wrapped together, bringing ugliness into a complete transformation.

Although the first set of skills as an artist was clearly sewing as a traditional technique, this ability remained repressed in her practice for many years. Now the language of spinning, sewing and weaving formally and metaphorically are enthusiastically used as embellishments to her work. In the late 1990s, Bourgeois began to fashion strange stuffed mannequins from a range of ingredients, including toweling, mismatched pieces from rugs and tapestries and stretch fabric, as well as fake fur. These works were really a composite drawing, albeit in crude sections, of material swatches that, when completed, described like a line-up witness the complexities of the human form and what they might secretly reveal. Patched together like a faded scrapbook full of disappearing memories, the artist has created a material collage. This collage serves as an external skin, complete with muscle tone, that seems awkward and disturbing but also domestically caring and crafted. The work, Seven in Bed (2001), seems to be a recreation of childhood experiences where the young artist and her siblings would pile into their parents' bed, facing in all directions, including love and hate, intimacy and detachment, hope and despair. Here, mothers, fathers, lovers and children form a stuffed, intertwined human horizontal fence that seems comfortable at first glance but begins to send a chilling signal with its details. There is something distinctly Egyptian about these wrapped figures that have been laid out for a temporary rest, but like the pharaohs before them, they must find a permanent safe haven in which to continue their journey.

Louise Bourgeois' past is her future when it comes to shaping the convincing forms that are personal and up close. Her recent explorations of needlecraft, after years of experiments in modernist and post-modernist idioms from carving to assemblage and installation to performance, have brought this extraordinarily talented artist full circle next to her mother's kitchen table as a defense against her troubled past.

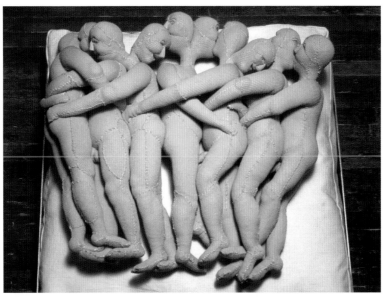

Louise Bourgeois, *Seven in Bed*, 2001, Fabric and stainless steel, 11 1/2 in. x 21 in. x 21 in.; 29.2 x 53.3 x 53.3 cm.
Collection of the Artist, courtesy Cheim & Read, New York. Photo: Christopher Burke

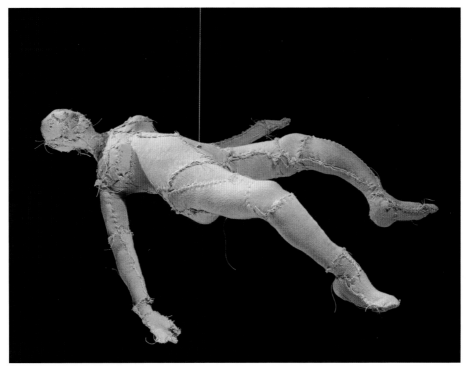

Louise Bourgeois, *Arch of Hysteria,* 2000, Pink fabric, hanging piece, 5 1/2 in. x 17 1/2 in. x 11 in.; 13.9 x 44.4 x 27.9 cm.
Collection Claudia and Karsten Greve. Photo: Christopher Burke

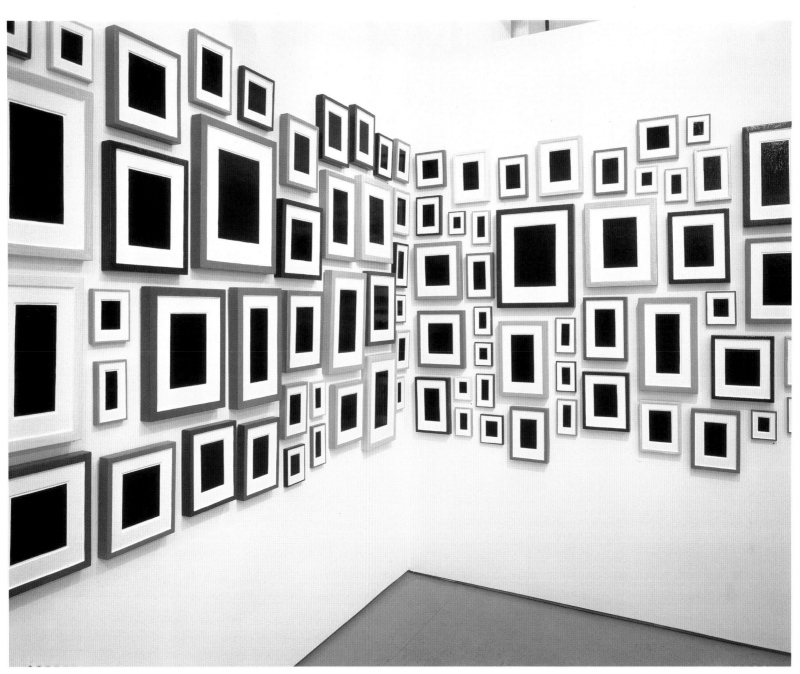

Allan McCollum, *Plaster Surrogates,* 1982/84, enamel on cast Hydrostone, sizes variable, each unique.
Detail of installation at Richard Kuhlenschmidt Gallery, 1984. Courtesy of the artist and Friedrich Petzel Gallery, New York

Brownstone Collection

BARE BONES IN THE KITCHEN

In the now classic film "Five Easy Pieces," Jack Nicholson asks a bewildered live-by-the-rules waitress to dramatically pare down the ingredients in his sandwich order to a slice of bread with chicken salad. The uniformed girl, who insists on "no substitutions," just can't accept the unconventional menu change, so the lead character defiantly sweeps the entire table clean in an effort to start from scratch. It meant destroying accepted traditions with a simple approach: no narratives, no embellishments, no additives, no lettuce or mayo, just the basics on a plain white plate.

The end result of clearing away unnecessary and unwanted recipe components, in the words of Frank Stella as an art world maitre'd and master chef, is "what you see is what you get," a kind of manifesto for the genesis of a new movement brewing in the studio kitchenette labeled Minimal Art. In 1966, a loose-knit fraternity of downtown artists started to streamline their experiments into new territory. This territory captured the interest of several of New York's five-star museums, including the Jewish Museum and the Guggenheim, which supported this revolutionary groundswell and acknowledged with a curatorial blessing the existence of an original and noteworthy development. "Something" was definitely cooking.

At about this same time Mel Bochner, the respected artist/critic who had been dissecting convention for years with his work, singled out Andre, Flavin, LeWitt, Judd and Robert Morris as leading proponents of a new label that was not at all familiar or understandable to most. It should be pointed out, however, that these "disciples" of minimal theory had lots of other earlier artists to thank (whether they realized it or not) for paving the way for their curious "new" art.

The biggest ribbon-cutting ceremony that served as a perpetual spark took place just after the turn of the last century in the studios of Braque and Picasso. After all, the basis for the Minimalist movement was the breaking down of two and three-dimensional images into pure geometry, shape and color. The Parisian Cubist duo seemed to initiate the theory that one could crack established traditions into a simpler straightforward picture plane reducing detail and abstracting reality. Without these noble pioneers, Minimalism as we know it would not have had a chance to germinate. Perhaps it was Mondrian who carried the pre-Minimalist ball the farthest when he began to reduce subjects like trees and then buildings into short, vertical and horizontal lines that

offered the viewer a glimpse at a disappearing object stripped of its particulars and emotion and set into a quasi-geometric grid. The end result of Mondrian's conclusive and now predictable final stretch was the groundwork covered for future generations of Minimalist artists.

Soon after, architecture proclaimed less is more, and even furniture and household objects inherited a distinct clean linear style that hoped to reduce things to a functioning skeleton of bare bones. Brancusi was another trailblazer, with others like Malevich and Albers, who saw the stark opportunities of simplicity as a new form of beauty with a freshness of spirit and ingenuity. Little by little, step by step, a solid foundation was being built as the bricks and mortar started to support an identifiable movement, with leading galleries jumping on the porch to line up at the front door. As museums began to realize the necessity of acquiring Minimalist works in their relative infancy and modest notoriety, a distinct group of courageous collectors also began lending their financial support to obtaining something new that looked promising, with a predictable value for such pioneering work with a bright future.

Gilbert Brownstone left for Paris as a college age kid and liked it so much he seldom returned to the United States. Issues of novel style and attitude, rich history and elegant tradition, grace and beauty, seemed to seduce the young Brownstone into giving over to the mysteries of Paris and of contemporary art. Later he became a legendary force and influence on the Paris art scene as a successful art dealer, curator and distinguished collector. Among other things, he directed the Picasso Museum. Many people turn to art for inspiration and solace, but Mr. Brownstone bought these paintings to assimilate their "inner power" and move him through a period of great loss in his life. He responded to the meditative and spiritual influence of these starkly uncomplicated images, which added a healing intellectual strength that spoke to him. Together with his elegant wife Catherine, who contributed a natural formulative position on style as the former director of French Vogue and Elle, the Brownstones formed a quiet partnership of appreciation. They surrounded themselves with works of art not for investment, but for the sheer joy of living with crisp creative energy. The Brownstones have a multitude of interests that take them back and forth from Palm Beach to Paris to the south of France to Havana. Their collection of art works is not limited to the Minimalist period, but to pieces that stimulate their joint sensibility and passion.

The works in the show, titled "Minimal to the Max," all donated by the Brownstones to the Norton Museum of Art's permanent collection, are unabashedly straightforward with their simplicity and directness. Josef Albers, who claims a major branch on the family tree that got Minimalism to this point, became an important link between the abstract geometric painting of the European pre-World War II art world and American post-war Minimalism. His work, Study for Homage to the Square: Light Resonance, could act as a theoretical banner for a great number of Minimalist artists, as a basic square serves as the source for nearly all the images presented. And why not? If Minimalism broke the rules in a search for simple geometry, it was inevitable that a block would serve its purpose well, from building pyramids to Rubik's cubes to Sol LeWitt's jungle Jim squares on squares. The perfect square also plays a major role in works exhibited here by Larry Bell, Jesus Rafael Soto, Gottfried Honegger, Peter Schuyff, Bernard Aubertin and Jean-Pierre Raynaud.

After a careful examination of these diverse pieces on view, one really can sense, as with Gilbert's healing

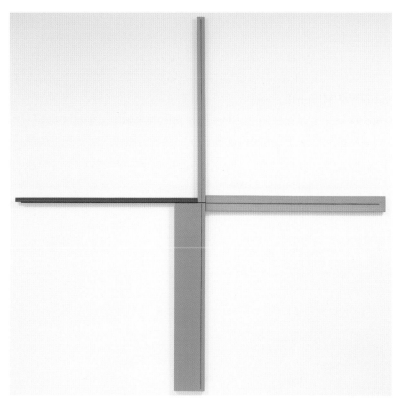

Robert Mangold,
Aqua/Green/Orange + Painting,
1983, acrylic and black pencil
on canvas with aluminum bar,
96 1⁄4 in. x 98 1⁄4 in.
(244.5 cm x 249.6 cm),
overall installed, No. 43909.
© 2008 Robert Mangold/Artists Rights
Society (ARS).
Courtesy PaceWildenstein

perception, that Minimalism provides a peaceful inner connection with a kind of crossroads of life. The shapes contribute a respectable astute perpetual balance and uncomplicated reason highlighting the purest principles of aesthetic harmony. Robert Mangold's Red/Aqua/Yellowgreen + Painting (1982) evolved from a series of pencil marks on canvas. His application of a much-used form, the cross, as a neutral non-religious shape, is just a simple, albeit powerful orthogonal crossing of two lines. But the work is packed full of spiritual and mathematical natural energy that is easy to contemplate. The left side of this cross-shape is a basic, painted line with the top vertical line doubled in size and the third right "wing" quadrupled and the bottom panel doubled again. This sequential adding on of exacting weight and color tends to slightly spin the composition like a Dutch windmill early in the morning.

Allan McCollum began to experiment in the late 1970s with the complete reduction of an art object to its limits without losing its semantic ambiguity and historical references as an object of art. His Ninety-six Plaster Surrogates No. 4 (1982) presents a wall full of uniformed frame shapes that differ only slightly in shape and their shades of gray. The colored interiors surrounding their matching frame have absolutely nothing to declare other than they seem comfortable as an anonymous group and ironically beautiful in the rhythms of their placement. Many Minimalist works have a visual message that goes back to the beginning of nature and its accompanying geometric order. The web of a spider, the shape of a honeycomb, the pattern of a sunflower's seeds, the spiral of a seashell and even the perfectly formed ball of the dung beetle are all nourished from high above by the fire-spitting sphere of our sun, giving life, encouragement and natural order handed down over millions of years. It is clear from this extraordinary art form that nature has indeed passed its magic baton on to man's creativity, encouraging complete balance, healing powers and simple beauty.

11

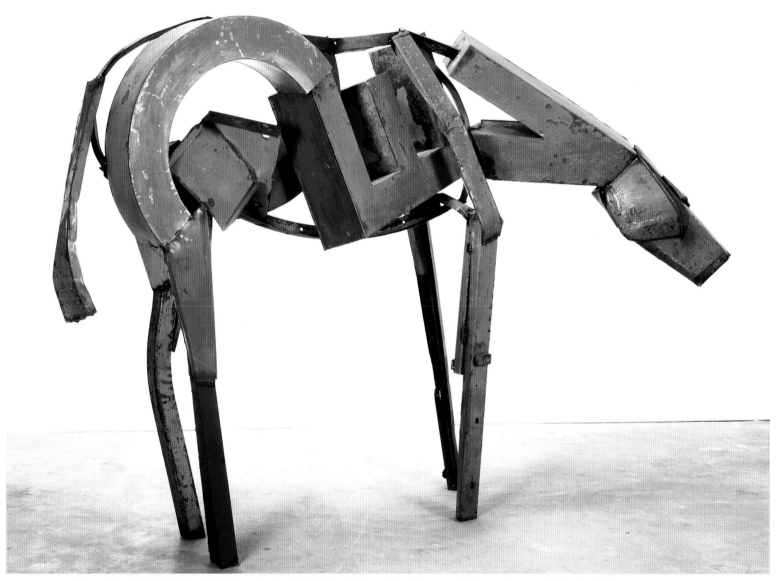

Deborah Butterfield, *Ferdinand,* 1990, found steel, welded, 77 in. x 116 in. x 33 in. Yellowstone Art Museum Permanent Collection, Gift of an anonymous donor.

Deborah Butterfield

HORSE SENSE

Deborah Butterfield's exhibition at the Appleton Museum of Art in Ocala, a beautiful, inventive and engaging show of contemporary sculpture, was overwhelming in its magnificence and ingenuity of the human creative spirit as expressed in hand-built equestrian images unequalled by anyone in history.

Constructed of sticks, mud, straw, found metal and bronze castings, these sculptures miraculously appear real in attitude and proportion. These three-dimensional compositions, though pieced together with odd, disparate materials, including, in some instances, parts of letters from discarded signs, create a persuasive magic and amazingly accurate portrayal of Butterfield's favorite subject.

Horses have always been a central issue for the artist, who grew up in southern California during the fifties and sixties. As a young girl, she not only rode horses but drew them as well. This early, passionate infatuation with equines was to remain corralled in the artist's heart and soul and is at the essence of her inspiration.

Butterfield parallels the natural instincts of wild horses — independence, perseverance, strength and stark beauty. An avid rider skilled in the art of dressage, she makes her art surrounded by an aromatic natural environment that inspires and challenges. While so many artists of similar accomplishments live in dense metropolitan areas like New York City and Los Angeles, Butterfield has the advantage of living and breathing the same air as her subjects, encircled by the serenity of the northwestern sky and the rolling hay fields bordering her ranch.

She began gaining respect and intense interest when her work was included in the 1979 Whitney Biennial. During the next decade, the art world witnessed her creative growth at O. K. Harris Gallery in the heart of Soho. There was always an awkward irony and surprise to discover horses in an urban jungle of industrial lofts and streets crammed with delivery vehicles that a hundred years earlier were propelled by real horsepower. But for this writer, the turning point for Butterfield was her departure from the supermarket approach of her former gallery to the exquisite space above the Prince Street Post Office at the Edward Thorp Gallery. It was here in

1986 that her sculptures, placed one by one in separate gallery spaces and lit only by the rusted industrial skylights above, seemed to come alive. It was at this milestone show that one could walk around each piece, sensing the animals' next steps and the anticipation of an abstract exhalation. In a twist of fate, man circling beast was an out-of-context experience as you blinked just for a moment to realize these steel forms seemed to be watching from the corners of their tinker toy-like "eyes."

Perhaps the essence of Butterfield's overwhelming appeal is the balance she creates between the abstract and the narrative. Clearly from anyone's perspective the shape of a horse, even in a darkened room, is apparent from the very first glance. But even more intriguing is how this sculptor instinctively knows how to collage together materials — usually rusted steel or tree branches—that are the complete opposite of the natural components — bone, muscle, hair — of these four-legged creatures.

Butterfield's work is the one hundred percent pure product of her lifelong association with the symbol of America's pioneering spirit and early mobility. In order to assemble several dozen smashed, scraped and bent fragments, many from discarded automobiles and now adaptively reused into the image they replaced—one must have a continuing hands-on experience of observing, grooming, riding and finally, proudly loving one's subject matter. Butterfield, like John Chamberlain, the greatest abstract expressionist sculptor of our generation, can be dropped down into the middle of a Sanford & Son salvage yard anywhere in the world to create her consistent magic from scratch. This ability is secure because these artists know their three-dimensional palette so well. They look forward to the challenges of solving problems in a visual crossword puzzle that requires circuitous links and clever connections, welded with riddles and shapes and color.

Butterfield takes a giant step beyond Chamberlain as she deliberately complicates the crossword equation by adding narration to her compositions as she builds from the bottom up. And here is where the artist's ultimate knowledge of horses combined with a superb sense of scale and taste start to become so convincing and resolved. Surrounded by a pile of materials, usually a distinct category like driftwood, Butterfield picks through with a seasoned eye, as a flea market junkie might do at sunrise.

Similar to a surgeon who knows every nuance of bone and muscle in the human anatomy, the artist examines each ingredient to determine if it can successfully substitute for a bending leg, a swishing tail or a watchful eye. As the selection process continues, separate pieces are temporarily clipped onto each other until the evolution of individual particles becomes a whole. This formula is repeated each time a four-legged creature starts to take shape.

In the work titled Ferdinand (1990), Butterfield crafted her subject almost entirely of advertising sign letters and related metal parts with a beautiful orange-red patina, which would seem to be an impossible feat considering that nothing could be farther away from the manageable shapes that the artist requires. Indeed, this is the challenge the artist has set up for herself with, not surprisingly, great results.

After all these years, the assemblaged herd continues to develop and expand bit by bit, piece by piece in the artist's studio, creating a handsome and perpetual migration into well-lit pastures around the world.

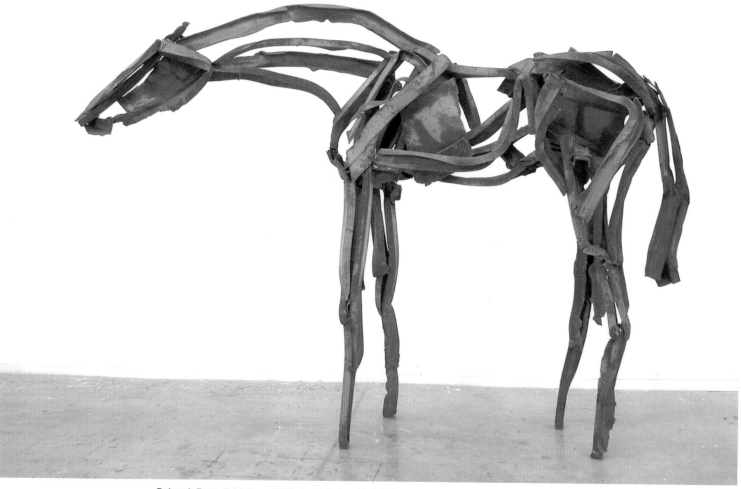

Deborah Butterfield, *Rosa,* 2005, found steel, welded, 86 in. x 124 in. x 28 inches. Courtesy of the artist.

Tony Berlant, *Imprimatur,* 2001, found and fabricated printed tin collaged on plywood with steel brads, 61 in. x 49 in. Courtesy LA Louver, Los Angeles

Tony Berlant

THE TIN MAN

Artists have been actively documenting, investigating and interpreting the surrounding landscape for hundreds of years. Breaking away from the relatively safe subjects of a traditional still life or a figure study was a courageous decision, as there were almost no limitations to this untamed and largely unexplored outdoor territory. No longer restricted to positioning his subjects within the architectural confines of a square studio, the artist could now investigate the seductive rhythmic beauty of nature in all its neverending, perfect glory.

Tony Berlant in his exhibition at Lennon, Weinberg gallery in Manhattan demonstrated the personal joys of continuing to discover our North American landscape, while searching for the perfect spot to literally nail down an intriguing composition.

Berlant made his home in Santa Monica, California, inside a converted corner grocery store that still bears evidence of its past life with faded, preserved signage on the first floor windows. Here in this bustling neighborhood, less than a mile from the invigorating breezes of the Pacific Ocean and its extraordinary coastline, the artist sifts through his photographs, sketches and personal notations to determine his next move. In this hybrid interior environment, the artist brings together the old and the new as a working platform from which to build another magical tin picture cut from a sign in the city. This is molded, manipulated and cut into pieces, which germinate into a blossoming capsule of engaging intelligence and raw beauty.

As a child, the wide-eyed budding artist Berlant spent a great deal of time searching the desert around Palm Springs with his family. Here the boy developed a taste for the stark splendor of the sandy, rolling hills, which were peppered with the cactus and desert flowers that would be an ongoing influence as the young Berlant cultivated his eye and love for nature. Other routes of family exploration led them into the reddish and rockish territory of Arizona, whose borders enclosed a fantastical landscape of glorious native wonderment. The permanent impression upon an evolving youthful point of view progressed with each extraordinary geological monument, like the meandering, spirit-filled Grand Canyon, cut deep into centuries of colorful, pastel layers of earth. The visual riches of this area included a huge "brushstroke" from outer space — the awe-inspiring meteorite crater, the carved stone-like Petrified Forest and breathtaking vanishing points with accompanying sunsets. All were assimilated into a creative mind that would later reconstruct from memory expansive, mysterious depictions of the Southwest.

Fortunately for the young Berlant, his innate inventive instincts led him to admire, acknowledge and absorb the aesthetic value of tribal traditions celebrated by Native Americans who live in harmony with nature. These regular childhood excursions influenced him tremendously. His ongoing fascination with desert life inspired him to become an avid collector of Southwestern Native American art — much of it derived from the secrets beneath the orange soil. Accumulating and categorizing prehistoric implements and patterned ceramics were a perfectly normal extension of the artist's exploratory vision. The method of Berlant's collage constructions depends on manipulating and rebuilding decorative pre-existing materials. These are then cemented on a wooden panel that has been hammered a thousand times or more by a standard tool used for centuries by indigenous inhabitants of the desert.

In his cavernous, high-ceilinged studio, Berlant has meticulously compartmentalized a rather astonishing collection of early-man tools, which include shapes from worked stones that are over a million years old. These devices, in the case of Berlant's persona, represent the laborious physicality of slowly piecing together forms hand to hand with the skill and dexterity of a human's eye directed by heritage and expert intuition.

In addition to the non-commercialized status of native tribes and earlier primitive man, Berlant has been influenced by artists who flourished in the past centuries, such as Bosch, Courbet, Cezanne, Monet, Picasso and Cornell. It is not surprising then, that after a careful examination of Berlant's compositional layers, and a playful investigation of space drenched in color, but sliced into neat portion control, his strongest contemporary influence comes from Willem de Kooning and Richard Diebenkorn, two legendary artists he knew. Like Tiger Woods with a five iron in his hand at age six, or Louise Bourgeois with a stitch in time at nine, young Berlant had the good fortune of similar advantages initiated by his family. Those advantages permanently stuck into a developing psyche that forever shaped the artist's vision, authority and confidence. To stay connected with these primeval roots of inspiration and attitude, the artist has continued to visit the desert just a few hours from his urban studio, which fills him and allows him to return with a renewed spirit from a thoroughly enjoyable visit. These personal observations of natural landscapes are etched in his mind. They begin to coalesce like a reconstruction of a dream that takes advantage of a bedside notebook for clues to a beginning and an end.

Berlant's method of working follows the great traditions of collage. He gathers large drafts of disparate goods — in this case the world's biggest collection of printed tin from advertisements to containers — that are roughly categorized in bins by shape, texture and surface imagery. Here, in contrast to most artists who capture landscapes with customary media like oil paint or watercolors, Berlant's palette, like John Chamberlain or Deborah Butterfield, is limited to the raw resources. He meticulously turns those resources into carefully defined "brushstrokes" again and again. As the composition takes its initial outline from a cartoon blueprint on tracing paper, selections are made from a surrounding inventory of sharp-edged scraps and newly found squares. These baked enameled commercial products that promote everything from hair tonic to organic vegetables, are sifted through to find a tonality that fits into the overall harmony of an earlier sketch. Signage, figuration and nearly all recognizable imagery are cut away like trimming unnecessary foliage from a snappy bouquet. Some piles of tin, which have a close proximity to a desert sky, for example, are held in reserve to be fitted together without stopping to search for appropriate material later on. As each pencil drawing is covered by interlocking shapes,

Tony Berlant,
Zuma,
1997, found and fabricated printed tin
collaged on plywood with steel brads,
45 in. x 42 in.
Courtesy Barbara Mathes Gallery,
New York City

they are held together with the artist's signature steel brads. This method of "gluing" the collage parts together adds a natural strength to each work while offering a satisfying overall surface of nail heads that blend the cut pieces to form a whole.

Earlier constructions, such as Coat of Many Colors, (2002, 49 inches x 61 inches), are a perfect example of how the artist convincingly creates a realistic landscape, pinned down with nails, bringing together layers of colorful tin that seem to gel with exuberance and accuracy.

One series of works celebrates the austere beauty of desert flora. These pieces are a magnified closeup of the artist's large scale compositions, where details like flowers invisibly blend into the desert's surface. Lucky U is a fine example from this collection that not only spotlights the stark beauty of a single blossom but also honors the compositional Abstract Expressionist influences of de Kooning.

So Soon is another gem, whose remarkable beauty is literally mesmerizing. Here the artist has selected from printed tin fragments depicting flower parts in a blue harmonic balance that's hard to beat. Near By appears to be a flower in full bloom at night that may have been planted by some alien Johnny Appleseed with a sense of drama.

There are precious few artists who remain so consistent with their engaging style and conventional visual wisdom. Tony Berlant has created a delightful postcard from the edge that exults in the best of nature's beauty and its inhabitants. His is a tradition of skill and craft combined with spirits from the past that offer us a comforting visual reminder of the constant joys from life.

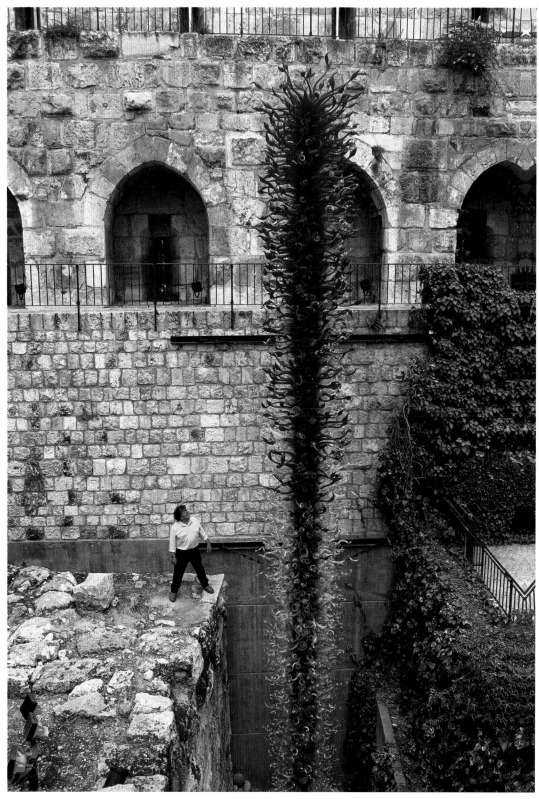

20

Dale Chihuly, *Blue Tower,* 1999, 47.5 ft. x 6 ft., Tower of David Museum, Jerusalem, Israel. © Dale Chihuly. Photo by Terry Rishel

Dale Chihuly

FIRE & ICE

The blockbuster exhibit of Dale Chihuly's glass at the Norton Museum of Art was considered to be one of the most visually exciting shows of the last century. People still talk about it and wondered out loud, how can he out-do himself? At the beginning of this new century, Chihuly drew more attention than ever with his outdoor installation in Israel. I spent a week with Dale there, experiencing the excitement of this project and writing a story on his activities. So for those of you who follow Chihuly, these are my observations from that visit to the other side of the world.

On the road to Jerusalem from Tel Aviv, one cannot avoid a brief daydream of how it must have been centuries ago along this olive tree-lined hillside path, a path well-traveled by so many with such importance in the history of mankind. Although greatly outnumbered now by small white Fiats streaking by, white robed souls with sandals can still be seen heading eastward. The Good Samaritans have vanished. They are replaced by tall roadside cypress, which break through a mysterious fog that lifts in the early morning air. As the bus slips uncomfortably into low gear, two weathered ladies in front of me speak Hebrew in unison at breakneck speed. I can't make out but a single word: "Chihuly."

The snoring solider next to me has his faded green machine gun pointed in my direction. As the barrel passes from my shaky knees to an imaginary bull's eye on my forehead, I receive a permanent reminder that where I'm going is a far cry from the safety of the modern art establishment. Entering Old Jerusalem one discovers a remarkable, beautiful city known not only for its rich history but also for the sheer stone physicality of its labyrinth of covered and never-ending narrow streets. These worn by-ways are packed wall-to-wall with dusty exotic merchandise. It ranges from incense burners and ancient, tarnished jewelry to newer gimmicks that would make the sandaled disciples who maneuvered these same paths gasp; a three-dimensional, winking, blinking, bleeding Jesus.

Amidst all this visual and sensual activity, a colorful scent encircles the Tower of David like a rising ring of smoke. It is here that a tradition of craft in silver, clay and glass is reflected in a daily display of utilitarian objects pitched by seductive vendors who excel in the art of the mega-hard sell. Not only was glass discovered here, but also some four thousand years later, just before the nearby birth of Christ, glassblowing was discovered by accident.

This is a land of intense heat and lots of sand. The combination was bound for the glory hole that modern

glass artists label as their orange hot palette. Thousands of years away from the physical evolution of glass, Tacoma-born Dale Chihuly creates wondrous fragile non-utilitarian sculpture of sometimes unheard of massive proportions that has brought this age-old craft into the forefront of contemporary art.

Within twenty-five years Chihuly became one of the best known and most widely respected artists in the world, with a backdraft of forward motion of multiple museum shows and public installations. His exhibition, In the Light of Jerusalem 2000, was specially created to pay tribute to this holy city on the eve of the millennium.. The quantity of glass and the grandeur of the pieces needed for the exhibition were so demanding that it was not only blown in the artist's Seattle studio, but also in factories in Finland, France, the Czech Republic and Japan. Over ten thousand individual pieces weighing a total of forty-two tons were shipped to Israel in twelve containers. It was a spectacular sight day and night, and not easily forgotten. At almost any angle within those historic walls a viewer could discover the sheer visual joy that these colorful shapes produced basking in the intense desert light. It was simply the most talked about event anywhere in Israel, with the attendance record topping 300,000 in only three months. There seemed to be something for everyone, from the thirteen meter tall Blue Tower consisting of two thousand glass pieces to the Crystal Mountain, made from some fifteen hundred crystals that are hung on over three miles of welded steel rod. The exhibition was mounted by a dedicated team of thirty people from Chihulyland, who were joined by dozens of local workers and volunteers in a unique art partnership.

At sundown on a Saturday, as the Sabbath drew to a close, Chihuly began a twenty-four hour marathon project to construct a huge column of ice just outside the Old City walls. A menagerie of film crews lit up the midnight sky to document the beginning of this remarkable project with a glistening sixty-four ton ice wall, which was harvested from a glacier near Fairbanks, Alaska. It was said to be the purest and clearest glacier in the world. The iceberg, in chainsaw-cut square bits, began its two-month journey in late summer, passing through the Panama Canal by barge and arriving in three refrigerated containers at the Israeli coastal town of Ashtad. From there a caravan headed to the museum with two hours to spare. As the gravel foundation was being laid, ominous looking trucks double parked with their diesel engines humming harmoniously in the growing shadows of an ancient wall that's witnessed just about everything, except giant blocks of clear cool ice by its side. With cranes, tractors and crews moving in all directions, a nearly unbelievable spectacle continued into the early dawn to greet unsuspecting morning traffic.

A singular Citadel has stately represented literally centuries of fortress fighting and dubious distrust of one conquering nation and faith after another. This perpetual physical barrier seemed impossible to negotiate—cold enough to numb your conscience and hard enough to end your life. So it came to pass with a great deal of irony and chutzpah that only one man with one eye and the vision of legions brought a glass white dove of cooperation and understanding. The maestro conductor of his own asbestos-gloved army waved a spiritual blow pipe in the desert air to finally break the ice, metaphorically melting away tensions with his artistic vision and generosity of skillful spirit for the ultimate benefit of mankind through art.

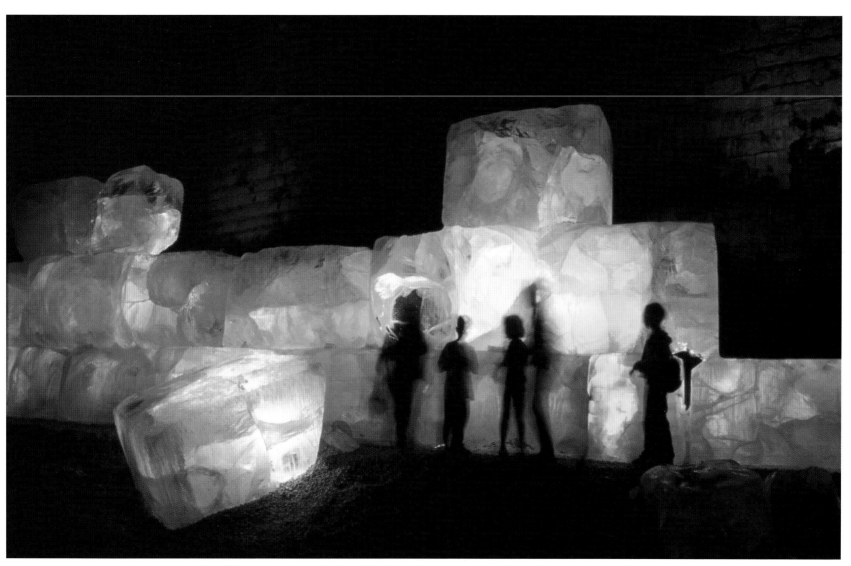

Dale Chihuly, *Jerusalem Wall of Ice,* 1999, 13 ft. x 54 ft., Jerusalem, Israel. © Dale Chihuly. Photo by Terry Rishel

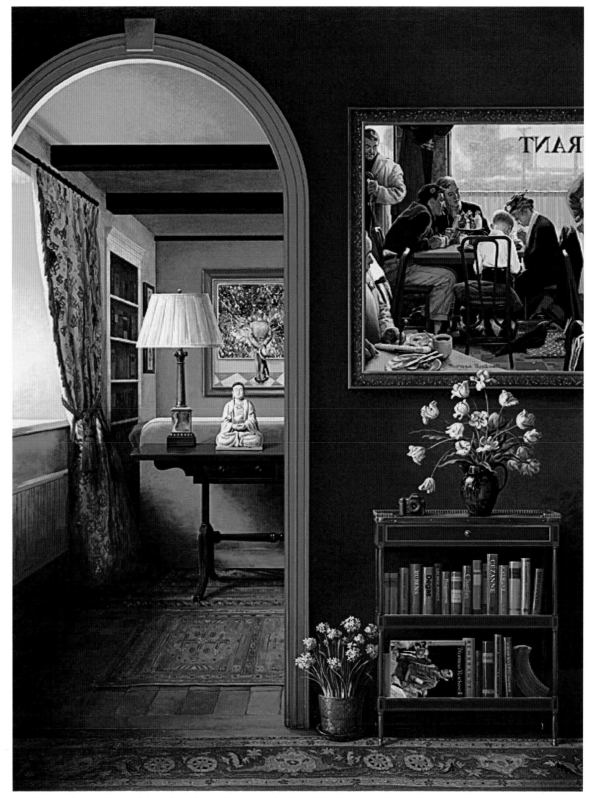

24

Jenness Cortez, *Focus of Attention,* Oil on mahogany panel, 40 in. x 36 in. Homage to: Norman Rockwell, 1894-1878, Saying Grace,
The Connoisseur, and Freedom of Speech. This Cortez painting also depicts: Meditating Bodhisattva sculpture,
China-Ming Dynasty, 1368-1644. Courtesy Classic Gallery, New York

Jenness Cortez

WINDOW DRESSING

Throughout history, artists have enjoyed exploring new territory in order to test themselves while pushing the limitations of their creativity. In the early development of painting, it was a challenge just to lay down homemade oils on a hard surface, color mixed accurately and manipulated to reflect one's selected environment. Step by step, the process of painting became scientific and was passed on from one generation to the next.

Some of the most important strides in picture making were visual impressions of the surrounding landscape and decorative compositions of interior still-lifes. Court painters were relegated to fashioning a believable pre-photography "snapshot" to preserve posterity and flatter their subjects. Since then, documenting faces and figures has remained pretty much the same. Commissioned portraits were generally staid and needed to fit comfortably and stylistically into a consumer's perception of acceptability. There wasn't much room or motivation to deviate from the adequate, predictable and required norm. On the other hand, those artists who fancied carrying a paint box and a portable chair in a backpack down a mountain trail, or had the facility and vision for creating a dramatic still-life composition, had full-blown carte blanche to satisfy themselves and others with any perspective, made up or real, that stimulated their creativity.

So, it was the figure that seemed to get short-changed in the innovation department, except for the likes of Picasso and a few noteworthy others, and presently, John Currin. Renderings of the outdoors and compositional studies indoors began to gain attention and started influencing innovation and a barrier-breaking attitude, from Impressionism to the hybrid color field pastels of Wolf Kahn to the photorealist-inspired crystal clear still-lifes by Claudio Bravo. But like every new stylistic saturation point, whether in theater or fine arts, artists are always exploring new methods and approaches to a standard tune. In the case of Jenness Cortez, whose amazingly skillful work was on view at DeBruyne Fine Art in Naples, Florida, this artist has developed an insightful and inventive twist to the staid, interior still-life by bringing a complex, hyper-realist, multi-layered metaphorical referenced composition to the viewer.

Like so many artists, Jenness Cortez (born in 1944) was fortunate to discover her unusual talent at an early age and began formal art studies at sixteen under the guidance of the noted Dutch painter, Antonius Raemaekers. Almost any artist worth their salt can reconstruct a moment in time when luck and motivation came together with the inspirational tutelage of a visionary teacher who directed and molded the fires of raw talent into a burning desire for accomplishment. After high school, Cortez developed a solid fine arts background as a graduate of the Herron School of Art in Indianapolis and later as a student of the noted painter Arnold Blanche at the Art Students League in New York City. In the mid-seventies, Cortez began a twenty-year concentration on sporting paintings and her powerful depictions of the horse. During this period, the artist received international acclaim for her work, with complimentary comparisons of drama and draftsmanship to George Stubbs and Frederic Remington.

During the mid-1990s, Cortez's long-time interest in constructing landscapes began to blossom like a desert flower nourished by experience and an inquisitive eye. Taking a cue from the nineteenth century Hudson River School and Barbizon School painters, Jenness Cortez's expansive vision comprehends all of nature as a manifestation of the divine. As the artist polished and honed her craft, her refined images evoked a transcendent quality that is rarely equaled in contemporary picture making.

In this exhibition, Cortez presented the viewer with a dramatic and symbolic magical mystery art history tour that packs a myriad of direct and indirect snippets of history's celebrated painters. These are complicated and ambitious works ripe with a wink to the past, where all of the paintings incorporate art about art. Jan Vermeer's well-known work, Woman with Scales, has a lot in common with Cortez's approach as both artists retain a degree of secrecy and layers of freshly varnished background details. The serene attitude of both artists is sustained throughout a strong, stable composition. Like Vermeer, Cortez places us at an intimate, voyeuristic distance within a relatively shallow space that has been molded around a central focal point. The results: Cortez's pre-painting homework and underlying grid of horizontals and verticals are arranged in such a believable, natural circumstance that one could not replace a single element without upsetting the delicate balance she has created.

Jan van Eyck's iconic and perhaps most memorable painting on panel, The Arnolfini Marriage, has some rather similar qualities and familiarity as Cortez's Focus of Attention, also on panel and also reflective of ingenious perspective that allows the viewer to "inspect" a room full of clues and references. One of the discreet bits of evidence in the van Eyck picture portraying a young couple solemnly exchanging wedding vows is the images reflected in the mirror behind the newlyweds. One image, a quasi-DNA-thumbprint, is the artist as conductor, manipulator, architect and scenic designer, circa 1434, who assists in witnessing a ceremony transferred to a studio easel that permanently registers the event. The second figure, perhaps a dealer, remains a mystery.

In Focus of Attention, as in The Arnolfini Marriage, the artists employ a shaded window on the left side that diffuses the light so that it simply dusts the interior objects with a warm glow. The drapery, tied at the waist as depicted in Cortez's picture, was a challenge to create, just like the material covering the suspiciously pregnant bride-to-be, who tries in vain to hide her little secret. In both paintings, Turkish rugs on plank floors form a blueprint for a vanishing point as well as the overhanging rafters and lamps in the center. A "Meditating Bodhisattva" sculpture from the Ming Dynasty also anchors a peaceful presence in Cortez's background, but the artist updates her interior, which could also provide a lovely spot for a private ceremony without smoking mirrors and posing figures. In this composition, Norman Rockwell's classic, The Connoisseur, portrays a polite gentleman, arms behind holding his hat, as he laboriously contemplates a Jackson Pollock drip painting that opens up a third window into this quite convincing parlor game. In the foreground, Rockwell's Saying Grace, a warm portrait of a prayerful couple, is scrutinized by restaurant patrons. Continuing on this journey, your eye then travels beyond the table through another painted curtain and finally through another window to the street outside. If the art history references aren't sufficient, Cortez showcases a small bookend library that includes the Rockwell Saturday Evening Post magazine cover, Freedom of Speech, along with carefully calculated titles on Degas, Cezanne, Rembrandt and Rubens.

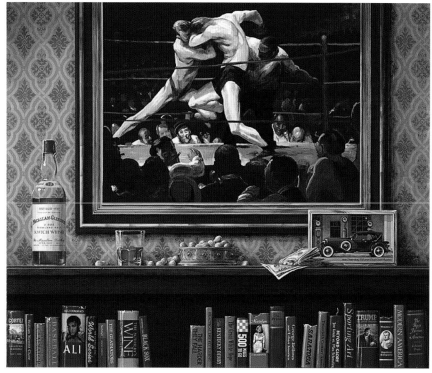

Jenness Cortez, *The Prize*,
Oil on mahogany panel, 30 in. x 36 in.
Homage to: George Bellows, 1882-1925,
Stag at Sharky's,
This Cortez painting also depicts:
Muhammad Ali, by Andy Warhol;
SARATOGA!
by Jenness Cortez;
Photographs of a
1929 Duesenberg LeBaron Dual Cowl Phaeton,
Marilyn Monroe and Donald Trump;
and an engraving of Napoleon Bonaparte.
Courtesy Classic Gallery, New York

Jenness Cortez loves to mix up a generous tossed salad with herbs du Provence and Italian/Dutch dressing that blends in the classic influences of Dürer, Homer, Caravaggio, Inness, Chardin, Rubens and a touch of Matisse for his recipe of bright color. Vermeer often depicted his art-dealing mother-in-law's paintings in his compositions. The picture Vermeer's Amaryllis, which reproduces Woman Holding a Balance, mentioned earlier, is overtly allegorical. The woman stands between a depiction of the Last Judgment and a table representing material possessions. The empty scale suggests a balancing act where the spiritual overshadows earthly pleasures and positive choices are to be made. Cortez juxtaposes the old and the new, including bright blooms of a feminine pink bouquet near a nourishing pile of fruit, representing the rewards of well-chosen actions in life.

In The Prize, Cortez sets up a composition utilizing a shelf full of books that seem to commemorate the courage and stamina depicted in George Bellows' Stag at Sharkey's. Here the viewer observes the ringside crowd where two boxers battle to win. The spoils of victory may be found on the ledge below: a bottle of single malt scotch, a wad of money, a classic car photograph. The books give a hint of struggle and ultimately, victory or defeat, with titles of "Ali," "Trump," "Marilyn," "The Gladiators," "The Kentucky Derby" and "Beyond Glory," with an engraving of Napoleon Bonaparte thrown in for good measure.

With Cortez's characteristically idiosyncratic portrayals of the art of art, we find ourselves pleasantly mesmerized by the complexity of these all-star, recognizable, historical references. Illustrated brilliantly here are the victorious and unusual talents of a splendid artist who brings life anew to familiar images that serve as windows into a private, compelling, imagined space. Her virtuosity dazzles the eye and romanticizes and rekindles our affection for savoring masterstrokes by master artists.

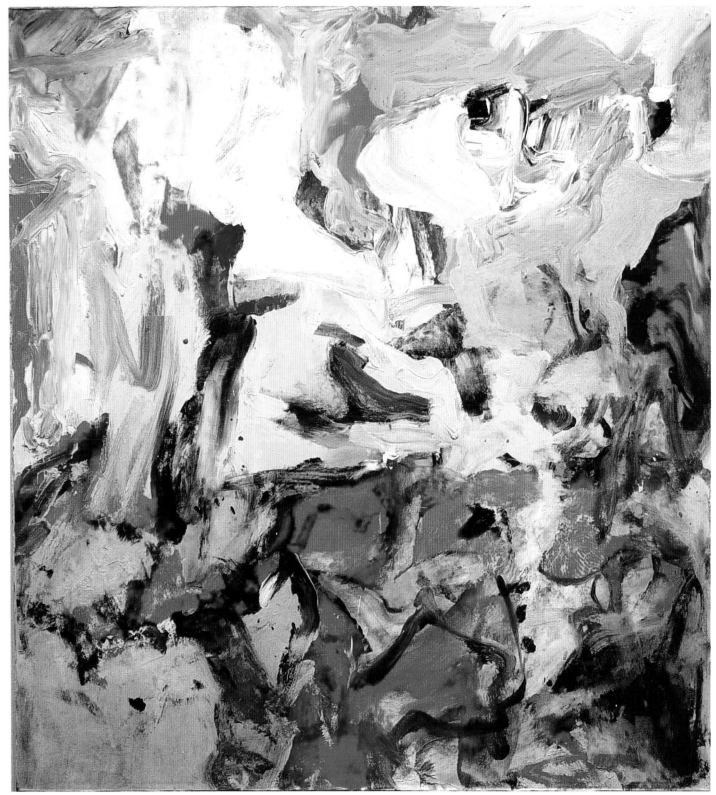

28

Willem de Kooning, *Untitled VIII,* 1976, oil on canvas, 59 in. x 55 in., Private Collection. © 1993 Willem de Kooning/Artists Rights Society, New York. Courtesy of L&M Arts, New York

Willem de Kooning

DUTCH BOY PAINTS

Willem de Kooning's exhibition at L&M Arts of a dozen extraordinary paintings created from 1975-1978 was arguably the best gallery show in New York City in recent history. But it wasn't much of a contest, considering this Dutch transplant was arguably the greatest American painter that ever lived—a lifetime achievement award that has no close equal. There are simply no existing painters that we might place a reasonable bet on who might eventually accomplish the same billing.

It's been said that the two most uniquely important contributions to American culture are jazz and Abstract Expressionism. Both of these categorical milestones were products of a developing winding road that began long ago on foreign soil. The germinated seeds of American jazz floated through history note by note as innovative musicians cleared away the customary and comfortable parameters of pure instrumentals and broke new ground by simplifying a beat and measure and creating a free-flowing, somewhat abstracted new sound. This fresh abbreviated-hyphenated sound seemed to spread everywhere from the urban streets of Chicago, New Orleans and the legendary jazz bars of downtown Manhattan. Suddenly, a horn player could reach into unexplored territory by utilizing his own intuition without a music sheet, blind as a bat and determined to find, connect and put forward an inner voice that attained acoustical magic.

Almost concurrently, a new breed of action painters surfaced, who, like their fraternal musician counterparts, were looking to expand beyond Picasso's notorious abstract Cubist-inspired reductions that would later lay the foundation for a natural evolutionary advance, leading up to a new brand of simplified exuberant free-association painting.

Willem de Kooning, born in the Netherlands in 1904, was a natural painter who followed his instincts and passion to attend the Rotterdam Academy of Fine Arts. Like so many of his contemporaries, he found his way through a circuitous route, passing over Paris and heading straight for New York as a stowaway. For a short time he was a house painter in Hoboken, like a number of his struggling contemporaries, which was a fortunate experience that stayed with the artist all his life. In 1927, he moved to a studio in Manhattan and came under the influence of artist, connoisseur and art critic John Graham, and the painter Arshile Gorky, who grew to be one of de Kooning's closest friends.

From about 1928, de Kooning began to paint still life and figure compositions, reflecting schools of Parisian and Mexican influences. By the early 1930s, he was confident and curious enough to explore abstraction, using biomorphic shapes and simple geometric forms, an opposition of disparate classical elements that prevail in his work throughout his illustrious career. These early works have a strong affinity with those of his friends Graham and Gorky, and echo the impact on the young artists Pablo Picasso and Surrealist Joan Miró, both of whom achieved powerfully expressive compositions through flowing, interconnecting forms. In 1935, de Kooning and

a few other artists got a lucky break with the post-Depression reconstruction job corps plan called the WPA, which miraculously trickled down to painters who could barely make a dime on their work. This period of about two years provided the artist, who had struggled to support himself during the low point of America's economy by commercial jobs, with his very first opportunity to devote full time to creative work.

In 1938, probably under the influence of Gorky, de Kooning initiated a series of male figures while simultaneously exploring on a more purist level another series of lyrically colored abstractions. As the work progressed, the heightened colors and elegant lines of the abstractions began to creep into the more figurative works, which continued well into the 1940s. This period includes the representational but somewhat geometricized women and standing men, along with other abstractions whose biomorphic forms suggested the presence of figures. Ironically, in 1946, too poor to buy artists' pigments, he turned to black and white household enamels to paint a group of large abstractions. The circumstances of being poor but desperate to continue his forays into especially unknown territory seem to give the artist's paintings at that time a sense of economy and fearless urgency, like a mad scientist who works into the night about to make an important discovery. De Kooning, like many of the downtown artists, including Pollock, Rothko and Clyfford Still, made trades when they could of their artworks to local hardware store owners, who reluctantly handed over artists' materials in a sympathetic gesture. The freedom and purity of only creating black and white pictures opened up de Kooning's direction into larger, more expansive pieces that would lay the groundwork for his greatest paintings.

In 1948, he taught at the legendary Black Mountain College that would produce young artists like Robert Rauschenberg, John Chamberlain, Cy Twombly and Kenneth Noland, and after a few years at Yale's School of Art he was financially secure enough to devote all his time to his studio. As the artist found his stride in the early 1950s, he began to explore the subject of women, exclusively developing a body of works that were shown at the Sidney Janis Gallery in 1953 that caused a sensation, chiefly because the maverick de Kooning was employing figuration in his works as his fellow Abstract Expressionists were only interested in developing non-narrative all-over compositions. These were important milestones for de Kooning as he moved in and out between vaguely recognizable subjects and complete abstraction. Around 1963, the enchanted light and tranquility of East Hampton won over the Broadway studio now occupied by Larry Poons. No longer did the artist need the energy and vitality of the city or its political and critical advantages. So with complete independence and a waiting audience for every picture he created, he moved permanently to the Hamptons on Long Island, where he would build a magnificent studio that offered quiet solitude while assimilating a natural clear light that would super charge his paintings on a grand scale with a hint of his physical environment thrown into the mix.

In the seventies, transformed, comfortable and stable with these fresh surroundings, he was able to daringly create a unique quantity of work, which became distinctive for its poetic fluidity, vibrant cohesive brushwork and the evolution of color schemes that gently pulled their sources from the reflective light and dune landscapes that encircled him. During this period, particularly between 1975 and 1978, the works appear purely abstract at first, until upon further contemplation the pictures reveal their organic landscape qualities that got permanently added into his swirling palette and then pushed, glided, smudged and scraped into an all over visual short story on his canvases that were full of intriguing passages, unexpected twists and surprising color combinations, and

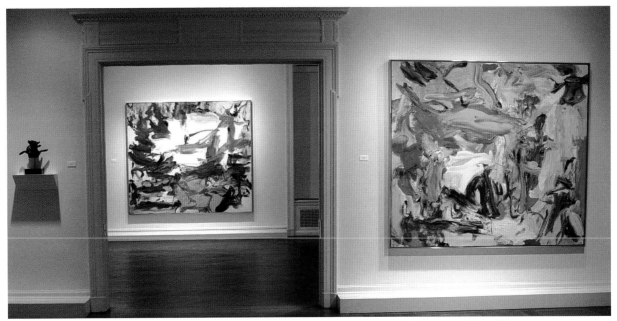

Willem de Kooning, *Installation view,* L&M Arts, New York (Untitled II, 1977, oil on canvas, 77 in. x 88 in.,
Collection of Ken & Judy Siebel, Untitled III, 1976, oil on canvas, 70 in. x 80 in., Private Collection). © 1993 Willem de Kooning/Artists Rights Society, New York

with a memorable ending. In the paintings completed just over thirty years ago during daylight hours only, the brilliant illumination and accompanying out-of-doors colors that inspire these works are undeniable.

What is so magical about this series of paintings? For one thing, the works seem remarkably fresh even after thirty years. The consistency of disparate marks and improvised strokes in all directions still form a powerful composition that is difficult to turn away from. At a distance, the works glow with large bold feathery shapes made with a house painter's brush. Every area within these large canvases (with an average size of 70 inches x 80 inches) is perfectly balanced and continues to energize the observer. Close-up inspection reveals a multi-layered passionate surface full of small drips, broken lines and harmonious juxtapositions of odd shapes that link with de Kooning's extraordinary talent for homogenizing color to form with masterful control.

Every great artist, from Picasso to Hockney, eventually seems to find the comfortable, natural, physical niche that sets the stage for making wonderful paintings. Picasso needed the isolation of a castle and he didn't much care about the light. Hockney needed the energy and excitement of Los Angeles. Francis Bacon closed the studio door to an almost windowless London hideaway from nine to five and then he left for the neighborhood bar to share stories and down a pint of ale. And so, remarkable as it may sound, Willem de Kooning felt he became a stranger to New York because of being there all the time. The novelty of his Hampton studio with walls of glass effortlessly produced one of the most prolific periods of his career, which gained strength and integrity with a renewed sense of confidence and well-being. In these golden years the artist has said that he felt like a man at a gambling table who feels that he can't lose. When he walks away with all the dough, he knows he can't do that again because then the habit becomes self-conscious. But de Kooning admits he wasn't self-conscious, "I just did it," and it just kept working like a perfect inspired production line.

De Kooning's contribution to the art of painting is one of the great achievements of 20th century art and these paintings from 1975-1978 unabashedly support his genius.

31

Jim Dine

FINE DINING

The Armory Art Center in beautiful downtown West Palm Beach inaugurated its new sculpture garden with an exhibition of monumental works by Jim Dine. The show, which consisted of a dozen large-scale cast bronzes, represented a handsome cross-section of Dine's signature style. Curated by Arij Gasiunasen, the exhibition was expertly placed so that the viewer could meander throughout the gardens to discover a pleasant harmony between the works and the surrounding environment.

Jim Dine's illustrious career began to take shape during the early years of the Pop Art movement, where his infectious wit and campy creativity fit snugly into a new frontier that embraced new directions while letting go of the more somber vestiges of Abstract Expressionism. As other innovators like Andy Warhol, Claes Oldenburg and Jasper Johns joined the fraternity of the Pop movement, their strength in numbers and the growing attention paid to these new directions in contemporary art encouraged these pioneers to explore the limits of their imagination.

Dine's earliest works created in downtown Manhattan centered around "happenings," which were staged events used to celebrate art environments that utilized performance and painted objects for small audiences. These free-for-all experiences opened up the boundaries of this newly christened Pop-like landscape. Later on, Dine, like his colleagues, began to discover the unlimited possibilities of incorporating common everyday items with a theatrical twist. While artists like Warhol went after items found in the corner grocery, like Brillo boxes and tomato soup cans, Dine explored the universe of things to wear, such as bathrobes, shoes and neckties. The artist's father owned a hardware store that displayed a virtual palette of objects to re-create and reconnect. Tools were not only familiar to his family's livelihood, but also had a strong metaphorical presence in his art as the elementary calibrated materials an artist needs for creating sculpture. In many of Dine's post-Pop three-dimensional compositions, his infatuation with using tools continues to be a leading ingredient in shaping his colorful forms. In Garden of Eden, the artist has created the framework for a folding screen that is literally covered with a handyman's dream—tools of every variety, from hammers and shovels to hedge clippers and saws, all separately painted in a rainbow of colors. In another work, a single greenish heart is supported with a selection of tools that lean cleverly into the heart shape.

Following the traditions of artists who produced work in the mid-1960s, Dine has created several pieces whose subject is presented in pairs. Like Robert Rauschenberg, who painted two "identical" abstract paintings, or Jasper Johns, who cast a double Ballantine beer can, Dine has taken a favorite subject, the Venus de Milo, and recreated it in pairs. In The Red Twins, the artist fashioned twin identical Venus figures on a square, painted base that are literally dripping like birthday candles from a chocolaty bronze cake. A second piece displays another Venus duo. This sculptural diptych, standing about seven feet tall, positions the famous silhouette side by side but with one figure looking forward and the other gazing backward. Here Dine has ingeniously carved a solid

Jim Dine, ***Three Hearts on the Rocks,*** 2004, painted bronze, edition of 6, 78 in. x 165 in. x 78 in. Collection of Arij Gasiunasen, Palm Beach

piece of wood with a chain saw so that the abstraction can hold a geometric balance with every surface plane. Slicing and dicing, the artist has made two magical forms out of a square, ready to be carefully reborn in bronze. Each cut plane has been painted a bright color, from a deep violet to a Hallowe'en orange. The artist then adds a last, light coat of black that only lays on the top of the cast texture, which skillfully gives an academic drawing quality to the surface.

Three Hearts on the Rocks might be the title for a secret ménage a trois gone wrong. The humorous title is a perfect description for this piece. Three heart shapes stand together, each with its own personality that has evolved from a large hunk of clay. As the heart forms were built up, the texture was created while the clay was still soft. The base is a cast of river rocks painted black. The three hearts are covered with a harmonious green tint that gradually turns to dark brown as it approaches the base. Hearts, like his signature bathrobes, have been a favorite subject for Dine for a long time. However, each heart shape he produces seems to have its own distinct personality, yet still belongs within the clear cut bloodlines of the Dine Dynasty. Another work, King Parrot, presents a golden bronze heart that is used to support a perching parrot painted with every color from the rainbow.

In the "most witty" category is Ape and Cat, (1993) a mighty bronze that portrays a loving couple who are clearly close friends. The female cat gently caresses the chin of her partner as she stands proud of her positive position and protection of her mate. The work can't help but bring a smile to a viewer as it is chock full of good humor and irony. Two other sculptures on the identical subject portray the same couple in huge blocks of bronze only to reveal a head and shoulders perspective. These elegant pieces seem to withhold secrets inside an impenetrable cube.

33

34

Red Grooms, *Lumberjack,* 1977-84, painted bronze, 99 in. x 47 in. © 2008 Red Grooms/Artists Rights Society, New York. Courtesy Marlborough Gallery, New York

Red Grooms
GOOD GROOMING

Artist Red Grooms is to the art world what Al Hirschfeld was to Broadway theater. In his show at the Norton Museum of Art, visitors were introduced to a virtual parade of familiar personalities that had been magically crafted in wood, wire, putty, oil paint, cardboard and aluminum, along with a host of other materials, cementing Grooms' current unofficial title of world heavyweight champion of contemporary, multimedia portraits.

For thousands of years, mankind has followed an internal instinctual compulsion to recreate images of himself and others around him. Early cave paintings reveal the natural albeit primitive abstract lines that form a literal cartoon caravan of bison on the run from the hunters in pursuit. These seminal works of art were painstakingly planned to last an eternity in a cold dark time capsule, illuminated only once or twice by the flickering light of a handheld torch.

The essence of humankind's creative spirit is to capture its history through representative drawing and to maintain a secret interpretative abstract memory shared only with the gods and fellow tribesmen. Perhaps most uncanny and certainly most appropriate to the subject is how abstraction played an important role in portraying a social environment of the human condition. The tradition of representing the image of others gradually became less crude as more attention was given to additional details and techniques with a painterly surface. The high point of this self-expressive genre seems to have emerged with the sixteenth century court painters, who distanced themselves from all abstraction and dedicated their efforts to sharp, recognizable realism. Later on, portraiture seemed most threatened by the invention of photography, the ultimate permanent and accurate mirror of our surroundings and the people who inhabit the planet.

However, with the maturity of photography as an extension of the artist's vision, it was no longer crucial to produce the exacting nomenclature of facial likenesses; but rather, portrait painting took a quantum creative leap with a new emphasis on expression as opposed to representation. This new imported ingredient began to flavor the impulsive juices of modern and contemporary artists, persuading visionaries like Picasso to explore with others drastic transformations throughout the twentieth century. As portraiture came and went, it still retained a remote solemnity—a straight-faced, serious, no baloney approach that left little room for wit and laughter.

Red Grooms was a pioneering abstract humorist who seemed to relish the open door attitudes and opportunities that the 1960s inaugurated and celebrated. After seeing a traveling exhibition from the Museum of Modern Art featuring George Grosz, Ben Shawn, Jackson Pollock and other modern masters, Grooms made up his mind to become a painter. In 1957 at the age of twenty he moved to Manhattan as a wide-eyed boy who soaked up the groundbreaking energy of exhibitions by Willem de Kooning, Philip Guston and Franz Kline. He liked their "emotional approach" and began making a determined effort to incorporate a somewhat theatrical tactic to his imagery.

Growing up in Nashville, Grooms was naturally attracted to plays, circuses, movies and all things entertaining. He loved the colorful carnival atmosphere of performance, which was to make an indelible mark on his career. Like most young outsiders trying to move into the New York art scene, the icons of American artists along with their personalities, appearance and lifestyles fascinated him. Red Grooms began assimilating and celebrating the artists he had grown to admire by developing his own brand of modern cave painting that incorporated a simple but amusing narrative abstraction of his friends, colleagues and stars of the staid art world.

Grooms possessed an inventiveness for combining a love of drawing, the sophistication of high art with the expressiveness and naiveté of folk and "outsider" art and the humor of the cartoon strip. He married these to a storytelling caricature in a theater of serious fun.

Like his contemporaries, such as Warhol and Lichtenstein, Grooms demonstrates how the roots of Pop Art allowed him to forge his own road in a way that was easy to interpret and delightful to enjoy. His two- and three-dimensional impersonations of such cultural icons as Sarah Bernhardt, Pablo Picasso, Mae West, Jackson Pollock, Gertrude Stein and Elvis Presley reveal him as one of the great visual historians of the contemporary cultural world. His earlier drawings, particularly The Artist's Parents, 1956, indicate a mastery of simple dynamic lines full of emotion and character. These developing talents and skills enabled Grooms to later make a successful transformation into highly characterized depictions of recognizable personalities.

In Alex Katz, 1963, a reclining figure with a top hat vaguely reminiscent of Abe Lincoln, Grooms masterfully combines folk art, painted surfaces and a found object—a green office chair—to enhance a unique visual appeal. One exception to the artist's sympathetic attitude toward humanity, which for the most part remains devoid of satire, is Call For Jesse, 1991, a mixed media construction portrait of the North Carolina ultra-conservative senatorial demagogue, who among other things wanted to abolish the National Endowment for the Arts. Here Grooms felt he could be unmerciful in his exposé of the leading tobacco advocate and the Philip Morris Company, a contributor to the politician's election campaign. The 1950s bellboy billboards advertising suggestion "Call for Philip Morris" is brilliantly incorporated into the construction by dressing Helms in a bellboy uniform with cupped hands surrounded by a frame of giant cigarettes.

One of his most animated pieces is a study of Jackson Pollock at work in his studio, where six arms appear to move in all directions to begin a foundation for a dramatic drip painting. Grooms' ability is particularly pronounced here, as he deals with an odd but effective perspective that includes a viewer on a ladder and a visitor at the door. Grooms' rendition of Pollock is instantly identifiable and believable.

Perhaps one of his masterpieces is Bedtime for Rauschenberg, 1991, a composition showing Robert lying on his famous combine painting Bed (1955) with other infamous icons from the artist's works, including the tire from Monogram, where it was fitted around a stuffed goat, and the rooster from Odalisque (1959). This reconstruction, part art history, part painted, carved wood and part theater revue, is the distilled essence of Red Grooms' triumph as one of the great interpretive and influential artists of our time.

Red Grooms, *Bedtime for Rauschenberg,* 1991, oil and enamel on wood, 95 in. x. 49 in. x 27 in. © 2008 Red Grooms/Artists Rights Society (ARS)

Damien Hirst, *Luke*, 1994-2003, butterflies and household gloss with mixed media, 180 in. x 72 in., 274.3 cm. x 182.9 cm. © Damien Hirst. Courtesy Gagosian Gallery.

Damien Hirst
CHAPTER & VERSE

There exists a rich and robust tradition of commissioning artists to portray through their eyes and hands events whose inherent spirituality needs to be captured, illustrated and preserved. Michelangelo is a good example; lying on his back facing the heavens, he labored to express the magic at the moment of creation between the outstretched hand of God and the fingers of the first human creature. So convincing was his interpretation of this auspicious occasion that the romanticized imagery remains one of the artist's most memorable scenes on the massive ceilings of the Sistine Chapel. Leonardo da Vinci's now deteriorated and reconstructed painting of the Last Supper recalls a remarkable composition that literally billions of followers recognize as the only snapshot that breathes life and credibility into a table of largely unrecognizable disciples dining for the final time with their master.

Centuries later, the contemporary art of today is, by its very nature, full of bravado (Schnabel), breaking the rules (Warhol), dismantling taboos and restrictions (Acconci), confrontational (Serrano) and free from fear and guilt, and is often at odds with mainstream religion or subjects of spirituality. So it seems a bit unusual at first that one of the most powerful figures in the art world and current chairman of the rule-breakers club, Damien Hirst, would be interested in a monumental commission of four paintings representing the four Evangelists. However, digging into Hirst's recent past, his work has centered on such thematic concerns as science, religion, life and death, along with the aesthetic conventions of painting—still life and portraiture. Matthew, Mark, Luke and John were the authors of the gospels, which reported the death of Jesus Christ. Each Evangelist had his own motivation: Matthew was inspired by an angel, a winged man, who revealed Christ's human nature; Mark, the lion, evoked Christ the King; Luke, an ox, epitomized his sacrifice, and John, always accompanied by an eagle, represented Christ as God. So indeed, these works exhibited at the Norton Museum of Art, "The Bilotti Paintings: Matthew, Mark, Luke and John," manifest numerous subjects tied to the artist's interests.

For a provocateur of the English art world, Mr. Hirst (born 1965) is a remarkably philosophical and prudent artist. He is perhaps best known for incorporating dead animals in formaldehyde and compositions with pharmacological support. These projects, which utilize stimulating subject matter, are a kind of common denominator for an artist whose style is initially difficult to dissect but ultimately satisfying. Therefore it was not surprising when the respected collector Carlo Bilotti asked the artist to consider creating a suite of works to occupy a pavilion for meditation that Hirst replied with an enthusiastically positive response.

In the tradition of the Rothko Chapel in Houston and the Matisse Chapel in St. Paul de Vence, Hirst answered the challenge with a thoughtful series of solid-color paintings that would be contemplative and beautiful.

Prior to this venture, Hirst made a series entitled the Cancer Chronicles, a dozen paintings representing the twelve apostles. Each of these monochromes is named for a specific disease and is covered with a perplexing

and physically expressive surface of dead flies. The Cancer Chronicles series reflects Hirst's continued interest in Minimalist art as well as the meditative compositions of Ellsworth Kelly and Mark Rothko.

After this project, the artist started another series, which was to become the Bilotti commission. In this version the artist affixed to the canvas symbolic fountain pens holding ink that spells words promoting the gospel truth. Also attached to his textured surfaces of cosmic dark blue and blood red are razor blades that can etch a phrase but have the disturbing ability to cut for beauty and pain or a violent martyrdom. Floating butterflies positioned with pins are employed as a common bonding agent to combine all four works. These beautiful insects bring color to these largely monochromatic spaces and allow introspective thoughts to wander and travel to distant places.

The framed pictures are on a colossal scale, measuring almost 200 inches high and are covered with Plexiglas to reflect a viewer's profile, which, like Francis Bacon, who admired reflection in much of his work, has a metaphorical and practical advantage. Mounted on a wall, these huge, overpowering paintings become altarpieces, placing the viewer in a humble position that for early convincing spiritual spin had its benefits.

On the margins of each painting are verses from the gospel of each Evangelist, reminiscent of a clever inscription by some Renaissance artists. The verses are subtly mirrored on the border, which would have made da Vinci happy, and philosophical without a more difficult code to decipher. These paintings, titled by the names of the four personages, were intended as portraits, albeit highly abstracted ones.

To further individualize each piece, Hirst created a color symbolism: Matthew is black, Mark is blue, Luke is red and John is greenish-blue. Seen from behind, these four works reveal yet another metaphoric material—a literal forest of straight pins that were used to hold the butterflies in place, a possible throwback to the multiple arrows piercing Saint Sebastian's body. These big and bold paintings are much in keeping with the artist's long-standing interest in creating installations or environments.

In most of his noteworthy exhibits, the artist prefers to fill up a room with a variety of objects that are often clues to a suggestion of meditation on life and death. These issues were natural subjects for Carlo Bilotti to consider—especially his life and its meaning to others. As an art collector, he has brought his commitment to gathering great works of art into a personal house of framed cards, which shelter us from adversity and negative energy.

Through Mr. Bilotti's passion for art he has cultivated a rewarding and enviable personal relationship with many of the important art dealers and artists he admires. He began collecting art in his twenties while attending law school in Naples, Italy. Since his first instinct to begin collecting, he has regularly acquired some of the finest contemporary art available. Starting from a collection that was mostly Italian artists, Carlo Bilotti expanded his interests and obtained pieces by Matisse, Picasso, Kandinsky, Miro, Lichtenstein and many more. He also developed a personal affiliation with Warhol and had him execute many projects. Later he commissioned works by Salvador Dali, Niki de Saint Phalle and Roy Lichtenstein. The paintings by Damien Hirst represent a rich tradition, stretching all the way back to the Medicis in Bilotti's home town, which continue to stimulate the senses and charm our contemplative spirits. Carlo Bilotti (who died a year after the Hirst installations at the Norton) found a comfortable and honorable heavenly place in the fraternity of visionary collectors who benefit our society, ignite our thought processes and support the greatness of man's creativity.

Damien Hirst, *John,* 1994-2003, butterflies and household gloss with mixed media, 180 in. x 72 in., 274.3 cm. x 182.9 cm. © Damien Hirst. Courtesy Gagosian Gallery.

David Hockney, *Henry,* 1988, oil on canvas, 24 in. x 24 in. (61 x 61 cm, mounted dimensions 64.8 x 64.8 cm).
Collection of David Hockney © David Hockney, Courtesy Museum of Fine Arts, Boston and LA Louver, Los Angeles

David Hockney

TALKING HEADS: PORTRAITS THAT SPEAK FOR THEMSELVES

Our evolving species has always been fascinated by the inherent desire to capture an image of the human spirit. Just after the discovery of fire, that hot energy that threw splashes of light upon the worn faces surrounding a camp for the night, mankind began a perpetual investigative journey into orchestrating a variety of handmade marks that would reflect his own likeness. As apprentices refined their craft and vision that had been passed down through generations, their ability to recreate a recognizable profile of another person became a fine art.

What is it that is so enthralling about a portrait that reveals a permanent expression of us on canvas? Perhaps the answer as we dig deeper is that we retroactively rediscover a personal identification with a facial structure from the family of man that has been with us for over three million years.

An even closer look may divulge the inner secrets of an evolutionary transition from a beast to a beauty. These revelations present a comforting reminder and clear evidence in a mirrored reflection that we are connected to our ancient forefathers, who were once covered in shiny hair from head to tail. How visually poetic is it that our perfectly balanced eyebrows highlight the skull with two worn down crescents that accentuate the eyes like a painter's skinny brushstroke. How captivating are a pair of oddly smiling lips, whose ideal symmetry aligns the nose and forehead with distinction and intrigue.

Some twenty-five years ago, the gifted painter and critic Seaver Leslie presented an insightful essay for Art Express, the national magazine I published. His provocative and informative observations on portraiture quoted here still seem fresh and appropriate today: "Portraits of our predecessors give us an understanding of our past, a connection across the distance of generation. Contemporary portraits presented to us in newspapers, on television, or in galleries provide us with an almost continuous identification game, which gives us simple pleasure. Building our repertoire of visual, social and historical knowledge in this way, portraiture can also elicit our empathy, our vicarious pride or our spontaneous, violent affection for a stranger with whom we suddenly become intimate. A great artist allows this intimacy to occur through his own understanding of the sitter.

From what does the mystique of portraiture emanate? Its source is the human spirit. Because it can capture that ephemeral essence, portraiture often conveys its message more powerfully than other forms of art such as narrative, history or landscape painting. The underlying force of a portrait is much stronger than a patron's vanity and more profound than an artist's intent to capture a likeness of pose and physiognomy. An image that conjures up a particular spirit as we gaze into eyes of stone, bronze or paint keeps the promise of great portraiture.

A portrait is two-fold. First, it brings the viewer close to a painter's vision. Second, it supplies information about the sitter's character. The keen observations of the painter often permit you to know the sitter better than a first-hand conversation might, for there are no distractions of verbal dialogue. The most personal confrontation two human beings can have is 'one to one,' 'face to face,' 'tete—tete,' and people respond naturally to the emotion

expressed by mouth, eyes and the lines of a face. The most subtle nuances of happiness, pain, despair or concern reveal themselves there. The first image to come into focus for a newborn is its mother's face. Through these early impressions we learn to measure our own well-being."

Every day the tradition and importance of portraiture maintain an influential presence in our society, from the glow of electronic Benday dots that compose a towering provocative silhouette in Times Square to a tiny Gilbert Stuart image of our first president on a perforated postage stamp. Throughout history we celebrate portraiture and continue to recreate likenesses of ourselves by the artists of our time. From Picasso, Warhol and Mapplethorpe to Chuck Close and Andrew Wyeth, artists hold the line and also break new ground with their interpretive responses to a face.

Portraiture has provided David Hockney, another great contemporary artist, with a perfect vehicle through which to celebrate the diversity of our species. His retrospective exhibition, "David Hockney Portraits," at the Museum of Fine Arts, Boston, was the first show devoted solely to the artist's portraiture. Organized by the MFA and the National Portrait Gallery, London, in collaboration with the Los Angeles County Museum of Art, this pivotal exhibition surveyed decades of the artist's illustrious career and revealed Hockney's fascination with the human form through depictions of himself, as well as important people in his life, from family members to lovers and devoted friends.

David Hockney has often asked, "What finally can compare to the image of another human being?" Those words capture perfectly his approach to art, for from Hockney's earliest years as an artist he has always turned to the human figure as a major visual source and lifelong inspiration. He was born in England, in the West Yorkshire city of Bradford in 1937; he embraced the realist tradition since the early 1950s, when he studied at a local art school. By the time he moved on to the Royal College of Art in London, Hockney believed that art should offer pleasure through exploration of both personality and artistic technique. During his long and illustrious career, Hockney has had a fascination of recording himself through self-portraits and depictions of the artist with others (see Artist and Model with Picasso) as well as his family, friends, lovers, even his dogs. He has utilized numerous methods—both traditional and pioneering—in order to investigate the outward appearance and inner life of his sitters and has developed a distinctive singular style that is evident and celebrated in his oil paintings, drawings, watercolors and prints.

Like Rauschenberg, Hockney embraces new technology to extend his palette into expressive worlds not seen before. Hockney's photo collages and grid works were simply without precedent when they began to appear in the early 1980s. Like Picasso, Hockney's genius supports investigation into pushing new concepts over the top. The MFA exhibition was unique, as it followed the development of his career from a young student to works created even as the show was being organized. "David Hockney Portraits" is categorized into groups of people the artist painted the most. In the last years of his art school education and the early days of his career, the artist made a conscious and deliberate decision to use people in a variety of domestic situations from his own life in his art.

One of the artist's many passions is autobiographical material, whereby he exposes the personal to make it public. The most redeeming and memorable pieces are portraits of his family, friends and lovers, as they seem to be crafted

45

David Hockney, *Celia in a Black Dress with White Flowers,* 1972, colored crayon on paper.
Collection of Victor Constantiner. © David Hockney, Courtesy, Museum of Fine Arts, Boston and LA Louver, Los Angeles

with an affectionate familiarity that rises to the surface of his works. Hockney, a hybrid of roadside preacher and liberal philosopher, is preoccupied with how to remove distance — both literally and psychologically so that we can all be closer to something — sharing our hopes, dreams and passions.

The main areas of exploration in this extraordinary exhibition included visual documents of his parents, who he tenderly portrayed on drawing paper, canvas and in photographic assemblage. In these family "albums" you can feel a strong connection of appreciation and respect for his parents, which was repeated over and over as a kind of homage to their influence and encouragement. Hockney's self-portraits also fit snugly into this category of family. His self-portraits in the early 1950s are open and honest and straightforward, and seemed to set the stage for what was to become a lifelong preoccupation with self-embellishment.

"Friends and Lovers" is a fascinating section in the exhibit that illustrated the artist's sensitivity to his subjects. In this group, the people he called friends were all captured in a cooperative mutual admiration club that seemed quite real, and in some cases, as in Celia in a Black Dress With White Flowers, the affection for his subjects seeped into his line quality and color hues, creating beautiful contrapposto compositions and touching personal references. His renditions of Henry Geldzahler, the legendary critic and curator at the Metropolitan Museum of Art, are remarkable portraits in not only their skill but also in the intimacy they seem to celebrate. I had the privilege of having Henry as a houseguest in my Palm Beach home for several weeks in 1989, as he made notes for his introduction to my book. During that period there were many calls between the artist Hockney and the critic Henry. Overhearing these top-of-the-art-world calls in Palm Beach and Southampton during my summer visits, I began to realize the significant importance that Hockney placed on his personal relationships with his friends. Hockney called Geldzahler regularly to elicit advice and commentary that not all well-known artists have the courage to request. Somewhere in this mix, we start to grow more comfortable with the pictorials of those the artist loved and how his pictures assimilate his open fondness and admiration for his subjects.

His portraits seem to provide the artist with a perfect vehicle through which to celebrate the diversity of our species. Although there is a healthy sampling of early works that were exploratory and experimental, his drawings and paintings completed during the last twenty years steal the show. It may be that his drawings on paper are the greatest works of his career. Color pencil portraits of Gregory (1975 and 1978) have no equal in contemporary art. There, tenderness and insightfulness bring the viewer up close where eye contact in unavoidably enjoyable. His pencil drawings of subjects like Francesco Clemente, Lucian Freud, Andy Warhol and Man Ray are simply astounding. Each dedicated line is laid down with an intuitive impulse that knows exactly when to stop, leaving behind sometimes just a meandering skinny line for a pant leg. His wonderful portrait of Andy Warhol (1974) may just be the greatest image of the Pop King — certainly the most beautiful — out of the thousands by other artists across the globe. Equally intriguing and breathtaking in their simple beauty are the pencil drawings of reclining Celia.

Hockney's portraits possess a rare ability, like George Condo, Pablo Picasso or Lucas Samaras, to jump to each corner of the ring as a slightly different talking head camouflaged every so delicately, not unlike a chameleon gliding through the gardens at Mar-a-Lago.

And so it is the artist's dedication to an ongoing fearless investigation into the exterior human spirit that makes Hockney's mature works so remarkable. In those we meet new faces and old friends that celebrate the dignity and inherent beauty of the human race.

26ᵗʰ Sept

David Hockney, *Self-portrait 26 September 1983,* 1983, charcoal on paper, Image: 30 in. x 22 7/16 in., 76.2 x 57 cm. Private Collection, San Francisco.
© David Hockney, Courtesy, Museum of Fine Arts, Boston and LA Louver, Los Angeles

Jasper Johns, *Savarin***,** 1977, lithograph on Twinrocker paper, 45 in. x 35 in. © Courtesy of Jasper Johns, ULAE and Eaton Fine Art, West Palm Beach, Florida

Jasper Johns & ULAE

The two most influential living legendary figures in contemporary art at the moment are Jasper Johns and Robert Rauschenberg, but in the pecking order of sainthood, Johns is a winner by a full length. Willem De Kooning had the undisputed lead until his death. Richard Diebenkorn, who was much less known and passed away a few years ago, was probably in terms of sheer talent and undeniable beauty the closest second, a considerable distance from other recently departed and knighted souls like Robert Motherwell, Tom Wesselmann and Philip Guston. What made the Jasper Johns exhibition at Eaton Fine Art so memorable was the number of absolute masterpieces in one room and the obvious difficulty in mounting an exhibition of works by a man whose production is notoriously modest. The show consisted entirely of prints published by Universal Limited Art Editions, better known by its acronym as ULAE, and was curated by their legendary president Bill Goldston.

Johns has had a forty-five year collaboration with ULAE, which began in a tiny Long Island studio in the late 1950s. The story of this nearly half century partnership and the revolutionary influence it played on printmaking is fascinating. The tiny seed that grew into a strong, meandering, flowering vine was first germinated out of one woman's desire to earn a living with an overwhelming need to make a contribution to the world. Born in Russia, Tatyana Grosman spent half her life fleeing war and revolution that took her to Japan, Dresden, Paris and finally to New York, where she settled in 1943. After her husband suffered a heart attack, the responsibility of supporting the family fell squarely on her shoulders. She decided to bring the French tradition of livres d'artistes to America by publishing illustrated books. At first, she concentrated on reproductions, but soon after a visit to William Lieberman, the curator at the Museum of Modern Art, she was encouraged to begin collaborating with artists to create original prints. The story gets better and richer with the chance discovery of two Bavarian lithographic stones unearthed from their front yard, a neighbor wanting to sell a litho press and a local print shop willing to demonstrate press techniques. With the equipment set up, they searched for a poet and found Frank O'Hara to write and Larry Rivers to illustrate. Mrs. Grosman saw this developing circumstance of chance as divine providence and set out to make the newly formed Universal Limited Art Editions successful and well known. Looking back, it's hard to imagine anyone accomplishing a better job following one's instincts.

Grosman's friend Rivers encouraged other artists such as Grace Hartigan, Helen Frankenthaler, Robert Motherwell and Marisol to also make prints at ULAE. Soon after, the Grosmans began seeking out young talent on their own by investigating countless gallery and museum shows. In some cases, they just sent off a letter and held their breath, as in the case of Jasper Johns, who was pleased with the invitation and later brought his close friend Robert Rauschenberg to the studio's attention. Later, ULAE brought in emerging artists like Jim Dine, Cy Twombly, James Rosenquist and Buckminster Fuller. One by one, these artists and others came in to literally make their mark. Only seven years after publishing ULAE's first edition, a large number of images were chosen to help launch the print galleries at the Museum of Modern Art.

The show at Eaton Fine Art focused on the pioneering spirit of Johns, and was a rare occasion to see some of the most famous prints from his target series, flags and seasons. One of Johns' most well-known images is Savarin,

Jasper Johns,
False Start I,
1962, lithograph on Rives BFK paper,
31 1/2 in. x 22 1/2 in.
© Courtesy of Jasper Johns,
ULAE and Eaton Fine Art,
West Palm Beach, Florida

with its bold and recognizable crosshatches as a background for a red coffee can holding the artist's brushes. False Start, a delightful lithograph printed in 1962 incorporates all the iconographic elements that Johns is well known for: stenciled names of colors from blue to yellow, layers of textured brushstrokes and an odd combination of primary colors that seem perfectly in harmony.

There are differences of opinion on the quality of work Johns produced, particularly with paintings over the last decade. A clear direction seemed to be missing as the artist dipped back into his oeuvre to include images repeated in the past and not fully resolved. Perhaps part of these conclusions may stem from the artist's own self-imposed secrecy and a kind of studio hibernation, which did not allow for the release of much material for public discussion. Say what you will, but Johns' print titled Bush Baby is a bona fide masterwork of color combinations, integrated shapes, relaxed patterns and overall synchronization. This print wipes out any critical questions as to whether or not the artist should pass along his unofficial crown to someone else. In Bush Baby the artist has constructed a delightful juxtaposition between vertical diamond shapes on the right and dazzling circles of primary color on the left. Two yardsticks with strings attached seem to lean against the picture and serve as a natural border of necessary separation. The print is fresh and invigorating and full of the surprising signature elements we have all grown to recognize.

Jasper Johns and ULAE continue to be partners in one of the great print shops of history. It was Tatyana Grosman who got the ball rolling and convinced so many artists who are currently world-renowned to utilize printmaking as a natural extension of their studio palette. Clearly Johns took the ball and ran with it harder and faster and more creatively than most of his colleagues.

51

Jasper Johns, *Bush Baby,* 2004, lithograph, 43 in. x 29 3/4 in. © Courtesy of Jasper Johns, ULAE and Eaton Fine Art, West Palm Beach, Florida

Elizabeth Murray, *The New World,* 2006, oil on canvas on wood, 8 ft. 1⁄2 in. x 6 ft. 7 in. x 1 3⁄4 in. (245.1 cm x 200.7 cm x 4.4 cm). Courtesy of PaceWildenstein, New York

Elizabeth Murray

SHAPING UP

Throughout art history, humankind has been compelled to inscribe marks and symbols on surfaces that communicate an inner sprit with an independent style. The Mayans, for example, had an intricate collective abstract visual language that was discretely recognizable for centuries. As painterly techniques became scientific after years of experimentation and scholarly investigation, artists forged ahead to document their surroundings with their own singular interpretations.

Painting continued to expand its horizons in all directions, but it was still more or less limited to recreating images of life, whether it was a portrait, a bowl of fruit or an engaging landscape. Painting had to reflect something that one could identify. As the rules began to be broken and artists started to find ways to jump out of this authoritarian mold, individual style and risk-taking pushed at the bubble with jabs and punches until the opponents of change received a technical knockout. When the floodgates opened wide, particularly after the pioneering efforts of painters who decided to shatter accepted principles by eliminating sacred cows of acceptability and abstracting images of realism, the work they produced thereafter could move into unimaginable directions. As experiments and discoveries expanded like an unstoppable alien virus, multiplying in studios late at night, vigorous innovation grew in leaps and bounds.

Finally, young artists, particularly in the 1950s, were free for the first time to harness their own intuitive creativity and attach it to the fragments of recent accomplishments by other more mature artists. And so, it was a stroke of luck for Elizabeth Murray (and for all of us) that she landed in a good spot on the occasion of her birth in 1940. Chicago, the "Windy City," was also experiencing the breezes of changes and cross pollination from Los Angeles and New York. As a youngster, you are not aware of current trends, but you do know intuitively what rings your bell, and like most wide-eyed children, you're open to suggestion and direction.

When Elizabeth was three years old, a nursery school teacher sat down next to her so that they could color together. Murray watched in awe as a magic wand of red wax began to saturate the construction paper from corner to corner. When it was little Elizabeth's turn to try, she realized the endeavor was not exactly magic, and if you wanted to bring something to life you'd have to take up the challenge with vigor. This concept was intriguing to the young girl as the physicality of a surface being deliberately altered and manipulated and covered with bright colors made a lasting impression. Coupled with an inherited Midwestern work ethic, this new perspective eventually did help make magic.

Murray's mother wanted to be a commercial artist, but bided her time as a homemaker, painting porcelain miniatures. Her father, a lawyer, offered intelligent advice and identified her talent early on. He encouraged his children to go to local theaters; cartoons became a favorite and related to her knack for drawing. This hybrid would become the basis for many of this artist's most celebrated paintings.

Chicago became the bedrock for Murray, who went on to study at the Art Institute and at the University of Chicago. It was at the School of the Art Institute of Chicago that Murray met Jim Nutt, with contemporaries Roger Brown and Ed Paschke. These men developed the highly influential Hairy Who fraternity of artists, getting much of their inspiration from cartoon imagery, odd juxtaposition of narrative subjects with a celebration of the bizarre and crass.

After a circuitous route, Murray arrived in New York City with her artist husband, Don Sunseri, in 1967, where they set up a studio on West 28th Street. Murray, like so many other determined artists, stuck to her guns and continued to refine her vision. Later, she began cutting regular and irregular shapes out of paintings or drawings and reassembling them in a modernist patchwork composition.

These exercises in the deconstruction of an image followed by piecing squared off fragments together again became a kind of visual crossword puzzle, where vertical and horizontal elements needed to link like stepping stones on a reflecting pond. Murray encouraged a viewer to connect the dots and shapes as you traveled across the picture plane. This simple concept allowed her to pursue something new and singular that could incorporate the challenge of mixing abstraction and the brightly colored cartoon visuals that she loved as a child.

The most comprehensive retrospective of Elizabeth Murray's work to date was at the Museum of Modern Art, where the evolution of Murray's mature vision became clear. In her illustrious career, Murray has transformed contemporary painting's conventions to forge an original artist idiom through the use of vivid colors, fearlessly inventive forms and multi-shaped constructed canvases. The works in the MOMA exhibition possessed a cinematic sense of drama and action, of emotional power and surprising beauty. Combining abstraction and figuration, she also draws on inspiration as diverse as the funny pages, Paul Cezanne paintings and the eccentric movements of Pop Art imagery. The artist has become well known and respected for the large, bold compositions on multi-faceted canvases. These often depict everyday objects, such as paint brushes and coffee cups, and lend a familiar, comfortable domesticity to her art.

The evolution of Murray's penchant as a kid for sketching cartoons and her attraction to large-scale projected animation in the theaters, coupled with her geographical influences and her obvious dedication, have been a remarkable recipe for rich, memorable works. One of those memorable works, Painters Progress (1981), oil on canvas, standing nearly ten feet high, portrays a surrealist artist's paint palette on a black background. There are nineteen separate panels that have been created to contain the central image. The multitude of these irregular squared off forms is necessary to bring the jelly bean shapes connecting objects into clear focus.

In Deeper Than D (1983), approximately nine feet in height, two handsome peanut shapes stand side by side, interlocking an "arm" at the top and sharing corner space with each other to support the illusion of a room. The canvas has been deliberately painted almost to the edges, leaving the evidence of a built up, multicolored surface, with a hint of Clyfford Still and the shoe step shapes of Philip Guston's late career work.

More Than You Know (1983), measuring nine feet high on about a dozen panels, is a coveted work loaned from the collection of Ed Broida. This striking image of a calamitous interior that seems to have just been flattened by an angry wife with the keys to a bulldozer, leaves the single male occupant howling like an Edvard Munch character taken by surprise. The red kitchen chair is split into two parts, and the legs lay flat across the work as if they are hiding evidence. In many of the works, Murray's affection for certain styles in art history becomes evident. Without an individual association, suffice to say that Elizabeth Murray is open to anything that seems to move her, with a built-in comfort zone of preconceived personalized elements. Faint allegiances to Frank Stella's cut-out forms emblazoned with scratchy color come to mind, as do compositions by Jim Nutt and Joan Miro. There also seems to be a distinct admiration for the graffiti art of the 1970s and 1980s, along with a spirit of neo-expressionism and New Image painting.

In What is Love (1995), Murray's recollection of cartoons is delicately balanced with a well-designed four poster bed that has seen better days. The central figure wanders with exhaustion in a dream-like state. The mattress square has been vigorously painted in dark purple with a Joan Mitchell spirit, and the modeled white sheet is accented with hypnotic lines forming a cartoon face that is also a pillow.

As a short story writer on canvas, Murray's strength is listening to her own natural ability and perceptive skill to transfer images into a modern visual language not known before. An idea surfaces and then is recorded in a notebook and onto transparent paper. This is projected to an empty wall, as the artist continues adding and eliminating — flattening forms — and over-painting the evidence, slicing up the pie piece by piece. Eventually and finally a refined and reconfigured reconstituted appealing work rises to the top, which continues to make this artist one of the most inventive and dynamic American painters at the beginning of the 21st century.

Albert Oehlen, *Geigenbau,* 2003, oil on canvas, 110 1/4 in. x 133 7/8 in. Private collection. Courtesy Museum of Contemporary Art, North Miami

Albert Oehlen

APPALLING GOODNESS

One of the great challenges of contemporary painting at the turn of this past century is to continue moving forward in a completely inventive format that remains characteristically fresh and new and exciting to the eye. At the same time, it must embrace an awareness and respect for recognizable achievements in picture making from the past.

Fortunately, there remains a small, healthy reservoir of painters who continue to explore an inner spirit with a personal formula that seems to keep constant with a satisfied audience. However, there is a certain liability in being too comfortable with a repetitive style. The technique may be successful in the marketplace, seduced and charged by supply and demand but missing in the search that goes beyond being comfortable into a risk-taking investigative journey that fewer artists are willing to travel.

One artist in particular, Albert Oehlen, has chosen a challenging path that is constantly crammed with idiosyncratic invention. Painterly twists and unexpected turns with ingenious surprises have propelled this relatively unknown artist into a leading position in the art world, where he continues to create mystifying canvases that simply have no equal. His journey of sincere exploration into an unplanned and unknown two-dimensional universe that is methodically built piece by piece is fascinating to observe and enjoyable to dissect.

Oehlen's remarkable show at the Museum of Contemporary Art (North Miami) titled "I Know Whom You Showed Last Summer," was the first major United States exhibition for this respected artist. The exhibition featured about thirty canvases from 1988 to 2003, which explored how Oehlen pushes the parameters of formal Modernism to its outer limits by utilizing striking color combinations in and around oddball shapes and forms, along with spatial relationships that stretch and distort the accepted standards of good painting. This willingness to go just over the edge in a curious balance of success and failure (or life and death), cheap on one side and expensive on the other, bends recognizable boundaries into a kind of sparkling twilight zone that puts a seasoned viewer into orbit.

The show, curated by MOCA's adventuresome and highly respected director, Bonnie Clearwater, displayed some of the most extreme examples of Oehlen's works. In the past twenty years, the artist has explored painting in a variety of media and styles, some of which are based on initial skeleton collages that are then transferred to canvas, retaining their original structure and adding a curious blend of sometimes unidentifiable, "unpainterly," "ungainly" ingredients.

Creating abstract paintings is the primary interest of the artist, as he believes that they make the most concise statements about his rational approach to art. From a distance, many of the paintings have a clear structure and respect for Abstract Expressionism, reminiscent of de Kooning and Kline. These basic sensibilities are often mixed together in a tossed salad of Neo-expressionism that brings to mind the bravado paintings of Julian Schnabel and David Salle. The foundation of Oehlen's strength is his uncanny knowledge, preoccupation and skill in combining abstract imagery with other neo-ism strains.

Oehlen, sometimes the comedian, commentator and observer of art history, jumps from one area to another on his surfaces to work out visual solutions that are radical and chock full of risk.

Oehlen was born in Krefeld, Germany in 1954. His father was a cartoonist, and had a proclivity for breaking down imagery into smooth-lined abstracted styles with an obvious sense of humor that influenced Oehlen and would stay with the artist throughout his career. As a young painter, he was ripe to explore revolutionary ideas in both politics and art. He met the Neo-expressionist Jörg Immendorff in 1969, and was struck by his willingness to "make something really ugly," which led Oehlen to an early starting gate of recognizing the ironic beauty and excitement of turning things inside out. For a short time in the early 1970s, Oehlen moved to Berlin, where he continued his interest in politics. Eventually growing disillusioned with his environment, he left the city to attend the Academy of Fine Arts in Hamburg, where he studied with the celebrated artist Sigmar Polke. Oehlen's assimilation of Polke's inventive vision and an ongoing investigation and utilization of art history would later become a major signature in his own work.

During his student years, collaboration with others became important to Oehlen, not only because of the sheer enjoyment in the rich exchange of ideas, but for the expansive role of fearlessly trying things with the other artists he may not have attempted on his own. After these cooperative efforts played themselves out, Oehlen was able to position the openness and searching spirit of earlier experiments onto complicated canvas surfaces.

Some of the leading Neo-expressionists in Germany, like Gerhard Richter and Georg Baselitz, continued to stimulate Oehlen's artistic temperament and affect his resolve to devalue accepted principles and go his own way. The artist began to cultivate an unusual theory that allowed each painting to follow its own set of rules that were inscribed as the paintings were being developed. One gesture could act as a springboard for another area of marks that were intentionally rebelling against each other, which created a satisfying tension. Without a preconceived plan of action to begin a picture that followed by and large the gospel of de Kooning, Oehlen could present an ongoing array of visual puzzles that he would set up for himself, only to later find curious and satisfactory solutions that kept the excitement on edge and moving forward. Without a preconceived notion of how a painting is to be formed, but at the same time being armed with an acute awareness of the issues raised by Modernist abstract painting, the possibilities of creating a stream of provocative works is literally endless.

The excitement surrounding this artist is generated by an audience of critics, curators and collectors, who see the work as unique and incomparable to anyone. Here is a painter who genuinely seems to greatly take pleasure in the manipulations of spatial illusions, of peculiar color combinations and crafting compositions where no one has been before. Oehlen presents a kind of game board on canvas, where he starts with a simple idea or gesture and begins to build, slowly avoiding convention while searching for an elegant, nonconformist escape from

established norms of good painting. Built-in contradictions and opposing forms keep the paintings moving with a kind of vibrating vitality that condenses this overall energy into a fast-paced fireball of intrigue. Oehlen has likened the experience of his painting to "suffering through a bad joke," where in the beginning you cannot figure out where the comedian is going, but in the end it's worth a standing ovation.

One of Oehlen's great masterworks in the MOCA show is Geigenbau (2003, oil on canvas, 110 ¼ inches by 133 7/8 inches). Here, Oehlen demonstrates the value of his long, informative journey that combines so many sensitivities, influences and memories. It feels as if one is greeting an old friend who's changed through the years—barely recognizable, but for a familiar twinkle in his eye and a distant scent that still clings to his unfamiliar profile. Geigenbau is at first glance a perfectly composed Abstract Expressionist painting, as good as any in a line up of usual suspects. But Oehlen carries the torch even farther into unexplained territory, where he has merged the narrative with the abstract and with shapes that have never been seen before. Every area in this painting magically flows into another floating space capsule that makes perfectly good sense. The more you examine this work, the more you want to follow and participate in the short story passages that the author has carefully inked onto gessoed cotton. The extreme confidence displayed here is part and parcel of the ironic beauty that rises to the surface of a boiling pot of odd forms and connecting visual references.

Titankatze (1997, oil on canvas, 70 inches by 60 inches), another large scale piece, is a grand hybrid of the best of what Abstract Expressionist style has to offer. With the sharp newness of perplexing, integrated connecting lines, odd, cryptic visual notes from a bumbling madman who flirts with ugliness and left-footed expressions, combined with the elegance of a blue-blooded gentleman out for a stroll, Oehlen has earned his position as one of the finest and most fascinating and courageous painters of our generation. At this moment in time I cannot think of a living painter who equals this man's extraordinary talent and uncanny vision.

Yoko Ono

THE MESSAGE IS THE MEDIUM

Yoko Ono, as early as 1960, not only was far ahead of her time — rattling conceptual swords and the cages of convention — but also was a true innovator that influenced the history of contemporary art. During her prolific forty-year career Ono has thoughtfully investigated an expansive range of media that went well beyond traditional boundaries, producing unthinkable new forms of arresting artistic expression. The variety of projects in her exhibition at the Museum of Contemporary Art in North Miami was so ambitious and at such a high level of invention and intelligence, that it couldn't help but leave a lasting reverence and a new perspective on the DNA roots of a creative, aristocratic, well-educated and talented Japanese family tree whose branches cast a long and indelible shadow on a wide variety of artistic pursuits. The exhibition included over 150 works from the 1960s to the present that focused on Ono's early period: objects and installations, language works such as instruction pieces and scores, collaborations with composers like John Cage, mesmerizing film and video, music and sometimes alarming recorded sounds from coughs to cries.

This was a show of historic proportions because it absolutely positively forced a reevaluation of Ono's overall influential position in the art world. It thoughtfully explored her commanding status within the post war international avant-garde and her critical role in originating new forms of music, film and performance. Projects on view examined her early and central role in Fluxus, a movement developed in New York in the early 1960s that combined a boiling pot of alphabet soup with interactive crossbreeding of all things creative. Her superb contributions to conceptual art in New York, London and Tokyo are also carefully documented here along with eye-popping experimental films, which are superior to many of the moving pictures at the recent Venice Biennale.

When you add to the accomplishment equation her vocal recordings, public art, groundbreaking and inspiring announcement billboards War is Over (If You Want It) and Fly among others, it would suffice to say this artist in her own right will leave a permanent, deep benchmark for generations. When you combine Ono's natural talents with the collaborative efforts of her late husband John Lennon, one of the great innovators in music that forever changed phases, lyrics and the way music is now mixed and visualized, the analogy is like having Babe Ruth and Ted Williams on the same team, up to bat with the bases loaded at the bottom of the ninth.

Among her astounding works is Ceiling Painting (Yes Painting) from her Position Paintings series, which seeks to alter the viewing experience by requiring an unorthodox relationship between the viewer's body and the work of art. This piece is essentially in three parts: a ladder painted white (now aged with a beautiful worn patina), a framed work hanging from the ceiling just above the ladder and a magnifying glass to identify the tiny printed

Yoko Ono,
Painting to Hammer a Nail
(3 paintings),1967,
mahogany, nails, rope, wood, metal
hammers, glass jar with lids, nails,
61in. x 10 in.
Image courtesy of Shoshana Wayne
Gallery, Santa Monica, CA. Photo
Credit: William Nettles.

word "yes" inscribed in the middle of the piece. At least one viewer at the 1966 Indica, London show — John Lennon — remembered feeling relieved that the text he discovered when he climbed to the top of the ladder was not negative, and he noted "…that YES made me stay." The rest is history.

Another winner is Wrapping Piece for London (also known as Wrapped Chair) that originally began with a ball of gauze sitting on a caned chair. The artist wanted the audience to keep making the ball larger until it literally filled the whole room. Unexpectedly, gallery participants ended up wrapping the entire chair, which Ono later painted white. It now remains a mysterious, ghostly work, robust and still full of growing character. This piece is part of the artist's extended exploration of the activity of wrapping. The metaphor is rich with meaning, suggesting traditional women's activities of binding wounds and swaddling infants. It also offers a scent of a weeping widow's web — perhaps conjuring dangling, swaying memories of disappointment, disillusionment and tears, all bandaged up and hiding some inner secret.

Another masterstroke is the installation piece Half-A-Room, 1967, which is full of preserved selected objects appropriated from an apartment Ono shared with a lover who one day picked up and left. The artist awoke one morning to realize that half her life had evaporated into thin air. "Life is only half a game," she noted. "Molecules are always at the verge of half disappearing and half emerging." Examining this room, fit for a Ripley's Believe or Not display, it seems obviously incomplete, but the always positive Ono insists that the room environment is both half empty and half full, like the glass of water in the familiar riddle.

But the artist here goes even deeper with her questions for answers. The installation includes a framed painting, a suitcase, a top hat and shoes, a garbage can and a woven basket. They are all sawed in half, painted white and handsomely aged over thirty years with a dusty quirkiness of clear Duchampian bloodlines. This masterpiece deserves its own public, permanent home.

There are so many superior aspects of this artist's activities that will sharpen the opinion of scholars of art everywhere, let alone the casual viewer who is set up, twisted around, confronted, reminded, inspired, educated and even amused (see Fly, her film produced with Lennon and you may have a protective smile for life), but you'll walk away with a new respect and an admiration that is reserved for only a few.

Roberto Juarez

TRAVEL LOG

Close your eyes and imagine for a moment that you have gathered together an expansive circular orbiting double helix scrapbook of selected tangible experiences of life. Zero in on your loves, your travels and your homes away from home and interconnect the colorful dots to form a web of abstract hybrid memories. Now you are ready to take in the scenic route of painter Roberto Juarez's reconstructive vision.

The artist has had the opportunity to travel and work in cities around the world, enabling him to capture a diverse landscape that encompasses all of life's encounters. His paintings are often a slightly reflective, foggy mirror on his surroundings and the memories attached to a certain place and a certain time. In spinning together a fragmented recreation of outside physical matter and an interior inventory of tastes and thoughts and feelings, Juarez is one of a handful of artists who consistently add another rare dimension to their paintings.

George Bellows clamored to document the chill and smoke of the Hudson River, but he never went beyond a first layered pictorial reference. Remington's depictions of stampeding cattle on their way to slaughter in clouds of dust and terror remain dry, flat and lifeless. Picasso's Guernica (1937) edged further than ever before into the realms of personal emotion —a recollection of pain and a place of unforgettable horror. These were abstract illustrative compositions gathered not from memory but from reliable reports in the press coupled with a moral obligation to document a historical moment. Sue Williams took personal disaster and sexuality and discovered an evolution of lyrical painted ribbons that captured the dramatic and traumatic incidents in her life.

Roberto Juarez's handiwork weaves an interlocking basket that retains and portrays personal recollections and experiences that produce extraordinarily beautiful and inspired surfaces. Born in Chicago, Juarez's father was from Mexico and his mother from Puerto Rico. As a child he discovered an intuitive attraction to art. He later studied at the San Francisco Art Institute, where he scavenged the streets for collage materials— a habit that stayed with him throughout his career.

His travels, particularly in Mexico, provided him with a new way of looking at painting. There he discovered a narrative art on ancient walls painted in a stylized decorative manner, which he related to the eccentric Chicago group of artists in an expressive fraternity called the Hairy Who. He began to seek out other creative outlets, such as film at UCLA, then moved to New York to become an assistant to Jedd Garet, an acclaimed East Village artist. Soon after, he met John Cheim, the director of Robert Miller Gallery, which cemented his professional direction within the art world at a time when multiculturalism was gaining acceptance.

Later, after accompanying his friend, artist Jack Pierson, to Miami Beach, "a lost paradise," he began to realize that these environmental occurrences were naturally seeping into his work. He also noticed that it takes time for an artist to digest his living experience and that these reflections can surface together to blend and produce unabashedly splendid visual statements.

In a compellingly handsome show at the Museum of Contemporary Art (MOCA) in North Miami, titled "Roberto Juarez: A Sense of Place," the artist exhibited more than thirty-five mostly large-scale paintings and explored how working in other surroundings has influenced his art of the last fifteen years. The exhibition was curated by MOCA director Bonnie Clearwater, who also contributed a fascinating essay to the show's catalog.

Roberto Juarez, **Black and White Pearls,** 2000, mixed media, 74 in. x 84 in.
Collection of Jim and Betsy Chafin. Courtesy Charles Cowles Gallery, New York

Roberto Juarez, **New Apartments DMV,** 2000, mixed media on canvas, 96 in. x 104 in.
Collection of the artist. Courtesy Charles Cowles Gallery, New York

Two of his works, Orchis-Morio and Lesser Butterfly (both 1996) are striking, nearly breathtaking portraits of orchids that pay homage to the works of Robert Rahway Zakanitch and Richard Diebenkorn, with their natural flow and stark beauty. The saturated hues of painter James Brooks and early layering of David Salle also commemorate a free-spirited approach to picture making, both elegant and on the edge. New Apartments DMV (2000) has a woven, handmade composition reminiscent of a potholder in a Bauhaus kitchen. This work incorporates an architectural grid with a tender, remarkable balance "built" by an engineer complete with an infrastructure.

With each new destination, particularly Rome, and the accompanying daily thoughtful journal, the artist's vision matured into an idiosyncratic abstract travel log integrating references to his life's experiences. In this critic's opinion, that travel log makes him one of the most important painters of our generation. A careful examination of his images reveals a searching narrative explosion charged with dignity and inventiveness.

Black and White Pearls (2000) is based on pre-Columbian Anasazi pottery designs that have a hypnotic and pleasant swirling motion. Bryant Park Tiles (2001) originated as a proposal for a public art subway passage that connected to Times Square. It is a painting of stunning beauty and perfect proportions, and is a brilliant signal of things to come.

As observed in the catalog : "No doubt Juarez's works will continue to change as he settles into his new studio (outside New York City), but his story will still remain as he has summed it up before— 'This place and time calls for many places and times, to manifest in a picture that could not have been made anywhere else.'"

Roy Lichtenstein, *Coup de Chapeau* (Self Portrait), 1996, oil and magna on canvas, 50 in. x 40 in. Courtesy Estate of Roy Lichtenstein.

Roy Lichtenstein
FOUR DEGREES OF SEPARATION

In the early 1960s sophisticated galleries with a strong presence in the Manhattan art scene that were willing to take chances on new art were few and far between. Just ten years earlier, Betty Parsons had taken the bold step of painting her gallery completely white as a novel but appropriate interior forum that could gracefully accommodate fresh visions in contemporary art. And so it was not totally coincidental that a lanky young man named Roy Lichtenstein, sensing the changes at hand, optimistically entered the Leo Castelli Gallery uptown to present his groundbreaking work for consideration. Fortunately for all of us, Ivan Karp, the colorful associate director of the gallery (who later founded his own legendary exhibition space, one of the first in SoHo) and a man blessed with vision and an unknowing measure of clairvoyance, characteristically welcomed the artist.

Although completely immersed in the currents of modern art, Karp didn't know quite what to make of this cartoon/advertising based albeit recognizable imagery. The paintings seemed rather crude and commercial, but they were a completely new way of observing and transforming American mass-market cultural icons into a soon-to-be respectable format. Curiously enough, a few weeks later another young man named Andy Warhol independently found his way to Ivan Karp with a similar portfolio of fragmented cartoon characters and depictions of popular culture. Neither artist knew of the other's pioneering visual spirit or of the importance in art history that their experiments would create.

A good connecting story is the tale about Richard Brown Baker (the handsome and distinguished Manhattan gentleman collector) who entered the Castelli Gallery in 1962. In response to a request by Mr. Baker to view new works in the back room of the gallery, Mr. Karp showed him some small Lichtenstein paintings depicting laundry detergent and foot medication diagrams, which he promptly decided to buy. After informing Leo Castelli of this surprising news, they realized there was no set price. They suggested the amount of nine hundred dollars, which he immediately accepted. Forty years later the images are enormously valuable and have become reincarnated as intertwined icons of contemporary art — trophies of independent decision making and confidence.

The legacy and influence that Roy Lichtenstein left us was evident in the Museum of Contemporary Art's (MOCA, North Miami) comprehensive overview of this master's palette in the exhibition titled Roy Lichtenstein: Inside/ Outside. Lichtenstein was stylistically the most consistent artist of the 20th century. His understanding of the potential aesthetics of identifiable printed materials produced a shotgun visual marriage in the studio, which

Roy Lichtenstein, *Still Life with Goldfish Bowl (and painting of a golf ball)*, 1972, oil and magna on canvas, 52 in. x 42 in.
Courtesy Estate of Roy Lichtenstein.

allowed him to explore and unleash uncharted territory of dramatically different vision and technique.

In retrospect, the seeds of Lichtensteinian imagery were already sprouting fifty years earlier within a 1914 pencil drawing by Pablo Picasso titled Plate with Wafers, which now has an amazing resemblance to Lichtenstein's interpretive sensibilities. Another rather extraordinary example is a 1947 collage by Kurt Schwitters (For Kate) that utilized comic book imagery, including Benday dots. Three other early connected works come to mind in Gerald Murphy's Razor, 1922 and Stuart Davis' Odol—It Purifies and Lucky Strike. These works became unwitting prototypes influenced by Leger and the accessible commonality of household objects as subjects for paintings. If Fernand Leger and Marcel Duchamp did not directly influence a generation of younger artists in opening some important windows they surely helped to mold the aesthetic situation in which Pop was possible.

As an art school student and teacher, Roy Lichtenstein was well aware of these images that assisted him immeasurably in building confidence to fully explore undiscovered aspects and applications of perception, unity and contemporary space. Fortunately for the young artist he had a brilliant art teacher at Ohio State University named Hoyt Sherman, who was also an influential writer on methodology in the studio. Sherman encouraged him to find out how to organize his perception and taught him how to go about learning to look. Planned or not, Lichtenstein was groomed and motivated for success with the highly professional influences he initiated for himself. Lichtenstein later matured into one of America's great narrative abstractionist/reductionists.

Concurrently, the average commercial art director (at arm's length to a promising Pop Artist) chooses his subject matter and then refines or abstracts recognizable material for reproduction. For Lichtenstein, who took the streamlined ball and ran with it, a second step of consolidating visual information was appropriating the actual printed newspaper page where lines are simplified and shading is mechanically created. A third generation of fine-tuning the original idea was Lichtenstein's habit of rough sketches in colored pencil that eventually moved into a final fourth degree of crisp, meticulous abstraction by applying his sketch to stretched canvas.

Lichtenstein's personal challenge and continuously winning formula always began with a carefully selected pre-abstracted narrative commercially drawn for newspapers, where details were eliminated and shading was produced with irregular Benday dots. Filling in the gaps with strong primary colors continued the refinement. With a successful formula for enhancing common images found in our daily lives, Lichtenstein's simplified subject matter became unending—a veritable bottomless pit of things that could be transformed and captured on his canvases. Depictions of mundane subjects such as doors, sofas, fish tanks, clothing and even houses began to elevate everyday images to high art. Later on he became proficient in taking on any subject with invention and pizzazz. A careful examination also reveals a parallel personality of the artist: perceptive, inventive, quiet, confident and obviously witty. In this case, you are what you create.

Malcolm Morley, *Jockeying for Position*, 2005, oil on linen, 32 1/16 in. x 96 1/8 in. Courtesy Sperone Westwater, New York

Malcolm Morley

RISK AND REWARD

For ages, artists have been researching high and low for images of life and leisure that relate to an agenda of representation. There is a wonderful collection of images out there that seem to tell a story of adventure and discovery that makes clear the artist's preoccupation with a subject worth fully exploring.

Edgar Degas started hanging around the ballet stage as a behind the scenes observer to capture the beauty of forceful movement in dance. His elegantly lopsided compositions in pastel depicting beautiful young dancers shaking off stage fright as they went before the bright lights in front of an adoring crowd are classic ambulatory examples of his investigative approach to graceful movement and traditional beauty. Degas was also one of the great documenters of sport horse racing, utilizing the same singular off center blueprint for his equestrian subjects and their determined jockeys. In these celebrated works, the elegance and showmanship of this highbrow sport was marked in rich chalk pastels that seemed to blend into the politeness of top hat society. Remington hopped on the bandwagon of the pioneers to portray the true grit and action of the Old West in paintings that offer us a delightful window into American history.

At the turn of the century, artists were beginning to look beyond a standard fare of romantic landscapes and studio still lifes. As painters and paintings matured, there was a bravado—a kind of de facto fight club of engaging artists who were willing to tackle difficult themes that required skill and concentration and for almost the first time, poetry in motion.

George Bellows' classic Stag at Sharkey's (1909), of two boxers caught in a moment of swinging appendage power surrounded by horizontal ropes and vertical poles, speaks of the pain and power of defeat. Edvard Munch's still unrecovered icon, The Scream (1893), catches the same moment of terror, like Picasso's Guernica, on the bombing of a Spanish village that seduces viewers' emotions and sympathies. Of course, if you look back long enough, an entire collection of images surfaces that commemorates the innovation of artists who deal with death and destruction with an aesthetic twist. Theodore Gericault's The Raft of the Medusa (1818) captures a floating disaster waiting to happen that puts you on the edge of your comfortable seat, vowing never to enter the water again.

Today's artists are fortunate to have this historic foundation of imagery and of trials and tribulations to hunt for other stimulating material that is suitable for exploration and fits into their scheme of things. Malcolm

Morley is one of those chaps who have gracefully taken bits and pieces from history and from the portrayals of others to record everything from horseracing and baseball to hockey and car racing, and the fatalities of life that are set up by the circumstances of danger and imminent death. The eye opener retrospective at the Museum of Contemporary Art (MOCA) in North Miami, "Malcolm Morley: The Art of Painting," was the artist's first museum survey in the United States since 1984. The exhibition focuses on Morley's connection with images of the past and his concentration on the art of painting.

Born in London in 1931, six years before Hockney's birth in the same proper British environment, Morley paints in a manner and with subjects that defy a clear cut categorization. Often, Morley is described as a photorealist, but he is not, in the technical sense of the word. He does, however, utilize photographic sources, much like Warhol (see Sunday Disaster), many of them from newspaper clippings that provide him with a rich palette of ideas. The painter defines his sole purpose as an ongoing preoccupation with the art of painting and the sensation of transferring closely observed forms to a square up and grid-laden canvas.

Morley achieved a great deal of early recognition in the late 1960s for his photo-inspired paintings. His seminal work SS Amsterdam in front of Rotterdam (1966) is based on a commercial promo reproduction of a photograph. For the photorealist fraternity, mastering and keeping a shape in focus is of primary concern. However, often for this critic, their works eventually begin to repeat themselves ad infinitum with yet one more superfluous supermarket reflection, empty SoHo street corner in the rain or a well-groomed thoroughbred horse.

Morley has taken the challenge of an equal parts risk and the ultimate reward for a staid envelope of photographically motivated images to a new dimension. Laboring for years, Morley, like Chuck Close, utilized the old billboard sign painter's technique of placing a grid over the original image, then locating and reproducing one small square at a time as he intermittently "twirls" his square canvas into upside down diamond shapes, again like Mr. Close. As a result, the abstract shape and color mesh together in a more homogenous format.

As the painter hit his permanent stride, his work embarked on a different direction and mission in the 1970s with an emphasis on the physicality of painting. Morley's technique changed to incorporate rough brushstrokes, the enigma for anal retentive artists whose personal aesthetic seems to be part of the pain and discomfort of recreating a photograph from scratch without detection.

Morley risked his beachfront and benchmark by sliding into a new frontier, not as dramatic, perhaps, as Philip Guston's reversal of style, but nevertheless, a courageous move that's working even now. Eventually he moved into still life, arranging objects from his childhood memories and Christmas list into a tableau. Many of these images recalled the pleasure of building model boats and planes, combined with the terror and trauma of the London Blitz of World War II.

Malcolm Morley, *The Art of Painting*, 2005, oil on linen, 101 1/8 in. x 79 5/8 in. (256.9 cm x 202.3 cm). Private collection. Courtesy Sperone Westwater, New York

At the dawn of a new century, Morley zeroed in on a double metaphorical recreation of action paintings, or paintings depicting some action, with super-realist renditions of athletes and race car crashes. The basic concept of a NASCAR race is so remarkably inane to begin with. It's a polluted race round and round to nowhere and with an audience's peculiar attraction to a quick-fix tire change. It then adds sainthood to a driver who gave the forum his last blood. All this is not typically visual fodder for most respected artists. To give Morley credit, he is not really interested in the blast of an engine or a thoroughbred photo finish. Rather, this painter's orderly, focused technique yields a dynamic picture of contact sports in flesh and metal that celebrates the fascination with speed and conflict. Without having a peek, it seems impossible that these subjects might have an aesthetic edge, but in fact they do, with a powerful sharp corner. The specific subject was incidental to the artist as he was seeking to create a contemporary American mythology using today's sports heroes.

At the end of the afternoon, when the smoke clears from the raceway and the sweet anticipatory dreams of catastrophe fade into the sunset, Malcolm Morley is ready for a new day of discovery. By mixing together the high marks of art history, the boldness of abstraction and the inherent beauty of controlled strokes, we are comforted that almost any subject can be pursued by an artist with true vision and taste, while others are literally jockeying for position outside the winners' circle.

Martin Mull, *String Theory for Dummies*, 2007, oil on linen, 50 in. x 50 in., 127 cm x 127 cm. © Martin Mull. Collection of the artist. Courtesy Ben Brown Fine Arts, London

Martin Mull

MULL'S BACKYARD ODDITORIUM

Martin Mull's much talked about show at the Spike Gallery in Manhattan's Chelsea district opened a lot of eyes to the professional and idiosyncratic style of a mature and respected painter who is better known to most Americans as a gifted actor, musician and comedian. But what most people do not realize is that in the late 1960s Mull received his master's degree in painting from the prestigious Rhode Island School of Design, long before he stepped up to a microphone. During his stay on the Providence campus he developed a legendary reputation as an ambitious, inventive and gifted painter — a kind of storytelling conceptualist—who could draw like Matisse and handle an airbrush better than anyone. Surrounded by a considerable fraternity of other multi-talented and determined fellow classmates, including Dale Chihuly, Charles Rocket, Jenny Holzer, Mary Boone, Nicole Miller, Todd McKie and David Byrne, Mull successfully mixed his uncanny ability to articulate narrative line and offbeat humor in the same gesture. Soon after, he teamed up with several other RISD students, including Neke Carson (who later also became a respected artist) and launched a rock band called "Soop," which eventually led him to California.

After appearing in several movies and starring on television in "Fernwood Tonight" and "Mary Hartman, Mary Hartman," he seemed to settle back with a sense of security that allowed him to pursue his true passion in the well-lit studio above the garage of his Brentwood home. From the perspective of knowing Mull while at college, and later watching his star rise into national notoriety, it is not surprising to see a renewed interest in his work based solely on his obvious, seasoned talent as a fine artist. In the early eighties, he began showing canvases in Los Angeles. These incorporated his superb skill with an airbrush, portraying delicately illustrated flea market porcelain objects, such as spotted Dalmatians in a bathtub, or a picnic in the grass with animated observers.

In 1991, he launched his first one-man show in New York City at the Helander Gallery on West Broadway in SoHo. The works exhibited there still carried the narrative spirit of wit with banal memories of middle class America, but the airbrush photorealist slant had disappeared, replaced by a kind of painted collage composition that snatched bits and pieces from visual snapshots of obscure urban circumstances.

As the work became more focused, the sense of risk and exploration offered a handsome edge to a new pictorial diary. Twelve years and thirty solo shows later, Martin Mull has evolved into a recognized first-rate painter. The

Martin Mull, *Art in America*, 2007, signed with initials and dated 07; titled and dated 2007 on the reverse , oil on linen, 50 in. x 60 in., 127 cm x 152.4 cm.
© Martin Mull. Collection of the artist. Photograph by Joshua White. Courtesy Ben Brown Fine Arts, London

images shown at the Spike Gallery are based on collected reference materials, such as discarded photographs, illustrations and wallpaper, which conjure up a suburban Midwest oddball innocence that seems to reflect on the artist's childhood observations. In this series of front- and backyard scenes, children toil and play at the same time, as in Creating Work Where None Exists. The pictures echo the artist's original technical mastery of airbrush, only now substituted with a paintbrush that seems to vacillate between danger and joy, dark and light. A vintage border borrowed from hardware store wallpaper sample books encloses many of the images. These framing devices surround the picture, softening the sharper edges of the 1950s domestic architecture portrayed. The reader is gently introduced into a circling pattern reminiscent of Zakanitch that creates an appropriate outline for his topics. In many cases, Mull seems to be able to make lemonade out of suburban lemons as he takes recurring predictability and finds a twist, like a great photographer — Diane Arbus comes to mind—to sweeten basic rights of passage into interesting multi-subject dream statements.

In Silverdale II the artist singles out one middle-aged housewife who stands motionless (and emotionless) near a pile of toys — a sailboat, a truck and a beach ball—that although designed to be ambulatory, are stuck just like everyone else on Maple Avenue. Some images have a billboard sensibility, recalling early Rosenquist explorations into household scenes. Many of the compositions could be show posters for a post-modern circus, as in Grafton Revisited or The Dance and Parents II. Almost always one finds a house as a home placed in the background, even though it might appear as a simple darkened silhouette. But somewhere below the romping in the grass, the fertilizer line and the picnic bench near the aluminum chairs, there's maybe something buried below, redolent of an opening scene from a David Lynch movie.

Mull goes about addressing these retro secrets and dated customs of white middle class America one at a time, each focusing on the American dream, or has it become a recurring nightmare? Edward Hopper offered the same kind of soft focus summary of American life, complete with loneliness and despair. In fact, the painting Real Estate presents an almost classic Hopper-esque dwelling, with a cardboard couple in the foreground, about to cash in on the GI Bill. In The Dance we observe another odd couple, a reluctant young girl and her senior partner, sporting permanent greasepaint smiles that seem to mask hidden mysteries from our juvenile past.

It is finally our perception and experiences of chasing the American dream that draw us to these emotional memories. Subsequently, it is the artist's penchant for cleverly collaging together the visual hybrids of photography and painting with real or imagined subjects from our past that offers us art-in-life al dente. What Mull has accomplished is his own backyard three-ringed circus, portrayed on canvas as if they were grand banners announcing sideshow curiosities for us to consider.

Dennis Oppenheim

OPERATION OPPENHEIM

I first met Dennis Oppenheim in 1971 at ARTPARK in Lewison, New York, where we were both artists-in-residence constructing large, site-specific works. The development of the Oppenheim project, both curious and mysterious and without explanation, was utterly misunderstood from every angle and by every visitor at ground level.

I later discovered the real secret to his one thousand foot "drawing," titled Identity Stretch. While photographing my own installation from a small airplane, I observed the unmistakable shape of two large thumbprints formed from hot tar in broken, curved and uneven lines. The artist had printed his son's thumbprint overlapping with his own on a piece of elastic, which was stretched and then plotted on a grid. The grid and thumbprints were next transferred to this outdoor site where a boiling spray truck followed the line of the blueprint. The work was then photographed from an airplane; viewed and appreciated by passing airborne passengers for years--and I would hope examined by some distant interplanetary palm reader. Looking back on those pioneering days, one can identify a certain cryptic ambiguity that purposely doesn't always make complete sense initially but sooner or later engraves an unforgettable lasting impression.

Dennis Oppenheim has his indelible thumbprint on everything he makes. He's a three-dimensional storyteller with a green thumb and a pointed finger connected to a slap-happy applauding hand. But it is a thumbprint always inked with a new twist that needs to be inspected carefully for a correct identity or connection to a title. Oppenheim's superb show at Eaton Fine Art in West Palm Beach was a whirlwind of exquisite, imaginative three-dimensional maquettes for larger projects, large scale conceptual drawings, and two outstanding outdoor installations that are graceful to observe and rank high on the conceptual beauty chart. One of these installations, a permanent three dimensional silver-colored maquette sculpture measuring fifteen feet high, titled Engagement (1997), has become a landmark for the gallery's Quadrille Street location. The work depicts two interlocking engagement rings stripped bare and divorced of detail except for the glass enclosed "diamonds," whose hidden electric fixtures illuminate with a certain sparkle that would make deBeers proud. Anchored in earth and conceived from the marriage of two circles, an eternal figure eight blesses this arranged union.

A second installation, less permanent and crying out for an oceanfront home with moxie, is titled Color Mix. The artist planted two earthen hills covered with grass and flowers. At the top end of both sides are welded steel

Dennis Oppenheim, *Color Mix,* 1997, two upturned vessels pour colored flowers (White and Red) to spread and continue growing down the incline.
The form of the work changes as time enhances the materials. Medium: Earth mounds, white, red and pink impatiens, steel pipe, expanded steel, 15 ft. x 30 ft. x 30 ft.
Courtesy of Eaton Fine Art, Inc., West Palm Beach, Florida

wine glasses, about twenty feet tall and turned upside down to let gravity pour out their contents--red flowers from one and white flowers from the other, which flow together into a mix of vintage rosé.

Oppenheim's theatrical palette seems to change with every new piece. His colorful sketches are the artist's springboard, which transform his concepts into reality. It is from these multi-layered studies that this artist's magic starts to boil.

Oppenheim's projects are well-documented in Barbara Rose's book Drawings. Within the drawings are the keys to defining and appreciating the artist's multi-faceted brushstrokes. Fortunately for the viewer, the artist's consistent quality in drawings full of Rube Goldberg-ish schemes and dreams illustrates a serious thoughtful plan of action from within the complicated head of a national treasure. Given the chance and the right amount of political power, Oppenheim could change our urban and rural landscape into an endless, upside down aesthetic and intellectual ride into the sunset.

Laura Owens, *Untitled,* 2001, oil and acrylic on canvas, 106 in. x 67 1/2 in. LO 192. Courtesy the artist/Gavin Brown's enterprise

Laura Owens

MISCHIEVOUS ORIGINALITY

It would certainly be understandable for someone who came upon Laura Owens' show at the Museum of Contemporary Art (MOCA) in North Miami to think the body of works shown there was part of a large group show of disparate artists with a narrative bent. Even a seasoned visitor could be fooled with a quick run-through observing an expansive collection of small paintings, drawings, large canvases, traditional landscapes, Modernist abstraction, figuration, art about art and a host of other images that are difficult to classify. The artist seems to move with ease between high and low, personal and social, figuration and abstraction, colorfield and cartoons. The truth of the matter is that Owens is clearly in love with painting in every shape and form, and with the excitement and personal satisfaction of creating anything that interests her. It's been reported that the artist is obsessed with the difficulty of beginning a new work, but once she finally gets "on the road," like a fine vintage automobile that takes a while to warm up, she races off into a glowing sunset where few have traveled so successfully and so amazingly fast.

Since the late 1990s, Laura Owens has been widely regarded as one of Southern California's most promising and talented artists, so for a young painter barely past thirty, this was a rare opportunity to examine her complex style. The exhibition at MOCA was the first major monographic survey of Owens' work, which traced her development from 1997 to the present and featured about forty paintings and works on paper that incorporated a large and imaginative range of subjects and techniques. The show was organized by the Museum of Contemporary Art, Los Angeles (LAMOCA) and coincided with Owens' inclusion in the 2004 Whitney Biennial. It allowed viewers to track the artist's development and to cement links between pieces that in many cases had never been shown together. The artist also created significant, new, large-scale paintings especially for the exhibit.

Owens' work may be confusing to someone first coming upon her method of painting. She combines a remarkable ability to merge a highly personal iconography from dissimilar sources, such as embroidered curtains from the eighteenth century or childhood aesthetic memories executed with a purposeful naivety and a clear grasp of art history. Owens delves into beauty and decoration as she integrates a wide range of subjects that interest her, including Chinese and Japanese landscape painting and her own photography. Like an explorer moving by intuition, she travels down paths rarely seen, and her risks result in amazing discoveries that she develops along the way. In some cases she mixes diverse images such as traditional craft, folk art, color field and bits of op art, as well as pattern and decoration. In applying paint to her canvases she employs a variety of techniques and textures

that in concert become some of the most unusual, inventive combinations seen in contemporary picture making in the last decade.

It is this amazing tossed salad of incongruent ingredients that consistently make Owens such a fascinating artist to watch. She takes a little from memory and borrows a bit from art history. She then double-backs into styles and ideologies, art movements and recognizable images of other artists to produce an assemblage of romantic, narrative, postmodern compositions that feel different—that seem revolutionary and even upsetting in their spirited fragments. These initial impressions are not always recognizable, but have a way of getting under your skin like a chigger bug that's not easy to overlook or ignore.

As open as the pictures seem to be, there are hidden secrets and soft whispers that flow through her canvases like a spring breeze. Occasionally the artist scans sketches into a computer and reworks them in Photoshop, sometimes making full-size transfer drawings that pull together all her elements into one engaging composition.

Owens was born in Ohio, where she discovered the joys of art at the age of fourteen. Like many successful, narrative painters she graduated from the Rhode Island School of Design with a bachelor's degree in fine arts. Perhaps it's the required two semesters worth of rigorous nature drawing that all freshmen have to get through that may have made a lifelong impression on Owens. It may also be the trendless, New England traditional fine arts program that emphasizes the importance of drawing and color theory that offered an appropriate foundation for her to go on to CalArts for her master's degree.

One wonders, with thousands of painters graduating each year, whether we are missing other notable talents who just love painting and don't move on and into the public spotlight. For example, another equally talented female painter, also from RISD and who, like Owens, could have been influenced by a rather obscure artist named Florine Stettheimer, is Victoria Wulff, who has painted magical stuff in near obscurity except for a recent Guggenheim fellowship. I'm sure there are legions of others who just need to trip over the right circumstances — curatorial interest, gallery invitations or critical acclaim—that can provide a nice cozy hammock in which to swing in any professional direction they want.

Almost right after graduate school Gavin Brown asked Owens to join his illustrious gallery in New York, which placed her among some of the coolest artists on several continents. It was just what she needed, a gallery that was well connected but allowed her the security to continue moving in unconventional directions that were appropriate and rewarding.

Comforting visual rewards with a female touch are basic ingredients in Owens' paintings that are hard to deny and make examining the works even more challenging. One of her largest canvases, Untitled (2002), is an acrylic and oil on linen, over 132 inches wide, in which her mastery quickly becomes apparent and overwhelming. In this sizeable work, a landscape like no other provides a natural stage for a happy painter to paint happy scenes in such a singular way that it calls for a re-examination of painting outdoor scenes. Bare trees bend and curve

like Franz Kline brushstrokes on top of a large stained Frankenthaler canvas sky that is dotted with creatures of habit. A large brown bear hiding behind a tree trunk encourages a viewer to enjoy what's there even though the surrounding objects, like Owens' repertoire, are from all over the place. Just below this friendly beast are two playing cards—the only inorganic objects in the composition—for a literal, hibernating "ace in the hole." The painting is so commanding that you tend to get lost at first. You then become engaged in the complicated, heavy dashes of her paintbrush, which pleasantly match other living objects in the air like butterflies and birds. A white rabbit ponders a squirrel above while a cockeyed owl humorously observes the goings-on.

If you were pressed to find a recognizable, recurring symbol of this painter's complicated oeuvre, it surely would be hanging monkeys as pulled from eleventh century Chinese scrolls. This huge painting presents familiar everyday objects and components that at first glance don't seem as though they could hold your interest for long. But these works immediately start to grow on you, and it is almost impossible to walk away until you savor the experience.

The new twist and spin the artist takes on these traditional images is full of clever references and completely novel, deliberate marks. These are the underlying strengths of Laura Owens, who has pioneered a new voice in picture making with a different slant that is serious monkey business.

Paul Kos, *Tunnel*, 1995, wood table, cheese round and toy train with track, 38 in. x 24 in. x 96 in. © Paul Kos. Courtesy Gallery Paule Anglim, San Francisco

Paul Kos

MARCHING TO AN ARTIST'S BEAT

Paul Kos is an influential and leading figure of the early California Bay Area conceptual art movement. He is recognized as a forerunner in the extended palette of video, installation and performance for sculptural compositions; these devices added dramatic multimedia elements not recognized before as potential components in an artist's repertoire.

For hundreds of years sculpture remained basically the same. Forms were representational, political, spiritual and generally beautiful and well crafted. Whether they were chipped from stone or wood or cast in bronze, the intellectual limitations were built-in, and the notion of sculpture turning into anything else with something to say was not considered. With the advent of artists like Kos, boundaries have expanded and then exploded like a domino effect on the Berlin Wall. Revolutionary artists as diverse as Duchamp, Beuys, Nauman, Scanga, Acconci, Nam June Park and Rauschenberg, climbed over the "wall" in all directions, planting seeds that continue to grow.

In the best hybrid spirit of these illustrious forefathers of expansive vision and inventive intelligence, Kos is clearly a good representative cross-section of conceptual thinking and creating. With aesthetic twists and turns, curveballs and curtain calls, visual games and intellectual wit, Kos' works live up to the title of his retrospective exhibition, Everything Matters, at the Grey Art Gallery in Greenwich Village by seemingly being able to put his deductive eye onto virtually anything. If he thought long enough, like a Second City comic looking for a line with only one subject to jump from, Kos could sew something together just for tonight.

Many of the artist's works explore paradoxes of belief systems. The ritual and imagery of the Catholic Church are recurrent themes, and the bell a frequent metaphor. In one striking piece, Kos marries medieval and modern technologies in Chartres Bleu (1983-86), which recreates an entire French cathedral window out of twenty-seven vertically stacked video monitors that duplicate each stained glass panel. Kos has condensed a twenty-four hour day into twelve minutes so an observer suddenly feels the time zip by as the light enters a colorful filter and quickly fades into darkness. There is an extreme hypnotic spiritual connection to this piece. Kos has expressed his own philosophy by paraphrasing a statement by poet and former president of Czechoslovakia Vaclav Havel, who observed that in the West everything works and nothing matters, while in the East nothing works and everything matters. "Things do matter to Kos," notes Constance Lewallen of the Grey Art Gallery in Greenwich Village. "Through metaphors drawn from his own experiences, passions and activities, he makes works that require, even demand, participation from the viewer. This participation might be physical (ringing

83

a bell, walking into an architectural space, tripping a sound element) or intellectual, but the viewer does his or her part."

If there were one defining characteristic of Kos', it would be his sense of play and his references to games such as chess, pool and petanque, a traditional French sport. You have to be on your toes to fully take part in some of these events. For example, in rEVOLUTION: Notes for the invasion: mar mar march, the artist commands a passerby to take a closer look at a small video installed at the end of a darkened room. En route to the video monitor are two-by-four lengths of wood spaced evenly apart on the floor so that you must become a willing accomplice by lifting your feet over obstacles in an ambulatory rhythm that feels something like you're all of sudden in step with an army that may sweep you away. As the viewer reaches the other side of the room, the video screen documents a typewriter typing out the word MARCH, which becomes a hypnotic manifesto. Those of you with a vintage Royal typewriter can practice this at home. Spell out "march," at first only two letters at a time (as in the video), until you get that itch to march—dada, dada, dadadada, dada, dada, dadadada—and "presto," you become an interactive bandleader.

Around the time of the fall of the Berlin Wall in 1989, Kos decided to draw upon the remarkable story then unfolding for a new body of work to be exhibited in southern California. One work shown at the Grey Art Gallery titled Just a Matter of Time consisted of fifteen identical cuckoo clocks, their hands removed, houses painted gray and hanging pairs of weights replaced at the end by well-worn hammers and sickles. The metaphorical meaning seems clear—communism as "cuckoo" as it sounded sooner or later had an inevitable fate as each of the fifteen countries (clocks) "sing" out of sync at unscheduled moments. It needs to be mentioned that his conceptual sculpture also has a handsome tonality — in the case of the cuckoo piece, a repetitive, swinging parade of beautiful objects hanging by a wire. Other works celebrated a commonplace sensibility that brought a smile, like the Swiss cheese round in Tunnel (1995), where a miniature train circles like a hungry mouse within the cheese.

Another favorite in the simplicity category is Equilibre IV (1992), which consists of a vertical broom and a stretched out coat hanger in the shape of a high-wireman's balancing device connected at each end with a lighted candle and a bell. Simple beauty and equilibrium have also been stable components through Kos' career. His photograph Emboss I has the simple vitality of a Harry Callahan, the class of a Henri Cartier-Bresson and the wit of a William Wegman as he "punctuates" with gravity a lady's backside with a design reminiscent of a notary seal.

There is also a continuing loop of early videos that seem innocuous now but must have been considered revolutionary at its inception. One striking video, A Trophy/Atrophy, documents a stuffed two-headed calf. The larger head apparently got the food, the smaller one atrophied. The artist mounted the heads on the wall behind him and made a 16mm film of himself as he shook his head from left to right. As the action speeds up little by little, the artist begins to blur into a likeness of the two-headed trophy.

Everything Matters was a thought-provoking and unforgettable exhibition with an elegant inventive logic consisting of part slapstick, part theater and part movie house, created by an author, actor, producer, singer, set director and camera man who has finally gotten his due, coincidentally not that far from Broadway.

84

Paul Kos, *Equilibre,* 1992, broom, coat hanger, candle and bell, 57 in. x 40 in., edition of 5. © Paul Kos. Courtesy Gallery Paule Anglim, San Francisco

Hunt Slonem, *Cockatoos,* oil on canvas, 80 in. x 96 in. © Hunt Slonem. Courtesy of Marlborough Gallery, New York

Hunt Slonem

BIRD'S EYE VIEW

Years ago, Hunt Slonem was determined to close out Manhattan's downtown concrete jungle by insulating himself behind the thick brick walls of a Houston Street tenement, whose interior was somewhat reminiscent of the Bronx Zoo aviary. Like so many artists before him, Slonem enriched his life and his inspiration by surrounding himself with personal objects of his desire. Working and living in the same environment is an absolute necessity for most artists. The practicality of rising with the sun where you paint when you awake to the multiple chants of exotic birds—lots of them—becomes a built-in daily motivating alarm clock for exploration.

George Bellows loved the inspiration he derived from the Hudson River; even in the dead of winter he was compelled to sit alongside a natural aquatic border to soak up the movement of barges as they floated by in the cold hazy mist of a Manhattan morning. Perching on a wooden stool, wearing leather gloves that clutched a paint brush nearly frozen in time, the artist liked to encircle himself with the true life elements of a fascination that kept him occupied for years.

Larry Poons, who took over Willem de Kooning's studio on Broadway, lived inside his canvas. Every wall and floor was covered with years of residuals that had strayed off course during his wild throwing sessions, which launched paint into the air and onto a waiting canvas. The requisite of living knee deep in his work—one literally bounced as one walked on the spongy acrylic surface—was the same constant physical stimulation that artists seek when they have found a direction they must follow.

For Hunt Slonem, entering his own cage that he shared with dozens of winged companions not only isolated him from the demanding distractions and stimuli of the city, but solidified a bond with his subjects that is indeed rare in the history of art. The exhibition of his large-scale paintings at Marlborough Chelsea in Manhattan showed off the intensity of the artist's commitment to co-existing with his models. There is a remarkable intimacy and understanding of his living still life "props." These airborne creatures seem to come alive again as they nest on a flat canvas protected from a dangerous outside world by a thick idiosyncratic cross-hatched mesh that covers every picture like a mosquito net. For years, the artist painted his feathered friends frolicking among the decorated branches. Their large colorful beaks were proudly held high as they looked back to their provider, who lovingly recreated their astonishing beauty on a daily basis. The show in Chelsea went well beyond his most notable silhouettes, with his portraits of human heads and ornate objects retaining the same kind of magic the artist has perfected over the past thirty years.

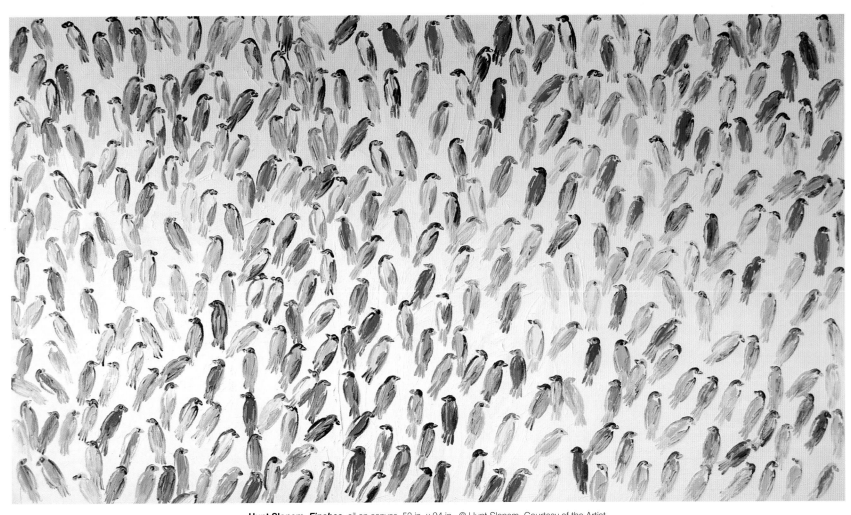

Hunt Slonem, *Finches,* oil on canvas, 52 in. x 94 in. © Hunt Slonem. Courtesy of the Artist.

In his remarkable maturity as an artist, Hunt Slonem has developed an eccentric style of cross hatching his surfaces with thousands of scored lines wandering in all directions. Once his paintings have been completed with visual stories and compositional balancing acts, the traveling circus he formed is then completely blanketed by the fine latticework that adds an integrated spirit to his canvases. Sometimes nearly hidden by conflicting parallel rows that enclose his subjects, the pictures often promote a mysterious spirituality that seeps through to confront the viewer.

In one work, Haitian Rope Morpho (1997), the artist offers a hybrid of organic shapes that pay a distant homage to Terry Winters, whose seed pods and attraction to nature dovetail into Slonem's own primitive instincts. In the bright orange composition, long-tailed yellow cockatoo-like birds synchronize with the vertical seed pod shapes, fiddle ferns and pomegranates that nourish this beautiful species. This delightful display interconnects black lines on vivid surfaces as the artist moves wet pigment back and forth until the entire design is protectively and systematically sealed. We are looking in while the birds are looking out, and somewhere in the middle a simple melodic harmony pulled from a prehistoric past comforts our intuitive desire to commemorate nature. Red Butterfly (1998, oil on canvas, 108 inches x 144 inches) presents a large slice of the earth's atmosphere, where butterflies dance in a pattern of gently flapping wings that seem to endlessly circulate.

While an exchange student in Nicaragua, the artist played hooky to hunt for exotic butterflies that captured his imagination and permanently branded in his memory a love of creatures in their home environment. A long-standing symbol of the soul in Western mythology, the butterfly was frequently the attribute of Psyche in neoclassical painting and sculpture. Continuing with this tradition, the artist here has crafted a fusion of neoclassical sensibilities reminiscent of great still lifes, often set in similarly crafted gilt frames with a contemporary application that energizes a canvas, with the old supporting the new.

Slonem, a rare adorable bird in his own eccentric right, portrays his great love for winged specimens and nature with a charming mix of abstract expressionism, color field attitudes and classic sculpted gardens redolent of Claude Monet. The playful images of Paul Klee and to a certain extent Alexander Calder relate to many of Slonem's witty and fanciful arrangements. Experiencing a Hunt Slonem show becomes a celebrated and exciting event, complete with a caged three-ring circus where creatures silently sing as they jump to a permanent perch of position and respect.

Julian Schnabel, *Maria Callas II,* 1982, oil and wax on velvet, 108 in. x 120 in. © Julian Schnabel. Courtesy L&M Arts, New York

Julian Schnabel

A BOUQUET OF MISTAKES

When you think about artists who have gotten under your skin like an invisible chigger at a Sunday afternoon picnic that you scratch at but can't quite forget about, one clear common denominator—sheer outlandish invention—leaves a permanent impression on your judgment. For it is invention, not necessarily a command of one's craft or a highly skilled technical ability, which seems to be the shared thread that tied together the pioneers who cut through an invisible curtain and constructed an expansive beachhead. There, artists dug deep into unknown territory that was just under the surface all along, waiting to be explored and developed. But this investigation of the new depended upon the transitional, recognized stepping stones that lead an art movement in an energetic exploratory direction. Fresh imagery that floats to the top breaks ground with a thrust of the sword in a different direction, fully utilizing an acute awareness and control of the past and a fearless push towards the future.

For example, Picasso's discovery and preoccupation with African abstract masks allowed him to mix the remnants of cubism with an ambitious formula that completely changed the way we interpreted modern picture making. Another pioneer with the same curiosity and admiration for the past in print was Andy Warhol, who insisted on cultivating and elevating familiar imagery that was just under our noses. His creative confidence and cavalier attitude that produced off-registered images on canvas allowed a long list of artists to interpret their imperfect world through a new lens by using existing visual materials. The quality and brash bravado of Warhol's works, like so many legendary innovators, persuaded a skeptical public to follow while embracing an unimaginable direction that attached permanent sainthood to the artist. Robert Rauschenberg, the reigning king of acquiring and incorporating images by others (or photographs taken by him) of seemingly random roadside vernacular subjects into his work, also established a clearly defined signature throughout that remains his private territory— always bolder, bigger and secure.

With the flood of vociferous artists into the melting pot of Manhattan-epicenter of the art world-it's a challenge just to find a spot above the water line to survive somehow, while struggling to expand beyond currently established identities in contemporary art. But somehow, there are artists who find their way into the mainstream by poking out their elbows and twisting cleverly and decisively through an evolving cocoon into a new world not seen before.

Julian Schnabel's ambitious exhibition at L&M Arts in New York City of over twenty works from 1978 to 2001 underscores the remarkable path one artist traveled like few before him with the genuine fearlessness of an astronaut on a mission to Mars. Schnabel's rise to fame began with his very first show at Mary Boone in the mid-seventies. From the beginning, Julian Schnabel seemed to instinctively possess a slant so daring and brave and so full of risk and uncertainty that the mix had barely cured before it took off with a roar. Beginning with

the early controversial plate paintings, the exhibit brings together an insightful examination into the depth and richness of this celebrated young figure.

The broken plate works first presented on West Broadway were a curiosity, like the American premiere of the Volkswagen Beetle; it seemed ugly and awkward, but it was convincing with style and intelligence and integrity. The little bug on four wheels remains a design icon in our history, and even now with its streamlined, improved proportions it carries the unmistakable lineage of invention that no one else can claim. Schnabel's plate paintings were so unique and so foreign to our expectations that the mystery and novelty attached to these works propelled them into an iconography that is forever recognizable and perpetually influential. The Patients and the Doctors (1978, oil, plates, wax, bondo and dental plaster on wood) is the title for his first plate ensemble. This picture was a scandal of sorts because few could immediately see the incredible breakthrough the artist had claimed. Common, secondhand "china" was broken and pressed into a thick plaster base, creating a new canvas — as original as it comes — to paint over and through with the leftovers thrown in for good measure. This was a rare experience, asserting a strict idiosyncratic authority that manifested itself with an odd originality, married to a crocked bride both ungainly and, ironically, mysteriously beautiful.

Schnabel found comfort in pushing open an envelope long sealed by rules and accepted regulations. He now has a singular surface all his own to create from scratch and build upon. Divan (1979), another exquisite composition with a plate base, accepts the impossibility of interjecting figures on top of and around a three-dimensional obstacle course that is as inhospitable as a primitive jungle to a first time explorer. Evel Knievel, that daring motorcycle rider in the sky who nearly made it to the other side of a wide valley, summed up his ascension with an observation that where there's no risk, there's no reward. Risk and the unknown tied to the hip of a genuine talent bent on the radical reformulation of great themes in western art spawned a stunning re-evaluation of all contemporary painting.

Picasso may have invented collage and assemblage, with Rauschenberg carrying the torch into the early seventies, but it was Schnabel who picked through the leftovers and the overlooked combinations. These jump out of nowhere and daringly construct larger than life images in rough paint with tons of objects, producing a sense of the epic that continues today to fascinate and provoke a worldwide public.

Perhaps Robert Pincus-Witten says it best in his astute essay "Histrionics and History." He states that Schnabel represented a new generation's rejection of the Compleat Minimalism of the day, whose taut and pristine surfaces were torn asunder by his rupturing aggressivity. "Still, Schnabel did take clues from Pop Art. It provided the artist with a fully democratized image bank to rifle, one culled as easily from high art as from low popular sources. To be sure, Schnabel's development is keyed to familiar stories - that of a style generated by reacting against an earlier one and its theoretical complement - that of intuition trumping analysis."

But it was abstract expressionism that seemed to be Schnabel's true love. His dedication to these simple principles introduced by de Kooning and Kline were coiled and stretched to the limits, until maturing into the artist's own take that threw in everything but the porcelain kitchen sink. It's in Maria Callas II (1982), a simply divine composition he's assembled on a lightly layered black velvet base with a scratchy painterly patina, that he becomes a cooperative host to an elegant, free flowing white splash that seems to fit the bill. This odd balance is

what constantly recharges the freshness of his imagery. This reservoir of emotional gestures presents a measure of gracelessness that is based on a steady stream of instinctual placement of disparate shapes and painting techniques. Picasso called his own painting a "horde of destructions," while Schnabel finds a perfect observation with a label he calls a "bouquet of mistakes."

So, in a nutshell, Schnabel's signature style is always there, even though he does not rely on recognizable images that are repeated in a particular series. When a painter is constantly moving forward in all directions, particularly beyond his discipline like sculpture or in a variety of techniques like stained canvas, assemblage and unexpected accoutrements, he continues to expose himself to the risk of failure. This risk draws a kind of inner strength and determination. Beyond the plates, which have become a permanent brand associated with Schnabel like a Jasper Johns target or a Jim Dine heart, his large scale paintings remain inventive and provocative. Schnabel has the street smarts and a rare gift like the painter James Brown or collagist Dan Rizzie, to bring literally anything into his gravity zone. Here he seems to secure it without blinking an eye at precisely the right moment and spot. Incorporating delightful found objects, patterned linoleum and letter forms onto recycled old surfaces like theater backdrops and truck tarpaulins, this artist is on the move and ready to boogie with the best of them through his own interpretive dance. That dance just might include a few traditional steps from Arthur Murray, Gene Kelly, James Brown (the singer not the painter) and Michael Jackson, mixed with a cardinal's march up the steps of the Vatican. This artist seems to have no fear, because like Columbus, he just knows exactly in what direction he's going, even in the dark. Most everyone else is worried about falling off the end of the earth. Schnabel has indeed mastered his own private path.

93

Dan Rizzie

DIZZYING RIZZIE

The biggest liability the artist Dan Rizzie has to contend with as his illustrious career flourishes is constructing works so engagingly beautiful and so over the top aesthetically that he could lose the striking edge that he has been sharpening daily for over thirty years. His exhibition at the Harmon-Meek Gallery in Naples substantiated the general conception within the art world that as painters go, Rizzie produces some of the most provocatively delicious surfaces of any artist dead or alive. The multiple images he layers upon deliberately reworked foundations are idiosyncratically as handsome, stylishly simple and harmonious as it gets.

There are indeed unusual combinations that artists finally obtain or fully understand and explore. The common denominator here is genuine instinctive taste repeated ad infinitum, combined with a superb natural confidence that allows this artist to greatly simplify his visual messages into short, concrete pictorial compositions. Rizzie's paintings and collages celebrate a delicate and uncomplicated balance between flavored Russian constructivist geometry, streamlined by years of experiments that is highly recognizable as his own invention, and a highly personal simple abstraction of nature.

His magical surfaces that support a central image are reworked and repaired, sanded and scraped, brushed over and often embellished with collage elements that reflect back to a mystifying decaying urban back alley aesthetic that meanders throughout his work.

Artists are nearly always influenced by the environments in which they grew up. Dan Rizzie spent much of his childhood in Egypt, where the minimal geometry of the pyramids and their aging facades were a constant focal point and subliminal indoctrination no matter where he walked. It was in this mystical and ancient community where the artist became accustomed to the basic pleasures of foraging for pottery shards in the fields near his home in Cairo. His dedication to discovering raw materials that can be adaptively reused continues to this day, as he makes regular forays into flea markets and secondhand stores for the basic resources and visual stimulation that are at the heart of his work.

While Rizzie was still a child, his father accepted foreign service assignments in exotic places like Amman, Jordan, Jamaica and India, which offered him a rich heritage and appreciation of encrusted surfaces, tile inlay and calligraphic inscriptions. Now a resident of the Hamptons for years, his acquired taste for beautiful materials continues to be utilized. Not surprisingly, like so many other great artists who admire assemblage and collaged surfaces, Rizzie continues with his habit of unearthing a well-rounded "palette" of found materials.. The unique combination of experiencing life in dramatic and historically and visually rich environments coupled with a genuine love of collage media and a sense of high-level wit has produced a successful marriage that continues to mature well after the seven-year itch. The strength of this partnership is secured further by a keen knowledge and appreciation of artists who have previously broken new ground - subconscious ingredients in a brewing

Dan Rizzie, *Jalapa,*
flashe on paper,
72 in. x 60 in. © Dan Rizzie.
Courtesy of Gerald Peters Gallery,
New York/Dallas/Santa Fe

Dan Rizzie, *Islandia,*
2006-2007, acrylic,
flashe and paper collage on canvas,
60 in. x 48 in.
© Dan Rizzie.
Courtesy of Peter Marcelle Contemporary,
New York

Rizzie stew. His careful and intimate placement of collage additions to a surface pays tribute to artists like Kurt Schwitters, Paul Klee and Henri Matisse. In some compositions he deliberately celebrates and openly credits Georges Braque's 1929 painting Le Journal by utilizing newspaper fragments reminiscent of that period.

Another surprising aspect to the work is the determined simplicity of each composition. Heavily worked surfaces allow the artist an all-over platform to make decisions only where the space necessitates additional components. These embellishments are often floating articulated circles of color or tracings of other circular forms that have the uncanny ability to hold their own weight.

The last step in Rizzie's balancing act usually requires a commanding abstracted organic form picked from a strange planet that also produces stylized vines, supportive stems and intoxicatingly rhythmic leaves. Often a utilitarian object, such as a flowerpot, anchors the other components while strengthening the picture's structure.

Works relate pleasantly to each other without regard to scale. Small pictures compete admirably with much larger canvases as they have been given equal attention to color saturation, surface tension and a common denominator of identifiable signature shapes.

There is nothing unresolved and no image that seems to outweigh another—an essentially flawless, memorable body of work of historic proportions that strengthens our respect for human creativity.

Italo Scanga

AN ANGEL FOR ITALO

Occasionally, there is an artist whose sudden passing on poses an enormous loss to the art community. Italo Scanga, who died unexpectedly of a heart attack at the height of his celebrated career, was one of those rare creative creatures that was widely exhibited and collected particularly in south Florida, where his bright colors, exuberant lines and dramatic carved and painted sculptures found an adoring audience with sunlit spaces ready to be occupied. His first one-man show in Florida in 1984 at the Helander Gallery caused an absolute sensation. The previous year Scanga was included in the Whitney Museum of American Art's Biennial Exhibition and the Museum of Modern Art's survey of American sculpture. Not knowing there were so many transplanted winter residents from New York here in Florida, the artist was surprised at first that so many visitors were familiar with his singular, pioneering and somewhat primitive style.

His close friendship with renowned glass artist Dale Chihuly also helped convince many collectors in Florida that he was worth acquiring, which built confidence both for the artist and his market. More importantly, the impact he had on dozens of other successful artists both as teacher and colleague shaped a more sophisticated vision for many who had overlooked the value in handcrafting sculpture with spirited objects embellished in a quasi-cubist motif, invented over the years as a kind of evolutionary scroll that could be read as a history of his all encompassing interests.

For those who were not familiar with the artist or his work it must be said that both were unforgettable. Outwardly the artist seemed to resemble a common laborer with suspenders, the kind of guy who looked like he could fix anything with speed and at a fair price. Inwardly, he was a complex and intelligent soul who celebrated living on a daily basis. Even if he had never picked up a paintbrush or carving tool his creativity, which could be applied to all categories of life, oozed from his pores.

Italo Scanga was the consummate artist's artist. At every professional level, individuals could recognize the rare qualities that Scanga brought to his work and life. His existence was a clear reflection of the artist's soul: robust and absolutely full of energy with an interest in all things that had a natural spirit of integrity. He loved his planet and the earthy crust that served as his creative foundation. For the majority of his career he foraged about as a sculptor connecting the products that were enriched from the soil. Sticks, wicks, gourds, boards, twine, line, reeds, weeds and even potatoes served as three-dimensional building blocks to create eccentric and poetic forms. He was a true scavenger of beauty—his art supply store was the flea market, where he became one of the greatest artist/collectors of that venue of all time. He was able to immediately understand how unrelated industrial and household objects could be welded together to bring a new life, dignity and a completely fresh slant to their original purpose. Figuratively speaking, an upside down tree branch was turned into a contraposto profile that

Italo Scanga, *Untitled (Head),* ca. 1987, oil on wood, 31 in. x 19 in. x 17 1/2 in. Collection of Sydelle Meyer, Palm Beach, © Italo Scanga Foundation

in turn would hold a musical instrument, a picture frame or a wine bottle. Scanga was a 3-D novelist full of intrigue, innocence and mystery—his colorful stories will go on forever.

It's not surprising that all other things originating from the earth captured Italo's reverence and imagination. He loved the smell of this land, its spices and herbs and the oil fresh-pressed from Italian olives. He cooked like a master chef with nonchalance and a simple grace that was remarkable. Italo was indeed a Calabrian saint, a patron saint for all of us, actually, wrapped up in his own sensual wet reeds that he cut and formed with affection like no one else. He was an extraordinarily talented sculptor who God very likely fashioned directly from the earth. An idiosyncratic painter; an intellectual and humorist propelled by a natural, searching, intuitive spirit, as pure as any artist who ever lived. Indeed, he was a national treasure that will be missed.

Yuroz, *Summer Reading,* 2007, Oil on canvas, 48 inches x 36 inches, © Yuroz. Courtesy of Coral Springs, Museum of Art

Yuroz

THE PASSION OF YUROZ

Artists become artists and continue during their lives with passionate energy because they have an intuitive mission to express themselves through their work. For example, there are those who only explore the beauty and mystery contained in color fields that ultimately identify with an individual's inner spirit, as in Rothko, whose canvas surfaces shifted in brightness with his moods. Artists like Joseph Cornell concealed a secret world in his Brooklyn basement, where he meticulously disassembled and studied fragments that he found visually poetic and addictively rearranged them into boxed, assemblage compositions. Jackson Pollock explored uncharted territory when he followed his desire to develop a rhythmic abstract pattern by utilizing simple drips of paint that were propelled by an artist's sense of timing. There are also artists who find a way to extend their vision by examining the properties of landscapes and still lifes, whether they are abstracted or realistic.

One particularly memorable passion revealing an artist's creativity and pioneering spirit was strongly reflected in the works of the Cubist movement during the first two decades of the 20th century. Cubism consisted of a desire to deny the work of their art predecessors in a way that would devalue their meanings and intentions. The movement's most significant members: Pablo Picasso, George Braque and Juan Gris, each developed certain styles that worked to bring their individual genius to the surface in a handsome format of challenging invention broken down into irregular curves. Throughout the history of Cubism, many changes came and went. During the early Cubist years, Picasso and Braque painted mostly still lifes in their analytical period. Over the years, the artists would retain new ideas and eventually left their distinctive Cubistic styles for new territory.

The common bond that the Cubists shared was the solid foundation each of these young men had with their classically trained backgrounds. Picasso's genius was discovered at a very early age and his drawing ability was extraordinary. Some early critics of this new geometric style questioned whether these artists could actually paint realistically. In fact, the ability to abstract form well is dependent upon one's confidence in understanding, articulating and defining forms in a still life or figure, for example. Gifted and well-trained artists who investigate narrative themes have the uncanny wit to creatively extend their individual insight and perception of society on stretched canvas. This common bond of investigative observations can create handsome and persuasive visual documentaries of our world through a different lens.

Yuroz has also found an idiosyncratic voice through his abstract neo-Cubist style paintings to express an inner reflection on the human condition—its pain and suffering, joys and loves and its beauty and natural grace. Like many of his predecessors, Yuroz loves to examine life. As a young man in Soviet Armenia he was determined to create great and innovative art. At the age of ten he became the youngest student ever to be accepted at the prestigious Akop Kodjoyan School of Art in the Armenian capital. Graduating with honors, he then entered the Yerevan University of Art and Architecture, where his creative abilities began to mature and distinguish themselves. But self-expression was not a popular subject for the Soviets, so originality and individuality suffered along with other creative pursuits within the Soviet Union.

Like other artists who seek the truth in their work and are compelled to express their feelings openly, Yuroz made a determined effort to immigrate into the United States. Once in America, he began a long journey of loneliness, poverty and basic survival that would sensitize the artist into turning his touching experiences and unique zeal for life into expressive portraits to which his audience overwhelmingly responded. For example, his early "Hollywood Boulevard" series depicted the homeless as beautiful and elegant subjects despite the

irony of their ugly surroundings and squalid living conditions. Eventually, his poignant interpretation of the human condition and the intuitive passion he felt for his subjects from personal experience began to earn him an estimable following, catching the attention of the Los Angeles Times in an encouraging review that would lend his work visibility and additional respect within the art community.

As the public and critical attention to the artist continued to expand, the challenge was to carve out a new stylistic dimension to the work that would satisfy an insatiable appetite for strengthening his creativity. This perpetual motivation of his craft led the artist to reexamine the excitement and challenge of further abstracting his figures. Yuroz found directional clues in the analytical and synthetic sides of Cubism, which reflected the artist's interests in painting and sculpture. During the analytical phase the early Cubist artists painted mostly still life objects, such as fruits and musical instruments, with enormous emphasis on manipulating the forms of these objects. Like Yuroz, these pioneering Cubists' sole purpose was to let the painting speak for itself as an independent entity rather than an abstraction from the artist. Afterwards, the Cubists moved on to develop what was later called the synthetic period. This period of Cubism represented the most dramatic and controversial change in the movement. In this stage, artists began to place everyday objects such as paper onto the surface of their paintings. The main aim in this new type of painting was to reconcile representation with abstraction.

Like Picasso and Braque, Yuroz retains a keen observation on life, which he takes beyond traditional contemporary boundaries into new pictorial concepts. He also shares many of the philosophical concepts of Juan Gris, who is considered the third most important creator of Cubism. Gris' work was more intellectual and logic-based than his predecessors. Like Yuroz, Gris remained loyal and constantly stimulated by the demands of Cubism until his death in 1927. But perhaps the clearest connection between Gris and Yuroz was the emphasis on creating a mood in their paintings.

In the exhibition at the Coral Springs Museum of Art, his fascination with people and places connected to strong moods from passion to imprisonment is evident in every work. Yuroz finds a great challenge in breaking down traditional visual barriers within the human form and its surrounding environments. Figures become sliced and flattened into separate geometric components that are integrated into the entire composition. Each "square" seems to connect with a neighboring cube to present a complete painterly design that is both recognizable and deliberately abstract.

Yuroz's neo-Cubist pictures seem to vibrate with interlocking passages that lend a spirit of movement and grace to his compositions. Colors are also inventively integrated as one tinted form folds into another. To further stretch the harmony of each work, Yuroz has devised a technique of intricate crosshatches and patterned scratches made with the opposite end of a paintbrush. A careful examination of these painterly devices reveals a textural concert of high notes and low notes, all interconnected to form a brilliant orchestra of harmonic devices. Yuroz the visual conductor maintains a strict control to create a handsome, visual song that celebrates the life and the loves of our world.

It is finally this unique combination of a rigorously and academically trained, highly skilled artist who has merged his life's experiences with his life's passion to present ongoing memorable images in a narrative neo-Cubist context that are compelling and idiosyncratically unique among artists in America.

Kiki Smith, *Untitled,* 1992, bronze with patina, 19-1/2 in. x 51 in. x 25 in. (49.5 cm x 129.5 cm x 63.5 cm), Edition of 2 + 1 AP. Courtesy PaceWildenstein. Photograph by Sarah Harper Gifford

The Smiths: Tony, Kiki & Seton

IN THE NAME OF THE FATHER

Famous bloodlines that produce an extended clan of talented representatives are rare circumstances that elicit inevitable comparisons and evaluations. Judy Garland conceived Liza Minnelli, who inherited her mother's same sparkling smile and distinctive voice. Henry Fonda produced talented actor/siblings Jane and Peter Fonda, who both leaned to the left. George Bush, Sr. cultivated a president and a governor, with all of them leaning religiously to the right. In the middle somewhere are dozens of other families not quite connected to creativity but whose descendants took full advantage of their relatives' wisdom and ambition.

There is a fascinating and little known history of artists who were lucky enough to have the natural parental surroundings that sparked an inner creativity. This creativity would later blossom into an independent spirit that flies off in its own direction propagating with confidence and a clear view point for the ingredients of discovery and success. The exhibition at the Palm Beach Institute of Contemporary Art (PB/ICA) titled, The Smiths: Tony, Kiki and Seton, transplanted an artistic family tree in full bloom for all of us to examine and ponder. It is also a show that is unique in American history and has produced a groundswell of national interest.

The works by Tony Smith, the revolutionary American Minimalist sculptor, are inspiring and retrospectively pleasant reminders of how this artist fits into the evolution of modern and contemporary art. They also offer a few subliminal clues to the extraordinary influence that growing up with art had on his two young daughters, who matured into independently extraordinary talents.

Kiki and Seton Smith lived in their father's childhood home in New Jersey — a home full of tradition, stability and creativity. A photograph in the exhibition catalog shows the sisters assembling their father's cardboard models with smiles and female chitchat that could be substituted for other American Family-like portraits—farm girls shucking peas and discussing the next harvest. They lived and observed every day the interlocking genesis of how art works are born, in an open process that the overwhelming majority of children never experience. The rest is a roll of loaded dice that travels in all directions, but with straight determination and confidence. Having a famous artist for a father with a stream of influential household visitors like Jackson Pollock or Barnett Newman provided an ideal breeding ground for patience, devotion, perseverance and commitment to excellence and exploration.

On the other side of the dinner table, Jane Smith, the wife and mother and also opera singer and actress who knew playwright Tennessee Williams, balanced out a comfortable nest that promoted ambition and taste. The by-product of this professional union is a legendary family that follows their own course with few connections between each member's art works.

Tony Smith, *The Fourth Sign,* 1974, cast bronze, black patina, 22 1/2 in. x 55 1/2 in. x 38 in. © 2008 Tony Smith/Artists Rights Society (ARS)

Kiki Smith lives in New York City and is consumed with investigating the details of the body, its cells, its functions and the inherent natural beauty of living forms. She also draws upon myths, fables and fairy tales as a base to examine our relationships with animals and nature. In Wolf, Kiki references Grimm's fairy tales with danger and temptation by constructing a powerful bronze wolf with a scare factor of ten, complete with a bright red child's glove clamped between two carnivorous white teeth. Other works deal with the female figure, abstracted in a private space and time so intimate that the viewer becomes symbolically self-conscious and alarmed. The rugged, circular patinaed doilies accompanying one of her pieces are among the most naturally beautiful feminine cast objects ever created.

Seton Smith is a longtime resident of Paris. She creates mystifying large-scale, soft focus photographs of images that seem to float just below the level of consciousness. Seton may have assimilated her father's influence first with a keen interest in architectural spaces, site documentation and a sense of symmetry, gravity and surrounding space. Many of her cibachrome prints evoke forgotten memories, déjà vu and a voyeur's over-the-shoulder viewpoint.

Tony Smith (1912-1980) is renowned today for the large-scale abstract sculptures he created in the last twenty years of his life. He studied drawing, painting and anatomy at the Art Students League in New York and later pursued architecture and design at the New Bauhaus. An apprenticeship with Frank Lloyd Wright and private practice as an architect gave Tony the foundation, vision and confidence to explore sculpture with an architect's eye. Smith's last project, completed in 1960, was a modernist studio structure on Long Island designed for artist Betty Parsons, who later as a gallery director showed some of America's most innovative Abstract Expressionists.

Gilbert Brownstone, the soft-spoken curator of this exhibition, with a big conceptual club and a perfect eye, knew the Smith family, and with panache carried the idea from start to finish. Brownstone is the former curator and director of the Musée Picasso di Antibes and curator of Musée d'Art Modern de la Ville de Paris. It is poetic that Brownstone, a celebrated art dealer, collector and curator in his own right, had the vision and contacts to suggest such a bold combination of related artists that has worked so well. There is little if any visual evidence that there is a crossover in recognizable connective styles between the three artists, but there is a clear and arguable link to invention and exploration by an unusual family that allowed art to be their symbolic heraldic crest.

It is not entirely clear what other living family legacies exist on this level nor is it particularly important to scrutinize other parallel examples. But what is crystal clear from this family is that loving, close, cooperative parents can have a perpetual influence on the destiny of their children's creative accomplishments and vision.

Fred Tomaselli

PRESCRIPTIONS FROM FRED TOMASELLI

Tomaselli's transportive visions and collisions on optically dazzling surfaces mystically explore contradictory turns of American utopianism.

The Palm Beach Institute of Contemporary Art hit a home run with its engaging and memorable ten-year survey of amazing works by Fred Tomaselli. The exhibition followed perfectly the institute's self-imposed marching orders to examine and display the art of our time. Fortunately for the South Florida community, the selection of Tomaselli presented a most remarkable and comprehensive picture of an artist who fits flawlessly into the specific mission of the curatorial team. Fred Tomaselli is an artist best known for collaging unorthodox media, such as prescription pills, street drugs, hemp and jimson weed, with traditional paints and resins. These ingredients lined up in colorful rows on an artist's wooden palette don't sound like materials that could create anything remotely alluring. However, through wit, skill, vision and remarkable talent, the artist has crafted some of the most starkly beautiful and inventive images seen over the last decade.

Tomaselli combines personal experience and cultural taboos with intricate repeat patterns that assist in reinforcing a delicate balance of irony — of beauty and the beast, of good and evil. Digging deeper, we discover a poetry of light and darkness, legal and illegal, quiet and unsettling, wrong turns and right turns, and of strict pattern design and randomness.

Tomaselli first emerged as an artist from the underground punk rock scene in Los Angeles in the late 1970s, and its historic zeal for experimentation and substance abuse continues to influence his artistic choices today. The artist, like so many others, developed as a product of his adolescent surroundings. For some it was industrial neighborhoods or gated communities; in of the case of this American artist, it was the California surf scene and resin surfboards, and its bits and pieces of a fantasy Disney aesthetic, surrounded by orbiting and mesmerizing concrete highways.

The artist's main themes, utopianism and failure and the ongoing contest between nature and technology, are subjects that the author turns into amazingly handsome, abstract narrative portraits of design and irony. The colorful, capsuled drugs the artist often employs and positions are softly buried in multiple layers of clear resin and wood. They are wonderfully seductive but untouchable, like a juicy apple from a glossy photo of the Garden of Eden. Many of these renowned and unconventional assemblage and collage paintings bring vivid ornamentation and repeat designs to the extreme. Radiating in all directions with tempting, delicious displays like the blinking, enticing, oscillating lights of a carnival ferris wheel, utilizing its own perpetual ups and downs, Tomaselli lures the viewer, like a yellow bug lamp attracts an insect, into a compelling multilevel and entertaining experience.

With all the secondary interpretations, eccentric materials and forbidden subject matter, it might seem difficult

Fred Tomaselli,
New Jerusalem,
1998, leaves, pills, photo-collage,
acrylic, resin on wood,
60 in. x 60 in.
Museum of American Art,
New York.
Image courtesy the artist and
James Cohan Gallery, New York

to bring to the viewer a glamorously exquisite composition. However, beyond everything, just below the surface, it is the grace and austere beauty that seems unforgettable. Birds (1997) is a superb example of a stunning picture celebrating a charming harmony of birds and nature. Against a black sky an Audubon's variety of winged creatures develops migrating patterns, while other birds rest in three hemp trees below. A closer look reveals that some members of this 'friendly' flock are terrorizing the others with vicious pecks.

In Dead Eyed Bird Blast (1977), the artist meticulously lays down a starburst pattern of birds exploding outward from the center, intertwined with a hypnotic arrangement of painted leaves and white pills. Another image, Gravity's Rainbow (1999, over 200 inches long), which was commissioned by the Whitney Museum of American Art, presents a dazzling array of swaying necklace shapes that have been strung with an eccentric interpretation of bead forms hand stitched together. Like so many of Tomaselli's "tapestries," this work seductively invites you in for a swing and a trial offer. Not only are there multiple strands of colored pills in alternative designs, but also a mind-boggling collection of cut-out substitute images, including flowers, birds, eyes, leaves, lips and hands all seemingly well-adapted to strengthening this superior composition. A sister to Gravity's Rainbow is an equally exuberant picture titled Echo Wow and Flutter. Here, the artist, with a steady hand and ambitious spirit, has doubled his necklace motif to form a spinning controlled network of circling objects that seem to be perfectly content in a weird arranged marriage of nature and man.

The large work Expulsion (2000) takes its cue from other exploding compositions. Red painted hemp leaves rise out of the ground in a mysterious and twisted pattern climbing upward to form a sunburst of radiant colors and shapes. A skinless Adam and Eve reluctantly exit a luscious garden with no chance of looking back. Tomaselli offers the viewer a modern illustrated story that captivates our imagination and soothes our senses with absolutely gorgeous compositions. Super Plant, composed of marijuana leaves and stems, is breathtaking in its simple harmony of green and blue. The leaves have a subtle natural range in hue and contour and, ironically enough, have a Shaker sensibility of sinless purity.

Each of Tomaselli's pieces requires the viewer's strict concentration and imagination. The more you look, the more you learn that his works take you to places you've never been—or just imagined—and seem to elevate your consciousness while transporting you to the past and the future, colliding and abiding with gracious harmony en route to an unorthodox utopian village.

John Torreano, *Eagle,* mixed media on wood, 9 ft. x 9 ft. © John Torreano. Courtesy of Feature, New York

John Torreano

TORREANO'S STARLIGHT SERENADE

Long before man figured out that he could use the stars as navigation tools or as a reliable calendar for planting and reaping, the celestial lights burned strongly every night. For billions of years they illuminated the immense, infinite darkness of our universe. The stars perpetually and literally surround us, dotting the sky with tiny pinholes of surging brightness that often takes millions of light years to reach us. We have all been mesmerized by this nightly concert of dazzling harmony that has inspired so many before us. The pharaohs' architects utilized the stars to formulate their own kind of global positioning. Without the stars (and the planets) Stonehenge would be just a circle of decorative rocks, and Columbus would have been lost before he got started. In fact, we've been enthralled by the magic and mystery of these sparkling gaseous giants for so long that astronomers and poets eventually invented names to go with connecting shapes called constellations. These connect-the-dots compositions were really only mnemonics — memory aids —to help break up the heavens into logical categories and put some order into exploring our galaxy with the naked eye. But the interpretive descriptions and their provocative titles, like the outline of the great hunter Orion, added a distant character association and a bit of romance and adventure to scanning the midnight sky.

It was songwriters who found an unscientific slant with encouragement from the stars that solidified countless relationships and extraterrestrial-like communication. "Hey There, You with the Stars in your Eyes" was an instant hit because of its widespread recognizability and its clever parallel to the human condition. "Lucy in the Sky with Diamonds" or Sinatra singing "Fly Me to the Moon" is our way of linking to a complicated network of stars and planets that seem to have an influence on our personality traits and even our passionate inclinations.

But it was artists who were compelled to document these visual phenomena with their own internal instincts for finding something universal and beautiful in the evening sky. For example, Robert Rauschenberg's silkscreen painting Star Quarters (1971) accentuated our fascination with space exploration and star-like notoriety with his abstract-narrative brand that included an outline of Dürer's rabbit and Muhammad Ali. Contemporary artists from Dennis Oppenheim to Vija Celmins have incorporated star themes into their work, reflecting an odd and outer space perspective from earth. Inspired by a majestic skyline well above our planet's atmosphere, occasional master works surface, like "Starry Night" by Van Gogh, that focus on the the mystical and haphazard patterns of celestial light.

For most of his career, John Torreano has been investigating and diligently documenting the aesthetic drama inherent in the changing landscape of the cosmos. He has literally reached for the stars to bring to his plywood surfaces a familiar distant constellation normally out of reach for us. Like an astrologer whose ambitions are to discover and name a new star floating elusively in the cloudy atmosphere, Torreano retrieves sections of space from memory and scientific photographs, such as those relayed by the roving Hubble telescope. The artist identifies these as "space edge" paintings, because the images are from the edge of the universe.

A little bit of the heavens was on display in Torreano's show at the Armory Art Center's Colaciello Gallery in the form of mostly black or white squares embellished with sparkling gems and spray-painted wooden balls. The exhibition, titled "Every Gem is a Handheld Star," explored the idea of making physical from the visual, forming a built-in conflict between the illusion being created with paint and the materiality of the paint itself. Most of the works on view took advantage of new discoveries recently published in scientific journals and NASA photographs beamed in by radio millions of miles from space. In addition to square pictures salted with a variety of colorful, sparkling gems and spray-painted, wooden half-spheres, Torreano has created several three-dimensional pieces, such as Cube From Sagittarius. This work substitutes as a square foot of hyperspace taken out of context, like a Scottish bog cut into brown squares.

Considering that we are naturally confronted with an expansive black space dotted with shimmering white light, the notion of color seems, well, alien. But if you look very closely at the midnight sky, there are, like in many of Torreano's compositions, spots of pure color here and there that accentuate the darkness. Keep looking and you'll find more of the same. ARCTURUS (Alpha Bootis) is one of the very brightest of stars, shining with a soft orange glow that lights northern spring skies. It is one of three luminaries that partition the northern sky into very rough thirds, the others being summer's Vega and winter's Capella. These are the colorful nuances that the artist is thankful for, for the inspiration and highlights they give his pictures.

Solare, (plywood, 72 inches by 72 inches) will stay in the same galaxy, so to speak, as it was acquired during the show by the South Texas Museum of Art in Corpus Christi, which has notoriously clear skies, where it will remain on permanent display. This is a large-scale work with an idiosyncratic surface of ingeniously sanded red paint and embedded gem shapes swirling about like a hurricane destined for landfall. This image represents a sunny-side up order and its inherent heat, intensity and energy are unmistakable.

In one series of about eight square pictures, the artist successfully transfers his extensive research onto board, where vague constellations or starry patterns pop through from the uneven meandering surfaces of hard wood. At first glance, these black and white snapshots of space all seem to be similar, like the tiny dots bursting into the darkness of a midnight sky when everything up there seems the same. However, as we know, the cosmos is full to the brim and then some with flying objects in all sorts of sizes, shapes and colors. Some even have tails, while others seem to wink back as they flash a sparkling white light in our direction.

Like the pop song "I'll Take You There!" John Torreano escorts us to all corners of the universe. Speeding past pulsars, neutron stars and supernovas, the artist maneuvers between floating rocks and asteroids to catch a rising star for his art. "When you move around these gems, you're mirrored in every facet," the artist observed. "It reinforces a feeling I have about art. It's unique from the point of view of every viewer."

John Torreano, *Gases in Omega Swan I*, mixed media on wood, 9 ft. x 13 1/2 ft. © John Torreano. Courtesy of Feature, New York

And so, as Torreano eyes the conflicts natural between illusion and the physical, we become the small scale observers of an endlessly changing skyscape — a giant black moving screensaver — that we enter for an orbiting excursion into the future with clues to our past.

Edwina Sandys

FLOWER POWER

If some alien spaceship passing through our galaxy happened to notice a huge swirling hurricane target shape moving slowly across south Florida, they might be curious enough to take a shot and jettison down for a closer look. And if they were fortunate enough to lower their neutronium landing gear on the expansive grounds of the Museum of Art in Fort Lauderdale during one of our infamous evacuation periods, the graceful and towering abstract "figures" installed there might convince these visitors from outer space that these sculptures could ironically reflect the strange anatomy of the residents of this colorful community by the sea.

It's easy to understand why at first unexplained glance another foreign species might exit with the impression that these are monuments to a gigantic race of blooming hybrid inhabitants, whose construction has the distinct characteristics of streamlined flora, from tulips to sunflowers. While the current exhibition by Edwina Sandys might merit some curiosity by not only Martian creatures, her highly skilled and semi-abstracted sculptures can't help but draw enthusiastic attention from a local audience of museum visitors.

Sandys' painted aluminum welded works on view celebrate the curious combination of shapes one might find in the garden, with the contrapposto stance of the human figure thrown in for good measure. In the sculptural work Sunflower Woman, nearly nine feet high, the artist presents a daring cut out form spray-painted a canary yellow tint that rises upward towards the sun. These pieces remind one of the magnificence of sunflower landscapes in the south of France, where each "face" seems to have its sights set at the best angle to catch the light.

Sandys' fondness for organic plant shapes that have a distinct relationship to the limbs of their human counterpart is a natural foundation for her singular style. In Tulip Woman the engaging inventiveness continues to be explored as the half-flower/half-person silhouette rises to the occasion with open arms. The neck, derivative of a flower's supportive stem, emerges to reinforce a handsome, simple outline of a red tulip, which has been scored with open cuts that allow the work to seem lighter and add a necessary airy element to reduce the overall mass. Three Graces, a ten foot high cut aluminum shape, utilizes the artist's ability to abstract the human form using the same basic structure that grows from the ground up. In this work, three distinct abstract figures engage in a dramatic circular dance of revelry and mysticism. They are equally balanced and utilize Sandys' signature cut-out style that allows for a circulation of space and air. These patterns of positive and negative allow backgrounds to penetrate through the works, adding color and texture, and in this case define the figure with gestures for eyes that interconnect with other suggestive body shapes such as breasts, arms and hips.

Guardian Angel, perhaps the most ambitious piece on display, incorporates a winged figure with four sides that seem to be protecting a smaller figure from within. This symbolic protective force is grounded by four ingenious points that act as clever compensation to the matching tips of four wings that point to heaven as they pierce an open sky. Guardian Angel has a complex constructed composition that makes use of the artist's penchant for

Edwina Sandys, *Tulips*,
painted aluminum, 12 ft. height.
© Edwina Sandys.
Permanent collection of
Clark Botanic Garden,
North Hempstead, New York.
Photograph by Etienne Frossard.

opening flat planes with cut-out mirror designs that are repeated times four. As the "angel" lifts her substantial aluminum wings, a white outline accentuates the intricate patterns on the wings that seem a bit reminiscent of a butterfly about to take off.

Edwina's works do seem to soar as her subjects' arms outstretched to the sky call for a contemplative message of the human spirit. Many of her past sculptures have dealt with the outline of a woman and her relationship to man. But in this show, Edwina Sandys has chosen simplicity and mild abstraction to be the interaction between object and viewer. It is this fascinating mix of directness coupled with wit and a clever cut-out format that has become her signature style now recognized in various installations around the world.

113

Kenn Speiser

SPEISERISMS

KENNSPEISERWORKS, an exhibition at the Newport Art Museum, was a career retrospective of well-known Providence artist Kenn Speiser, a visionary sculptor who adaptively recycles the banal into the beautiful. Visitors to the show were pleasantly confronted by a dazzling line-up of cutout shapes in some way oddly reminiscent of a highway construction site gone haywire. On some walls there was a flavor of industry demonstrating practical applications for their products. The exhibition was literally packed and stacked with unique works. Speiser's interest and affection for unusual materials began to take root during his explorations into expanding a sculptural palette while an undergraduate at the Rhode Island School of Design. At this highly respected college of design, a prestigious and persuasive fine art faculty applauded experimentation without commercial application. The encouragement was enriched by the explosive creative reverberations of an "anything goes" atmosphere that followed the near-death of Abstract Expressionism. Artists began to admire the intellectual freedom of excavating novel art sources right under their unpierced noses.

Speiser particularly remembers being inspired by the visiting legendary German artist Dieter Rot, who created a topographical map of Greenland with Brie cheese, which turned into an anti-gourmet "Green-land" practically overnight. Adding fuel to the fire in this young art student's belly was the concurrent creative revolution in New York City. Artists such as Robert Rauschenberg were assembling magical compositions from urban debris, while Jim Dine was transforming ordinary tools and household objects into elevated symbols of a pop vernacular. Jasper Johns cast a pair of painted bronze beer cans that became American icons, while Claes Oldenburg transformed common objects such as toilets into soft sculpture that together with other fraternity members such as Andy Warhol — who recreated Campbell's soup cans and Brillo boxes —opened up a veritable floodgate of creative energy and acceptability.

Among Speiser's delicious experiments was using blueberry pie filling as ink for silkscreening prints, which was about twenty years before Ed Ruscha's gunpowder prints and Warhol's diamond dust profiles. Later, after leaving art school, he had a stint with Impressions Workshop in Boston, which led to his own silkscreen printing business. The nature of print repetition and the patience and meticulous skill required to succeed would leave a lasting effect on the artist's idiosyncratic signature, or even more appropriately his thumbprint.

Labor-intensive structure and precision seem to be key elements within the methodical hoops that Speiser eagerly jumps through with amazing grace and clarity. He is not afraid of taking on any process no matter how tedious or remarkably laborious to fulfill his vision. Especially breathtaking are early examples of his needlepoint ingenuity. In August (1978) the artist massed together a Noah's Ark lineup of silhouetted creatures, poetically spaced together, generating a captivating whirlwind of sophisticated design.

Speiser can jump from one subject to a completely disparate one with an entirely different stylistic approach,

incorporating the same dignity and extraordinary invention that has become a permanent "ism" for those who follow his career. There are simply no bounds for Speiser, except perhaps performance-oriented expression that does not fit comfortably within his oeuvre. Give this guy a box full of zippers and he'll produce a conjunctive dangly sculpture that has an inherent and mysterious beauty on a par with early works by Eva Hesse and Donald Judd. Throw him a bag of golf balls and he'll drive back a birdie that recreates itself into an ingenious pattern (see Balls to the Wall). In this lively show, Speiser cooked up breathtakingly beautiful "paintings" with raw materials not known for their aesthetic qualities, such as garden hoses or hacksaw blades.

In the end, it is Speiser's absolute fascination with and ability to alter common objects that are sometimes overlooked, which is his true genius. A prime example, Hook Hanger Flap, the career equivalent to Picasso's infamously simple Bull's Head (1943, made from a bicycle's handlebars and seat) takes an ordinary trucker's mud flap and turns it (and us) on end. We discover an apparition of a woman's dress form on a hanger that seems to celebrate realism — but that can only be described as a unique example of a Speiserism.

Jack Pierson

PARADISE LOST

Jack Pierson was born in the historically famous New England town of Plymouth, Massachusetts. The first white visitors to this coastal landmark who were searching for a new life optimistically thought they had discovered paradise. But as the autumn leaves fell, with only gray stick-figured tree skeletons in the sky remaining, joy turned to the horror of dashed hopes and impending doom. Since then, the symbol of their dream, Plymouth Rock, has been sadly chipped away by merciless souvenir hunters with an occasional graffiti artist painting the entire rock orange for Hallowe'en. Tourists looking for a big rock that has been a symbolic American icon have a hard time dealing with the actual, sad reality of what they discover.

Pierson may have been subconsciously influenced by this bit of neighborhood history, as he still remains preoccupied with the disasters inherent in the search for success and modern day glamour. After leaving art school, Pierson followed the Atlantic coastline he knew so well all the way to Miami Beach. It was here in the sunshine that the artist found his creative direction within the seedy charm and past glory of a famous community. The Miami Beach of the early eighties had not yet transformed itself into a revitalized city. The past splendor of this place had slid into a seamy and desperate departure from its former stature, but this is exactly what the artist needed for his comfort zone and inspiration. Great found material developed into a kind of signature for the artist, and adaptively reusing objects is still very much a part of the artist's psychological palette.

Jack Pierson exposes a part of himself in every project he creates. Sometimes shocking, often tragic and nearly always alluringly romantic, the artist routinely reinvents provocative circumstances, risking heartache tempered with loss and despair. Pierson remains consumed by the ups and downs of writers, artists and actors who, like Plymouth Rock, were chipped away to near extinction from their original fame. Consequently, "star struck" gets a new visual interpretation from Pierson, in the high or low end of the Hollywood dream.

In 1991, Pierson gambled forty bucks at a flea market to purchase four letters taken from an old commercial sign. The letters turned out to be a kind of fallen apple on Newton's head for him, as he soon realized he could finally and literally put his thoughts into the theatrical lights that so fascinated him. The first work in a hopefully never-ending series was letters that spelled out "Scarface," a reference to the Al Pacino movie that pits good and redemption and life against evil and corruption and death. The word sculpture Kurt Cobain, 1994, acknowledges a bright talent who died young. There are other remarkably visual applications to this artist's singular vision, but for this writer the utilization and manipulation of these separate letters has to rank as one of the most brilliant discoveries by any contemporary artist during the last decade.

The letter forms, which are generally welded and fabricated painted tin or formed plastic, are not just any sign fragments casually picked up on the roadside. Each alphabet form has been handpicked with a sense of history and aesthetic patina and shape. Strung together they construct a handsome and witty assemblage with what

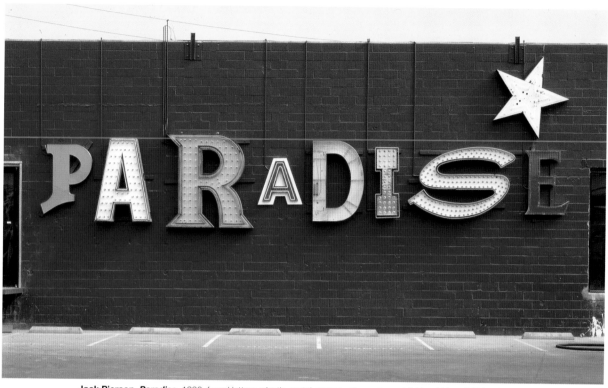

Jack Pierson, *Paradise,* 1996, found letters, plastic, metal, neon and incandescent lights, 14 in. x 540 in., 35.6 cm
permanent installation MOCA, North Miami x 1371.6 cm. © 2008 Jack Pierson. Courtesy Cheim & Read, New York

appears to be a minimum of effort. These works carry a simple message that we all recognize and ponder. Like a stage set, their front façade sparkles with nostalgia for an anxious audience, but the dark side is often caked with dirty secrets, frayed wires and spider webs.

A curious assortment of works in Pierson's exhibition, "Regrets," at North Miami's Museum of Contemporary Art, includes one large permanent installation, titled PARADISE. This phrase means many things to as many different people. Paradise to a few is a drug fix or a home in the suburbs with a heated pool. Here in America, we can integrate this giant greeting from our own perspective. Is this place a club in Bermuda, or a neighborhood bar where people escape? Pierson's giant, neon composition is made with individual unmatched hotel marquees from Las Vegas. He instinctively programmed the sequence of lights to change so that they signaled the phrase "Paradise Is--" The viewer, like in so many of his works, must fill in the blanks. The artist, choosing to remove himself from the center of urban life to create his unique visual statements, combines the past with the stark realities of today—subjects that are taboo, sexual, elusive and stimulating as he reconfigures his own sign language for all of us to decode.

Scott Peterman

CATCH OF THE DAY

Photography offers a unique advantage as an art form above and beyond other alternative media. This advantage is its singular and absolute ability to capture - in every focused and convincing detail - the human condition and the expansive, sometimes curiously mundane, surrounding environment. Great photographers have a special intuitive knack, an acquired skill and taste in finding just the right angle, light and believable moment to portray their subjects burned into a negative for multiplicity.

The best of portrait and landscape painters simply cannot refine their techniques enough to match the stark reality of a modern photographic print. Picasso's Guernica dismantled and dismembered his horrified subjects with narrative lines that permitted the viewer to sense from an aesthetic distance war victims' unreal abstract suffering. W. Eugene Smith's classic Tomoko in Her Bath, an intimate private portrait of a loving woman and her tragically deformed daughter, takes full advantage of the truth and emotional accuracy and energy that only a photograph can offer. For centuries, painters tried to instill the drama and shock of battle and death on canvas. But Weegee, the notorious first-on-the-scene journalist documenter, in Last Rites to a Milkman, along with Manuel Alvarez Bravo's bloody Striking Worker, Assassinated, created a shiver in a split second that simply overpowers alternative media. Therein lie the stark differences between a classic, perceptive, well-designed photograph and a painting. It is the photographer's unique "eye" that crafts, collects and arranges an insightful composition, full of genuine eccentric spirit that can actually convey to the viewer a strong emotional and aesthetic personal response.

Photographs can instill a visual aroma of loneliness, anger and despair. They can be sexually charged and stimulating, or by their nature provide ironic wit and whimsy.

Scott Peterman's minimalist photographs, exhibited in his first museum show at the Palm Beach Institute of Contemporary Art, have a firm grasp on the power of color images that seem to combine the simple geometry of Joseph Albers' Homage to a Square or Carl Andre's square structures with a straightforward theatrical backdrop that naturally frames the middle object with a balanced grace and beauty. Among this Maine-based photographer's works are stark, icy landscapes with surfaces that are highlighted with a temporary fishing hut—a small prison cell of sorts—locking the unseen, courageous inhabitants inside the outside with a forced solitude, providing fewer privileges and creature comforts than for your average inmate. The artist waits patiently for the perfect moment to document these tiny fishing shacks frozen in time, transforming them into ironic, mysterious, sympathetic portraits that assimilate the minimalist properties of contemporary painting.

Growing up in Minnesota, this writer experienced firsthand the seemingly bizarre tradition of precariously dragging a tiny shanty over the thick ice to a "hot spot" that may prove lucky over a five month mega-freeze. On first glance at an inhospitable community of floating outhouses, it seems inconceivable that even a few brave

Scott Peterman, *Square Pond,* 2000, C Print, 38 in. x 30 in. Courtesy of Miller Block Gallery

souls would bother. For me, the plain, chilly interiors were a form of torture. Inhabitants sit on small stools, staring down at a constantly closing frozen dark hole in which fishermen drop their lines with smelly bait into the unknown. After a day of having your shoes partially frozen to the transparent, two-foot thick ice floor, inhaling the carbon monoxide from a small heater and being sequestered into a windowless "bob-house," the idea of returning there to repeat such an agonizing experience is nothing short of painful.

So in addition to the incongruous aesthetic of a small utilitarian ad hoc square placed on a smooth white sheet of ice, there is also a device basically only available to a photographer—adding ironic emotional circumstances, however bizarre, as a surreal ingredient into the overall flavor of a picture. Like the German photographers Bernd and Hilla Becher, who monumentalize water towers, or Ed Ruscha, who documented boarded up ghostly gas stations, Peterman brilliantly and cleverly combines a geometric object akin to a natural landscape with grace and quiet dignity. Visualizing the precarious balance and relationship of man and nature adds additional reality components to these nearly spiritual portraits. Peterman often waits patiently for days to find the perfect atmospheric conditions in order to skillfully capture fleeting moments when fog or snow all but erase an entire background with a curtain of milky, magical opaqueness.

This young artist carefully manipulates the photographs by under and overexposing them in the darkroom, offering a rich painterly effect, like a vintage Rothko whose canvas is accidentally dipped in bleach. Eliminating evidence of individuals and leaving the perceived inhabitants' personalities to the scant marks or architectural blandness of the cold exteriors, the daily visual clutter of modern society makes these refreshing images an oasis for our eyes and our soul.

Ray Charles White

CAUGHT ON THE FLY

In Florida, we are surrounded by water on all sides. If we travel on any course except north, we will eventually hit a penetrable liquid border that shifts slightly each day as it has done for millennia. For most of us, if you've seen one ocean you have seen them all, but it is the visionary artist who seeks out and documents those subtle differences and idiosyncratic details that show the rest of us what we have missed if we blink at the wrong moment. Ray Charles White has been investigating the opportunities and challenges of photography since he was eight years old, when he began working in his father's darkroom. At twelve he had a photograph published in Sports Illustrated and soon afterward became utterly fascinated and committed to becoming a professional photographer in New York City. When he arrived in Manhattan from his native Toronto, he immediately set out in all directions to perfect his trade by chronicling many of the cultural heroes of the art world, from Roy Lichtenstein and Henry Geldzahler to Leo Castelli and David Hockney. White's infectious sincerity and literal focus on his subject matter helped him break through into a world overpopulated with photographers and undersupplied with real opportunities for success. Somehow, somewhere along the line, Ray Charles White has instinctively figured out what he needed to acquire in terms of meaningful experiences and professional connections. For a time he shot distinctive portraits for Andy Warhol's Interview magazine. He also recorded the difficult, fast-paced stage imagery of rock bands from Rush to KISS, and started to uncover the secrets of what constitutes a great photograph that would also coincide with his own vision and signature style.For a time he shored up his technical ability through academic excellence with Ansel Adams in Yosemite, but his big break came when he met Henry Geldzahler, the legendary curator of 20th Century Art at the Metropolitan Museum of Art, while he was living in Southampton. Geldzahler was an influential tastemaker who had a reputation for spotting genuine talent and for urging young artists to explore their ambition and vision. Geldzahler observed that White's special grace as a photographer was his instant and instinctive identification with his subject, and that nearly all of his best work occurred in the very first minutes of the initial session. White seems to know that in life, especially as an artist, you must follow your natural instincts to develop a truly unique visual vocabulary. Portraits and pictorial journalism seem to have given this photographer the perspective he needed — not just for registering images of art world achievers from his frame of reference, but in understanding the details of human nature and how one goes about finding that true decisive moment that is perpetual and meaningful. If the tides are timeless, then White's detailing of the oceans encapsulates a split second that becomes frozen forever. This profound photographer, collaborating with the Master Printer, Jean-Paul Russell of Durham Press, has the uncanny ability to mix simple straightforward images of water—calm, restless, transparent, dangerous, reverberating, exotic and rhythmic—while assimilating the same sensibilities of modern color field painters.

Ray Charles White, *Surface Tension,* installation view, enamel on anodized aluminum, 80 in. x 150 in. © Ray Charles White. Courtesy Durham Press

Ray Charles White's eye-opening work is hands down one of the most provocative and breathtakingly beautiful examinations of elusive water patterns ever captured on film. White has painstakingly become the photographic equivalent of legendary color field painter Jules Olitski, with a narrative and recognizable fresh twist. White has dug deep into the historical significance and utilization of certain characteristics of modern art and contemporary painting by focusing on the exuberance of illusional texture on the water's surface. In Concentric I, II, III, the photographer zooms into a square foot of water, packed with vibrating explosive raindrop circles that bring to mind Kenneth Noland's minimal, color-stained target paintings. His simple horizontal works on aluminum, as in Calm (2000), are starkly beautiful and bring to mind early painterly works by Larry Poons and Helen Frankenthaler. In Echo, a half-sister image to Calm, the recognizable sea surface has all but disappeared to reveal a handsome abstract graceful pattern. One of his most memorable works from this exhibition is Surface Tension, (2000, 80 inches x 150 inches) enamel painted on aluminum that presents an identifiable portrait of an ocean's surface in twenty interlocking squares leaning tightly together like Carl Andre's lead tiles or Albers' Homage to the Square. As each texture is different, but from the same salty source, there is an unusual design tension that jumps from one square to another like an undersea checkerboard. In Aquatic Study, a reflective water plant depiction, White takes his cue from the best of Abstract Expressionists such as Willem de Kooning and Franz Kline by delicately "painting" balanced poetic stem lines with mirror images of stylized leaves to produce a perfect picture. There are no gimmicks or preordained compositional references here, only an instantaneous moment when a photographer's radar sizes up his subject and presses down the shutter button to capture in the tradition of Cartier-Bresson a fraction of a second for all time.

Candida Höfer

AFTER HOURS

Since the invention of photography, the desire to create documentary images propelled early pioneers of this new medium to re-examine and further explore every detail of their expanding environment.

This popular creative tool quickly replaced drawing, engraving and painting as a more accurate and instant device to record our urban surroundings. Pioneering photographers realized that they could literally capture history in the making with a machine that was far more precise than the eye and hand. The slightly misleading romantic manipulation and stylized interpretations of the built environment on canvas simply was no match for the precise, unalterable, pre-Photoshop truths of a film negative.

Many of the earliest photographic images quite naturally were of historic structures—some in danger of disappearing—that demonstrated the power of photography to preserve and study the architectural heritage of mankind. Whether it was the façade of an Egyptian tomb, the seats of the Colosseum or the construction of new building projects, these images allowed the rest of the pre-industrial world an accurate glimpse of strange and never before seen places and spaces. Later, the invention of the inexpensive, mass-produced souvenir postcard album brought fascinating façades and ornate public interiors from around the globe back home to a curious crowd. The world was opening up through photography. Journalism quickly adopted the photograph, which could be developed over night and conveniently pressed into newsprint for the next day and into the eager minds of its readers as an instant visual communicator without words.

For decades, photographers have continued to be fascinated with their personal ability to capture on film this rapidly changing world—the old and the new together—first as a straightforward commercial account, and later as an expression of creative examination that evolved as a bonafide work of art. Candida Höfer, the celebrated German photographer, has continued a tradition of interior documentation and investigation as evidenced in her first North American survey exhibition at the Norton Museum of Art, titled "Architecture of Absence." Over the last thirty years, Höfer has created meticulously composed images of the interiors of public and institutional spaces, which are filled with the evidence of human activity, yet completely devoid of human presence. There were fifty large-scale chromogenic prints in this rich exhibition, which embraced the full spectrum of the photographer's illustrious career, with an emphasis on recent work. Notably, most of the pieces have been borrowed directly from the artist's studio and her gallery in Cologne, which offered a unique opportunity to present the best of her vision as well as iconic pictures that have never been shown in the United States.

The exhibition traced the aesthetic and technical development of Höfer's photographs and skyrocketing career over the last ten years, but also explored large-scale images created over the course of three decades, underscoring the artist's continued fascination with inhabited spaces—some simple and some ornate—that allow us to have an idiosyncratic and calculated subject framed by a camera's lens with an artist's eye. With this show, Höfer

Candida Höfer, *U-Bahnstation Theaterplatz Oslo II,* 2000, C-print, 60 in. x 60 in. (152 cm x 152 cm). © 2008 Candida Höfer, Artists Rights Society (ARS), New York

secured her position as one of the most prominent photographers working today, who delights in the "magical presence of things" and the sometimes overwhelming spatial encounter that viewers experience with her works. The giant photographs on view oscillated between the ethereal glow of light-filled modernist spaces and the super elaborate decoration of Baroque interiors. Höfer has obviously concentrated on a complicated geographical hunting expedition to capture just the right images of libraries, academic facilities, lecture and performance halls, galleries and waiting rooms, captivating for their minimalist formal qualities of precise composition. The artist also interjects a saturated color only possible with a darkroom's chemicals and often denotes a rhythmic pattern found in library shelves and decorative façades. The artist here jumps beyond buildings as mere objects, but sees them as self-enclosed time capsules—like scientific containers on a shelf complete with labels that preserve diverse architectonic evidence of our global society and its enriching achievements. These interior blueprints, decorated and well-lit, emphasize the entrances and exits, stages right and left, foregrounds and vanishing points that are the foundation of many contemporary paintings. Add in the other components of Höfer's signature style, such as patterns, utilitarian order, horizontal and vertical lines, streamlined shapes and forms, stark photorealism, diffused light and reflection, and the cross-pollination and influences of other artistic disciplines become clear.

In Bourse du Travail Calais IV (worker's stock exchange), 2001, Höfer submits a modern day Roman forum, complete with lower spaces for wandering beasts. The harmony of the picture is enhanced by the plush, dark brown, covered seats next to a maroon, curved stucco wall illuminated by ten round lamps. The natural order, geometry and roundness of this perfect, secret, sectioned interior is reminiscent of a beehive without the buzz.

In Stadtcasino Basel I (city casino), 2002, a starkly handsome, white performance hall supports a center platform, upon which rests a large black baby grand piano that acts as a magnet, pulling at dark rows of velvet seats to form a kind of robotic audience staring at the empty chairs on stage.

In Wikingmuseum, Oslo I, 2000, Höfer takes the handcrafted lines of a Viking-like sculptural boat from the cold waters outside to the warm Saarinen-like shrine inside, lit by two rows of brilliant square windows. The composition is memorable for its absolutely perfect symmetry, its confrontational spirit and the poetic balance between the hand-built texture of antiquity and the posh simple spaces of a modern museum. After a continued inspection of the large framed squares within the Norton's exquisite gallery setting, it became even more important on how these images gather bits and pieces from contemporary painting, as well. The same inventive twists and surprising turns in works that you might see in a Chelsea gallery are hidden and saturated in the vision of Höfer.

F. Hoffmann-La Roche AG Basel I, 2002, looks like it might have received its inspiration from a Pop Art Kleenex box in the shape of a surrealist bunker devoid of just about every detail, except for two adjoining exits. It is this complete systematic absence of clutter and embellishment in so many of her pictures that is so unforgettable. Assimilating scraps of prior triumphs, as in Karl Blossfeldt's superb examples of straightforward flower studies, or August Sander's stand-up no frills Sunday best portraits, and certainly Bernd and Hilla Becher's iconic depictions of water towers and grain elevators, builds strong compositional bones, stirs the blood a bit, and generally for most artists, including painters, strengthens the confidence to go beyond one's predecessors.

So if the undercurrent and subliminal effect is not enough, Höfer in one photograph has unmasked literal impressions and inspiration in the 2003 C-print Van Abbemuseum Eindhoven III, in which she strips everything away except for two transparent glass squares that reflect one's own image while paying homage to another.

The square within a square and two square shapes together was also the high water mark of the German painter Joseph Albers' "Homage to the Square" series. But if this tip of one's hat is insufficient, Höfer offers a bookish literal peek into the world of art with her double-squares filled with museum coffee table publications on the works of Georg Baselitz, Louise Bourgeois, Kurt Schwitters, Gerhard Richter, Giorgio Morandi, Andy Warhol and others.

In her revealing catalog essay, Virginia Heckert, the celebrated former curator at the Norton (now at The Getty in Los Angeles), observes, "Höfer's photographs of architectural interiors create a balancing act between a variety of extremes, oppositions, or tensions: elevation and perspective, absence and presence, public and private, structure and detail, minimalism and effusiveness, functionalism and aestheticism, objective and subjective vision. While Höfer's work is informed by a variety of aesthetic traditions familiar to us through her association with the Becher school, insight can be gained by relating her imagery to the more pragmatic tradition of architectural photography, which has a history as long as that of the photographic medium itself and which, from the beginning, learned to strike a balance between commercial and aesthetic concerns."

Leonard Nimoy

BLINDED BY THE LIGHT

Good and evil are familiar themes to Leonard Nimoy, actor, author, poet and serious photographer. As a young boy in an orthodox synagogue he observed that Kohanim in his shul in Boston split their fingers in a "V" sign as they administered the priestly blessing to a devoted congregation. His father explained they were forming the Hebrew letter "Shin," and by wrapping themselves in a spiritual cloth called a tallitot were able to hide from the Shekhina, whose blinding light was apparently too intense for man to view. Years later, as the alien character "Mr. Spock" on Star Trek, he fought evil extraterrestrial space battles that incorporated an occasional bright beaming light that enveloped their ship. But more specifically connected to his religious background was his reuse of the "V" sign as Spock's iconic Vulcan greeting, along with his solemn entreaty to "live long and prosper."

For centuries artists have incorporated religious theory and subject matter into their paintings. Contemporary photographers like Robert Mapplethorpe and Andres Serrano painstakingly explored taboo subjects, with inherent subliminal sexuality, peppered with a distinctive grace and dignity. Mark Rothko spent an entire lifetime creating paintings that celebrated a mysterious spirituality by mixing delicate washes of color, which seemed to spin around a square into infinity. Late in his career, a haunting depression was reflected in the dark and forbidding colors that appeared in his last group of paintings prior to the artist's suicide. Harry Callahan, the late photographer, also had an uncanny spiritual sense when it came to figures in space. His subject was almost always his beloved wife Eleanor, who he would isolate as a small human object surrounded by life. His simple portrait of his life's partner, perhaps his most famous, shows a woman floating in a body of water with her eyes shut and her hair drifting with the tide. It is a photograph that Nimoy happens to own, which may have offered him a clue to opening the illustrative puzzle of black and white spirituality.

Like Callahan, Nimoy has painstakingly devoted his research and darkroom time to exploring a woman's spiritual glory in the flesh. This search has drawn the photographer closer to the sensuous and seductive aspects of his subjects—draped, bathing and sometimes asleep. Like the legendary French photographer Henri Cartier-Bresson, he has captured her in unguarded moments of meditation and rest.

Nimoy has harnessed his intellectual curiosity and creative energy into a beautiful collection of black and white photographs. The exhibition at the Armory Art Center, "Shekhina—Photographs by Leonard Nimoy," presented a photographic journey into Nimoy's Jewish roots and a singular exploration of another form of outer space surrounding the feminine aspect of God. Some of the images seem to be lit from within, full of spirits guided by an invisible wind, and have developed a metaphorical connection to their power as life giving symbols of Shekhina. One dramatic image portrays a pregnant woman holding a powerful light source, revealed to be her

Leonard Nimoy, *Pregnant Shekhina,* 2000, original size 14 in. x 11 in. Image by Leonard Nimoy. © Leonard Nimoy

baby. Other compositions are reminiscent of the Abstract Expressionists' structure for cultivating a lyrical and poetic dancing line or forms that create balance and stark beauty.

Nimoy's provocative images of women interconnected with nature suggest their powerful role in the bond between one's life and spirit. It was curiosity that persuaded the young boy to peek from under his religious garb at the mysterious piercing light. And it is curiosity that propels the modern photographer to keep exploring uncharted territory that marries an odd balance of aesthetic principles with religious significance. Nimoy has somehow elegantly captured an eerie, elusive and invisible sensitivity with his camera—a perfect creative tool that captures a bright light during the blink of an eye.

Nimoy has utilized a camera to pursue his investigation into the mysteries of the Shekhina. The photographer always imagined her as omnipresent, watchful and often in motion. What you walk away with after viewing these photographs is the realization that artists have the creative power to follow through art their own individual spirituality, which strengthens an overall vision for each of us to consider.

William Wegman

SIT

Some artists stumble across a good idea after a long period of pre-meditated analysis or a lengthy submersion in the studio looking for a creative answer that must come from experimentation. Others trip over a visual circumstance quite by accident and find that they can build successfully on one basic idea for a long time. Giorgio Morandi, the celebrated Italian painter, was seduced by the simplicity of tin cans and other cylindrical objects, and he ended up painting basically the same compositions over and over for more than thirty years. Artists have an instinctual knowledge that once they become familiar with their subjects, an endless array of possibilities presents itself for execution.

In the late sixties, John Chamberlain embraced automobile parts for his sculpture palette and hasn't let loose to this day. Haim Steinbach began placing common household objects on a triangular wooden shelf, a theme that decades later he continues to explore methodically. Giuseppe Arcimboldo, as early as 1568, decided to use fruits and vegetables exclusively as compositional fodder for magical head and shoulder portraits that became his lifelong preoccupation. And so with this eccentric variety of subject matter, refined and dissected, these artists also became well known for the singular topic they continued to explore throughout their careers.

Fortunately, William Wegman is no exception to this rule of thumb. In fact, his subjects, the beautiful breed of hunting dog called Weimaraner, became more recognizable than the artist himself. His exhibition at Florida Atlantic University's Ritter Art Gallery titled "It's a Dog's Life: Photographs by William Wegman from the Polaroid Collection," intentionally explores the premise of the artist and the preoccupation with the variations of only one basic subject matter. For almost twenty years, the artist, Wegman (b. 1943), has been producing amazingly inventive large-scale photographs with the 20 x 24 inch Polaroid camera. It all began in 1979, when the artist — already well known in the art world for his wry video and conceptual photographic work — was invited by the Polaroid Corporation to try out an unusually large-format camera that had just been invented. When Wegman and his sidekick, Man Ray, the dog, traveled to Boston to utilize the camera for the first time, a remarkable collaboration was launched. After Man Ray died in 1982, Wegman continued his exploration of the medium with non-canine subjects. Later on, he began to work with Fay Ray, his new Weimaraner, and an expanding universe of her progeny.

Wegman is best known and respected for his color photographs of Weimaraner dogs dressed and posed in a variety of settings. His slapstick straight-faced directing of posed, costumed dogs has made the breed the most famous, permanent mascot of the art world. In fact, even Middle America associates these beautiful creatures as subjects of a photographer, though they may not know his name. In the same way we associate a Brillo box with Andy Warhol, a Klansman with Philip Guston or a beer can with Jasper Johns, a brown Weimaraner will always connect instantly to William Wegman.

William Wegman, *Connector,* 1994, Polaroid, 24 in. x 20 in. (60.96 cm x 50.8 cm). Private collection. © William Wegman.

With a strong background in video and photography, the artist has a natural sense of orchestrating a simple image positioned and costumed in multiple ways. At just the right decisive moment with a super-cooperative dog, Wegman snaps away in a seemingly unlimited universe of replacing man with dog in a surrealist world of domestic activities. Poses range from riding an exercycle, sitting at the dinner table, floating in a boat, to lying in a comfy bed in front of a romantic, lit fireplace. Wegman turns out handsome, evocative, non-human portraits that are on a par with Richard Avedon and Diane Arbus and that have become American icons.

In one photograph, Man Ray & Mrs. Lubner in Bed Watching TV (1981), Wegman sets up a hilariously familiar domestic routine with two subjects peering blankly at a television. At second glance, you notice the cabin's outdoorsy atmosphere that seems like it might be a scene from the David Lynch movie "Blue Velvet," complete with a staghorned peeping Tom peering through the window, surrounded by taxidermy on the headboard and an owl on the side — none of which look particularly happy.

In the late 1980s, Wegman pre-empted a lot of artists who came later by acquiring secondhand store cloth materials and draping the printed fabric over his dogs, exposing scenes on a version of a small outdoor drive-in movie screen. Colorful repeat patterns on cotton of waterfalls, ships, birds and invented fauna, which were originally headed for the family room couch, become ambulatory advertisements that carry their own aesthetic with a Rauschenbergian twist. In some instances, Wegman has covered the entire dog, including exposed paws, to form an odd hybrid of origami and high fashion that pre-dated by twenty-five years a recent auction record of a sculpture by Maurizio Cattelan of an elephant covered with a cloth, with cut holes for the eyes. A steadfast, cooperative model certainly didn't hurt. And for Man Ray, the super model and most famous dog photographed in history, the journey was nothing but fun and fascinating as he cavorted near his master's side — obedient, helpful and courageous as man's best friend.

This was a fine exhibition that celebrated the inventiveness of the human spirit and the love and admiration between a man and his dog. The results are doggone wonderful.

129

Peggy Greenfield, *Sweet Memories,* ceramic with fired glaze transfer images, 14 in. x 6 in. x 3 in. © Peggy Greenfield Courtesy of Paul Fisher Gallery, West Palm Beach

Peggy Greenfield

GREENFIELDS AND CLAYBEDS

Artists have been manipulating and forming clay objects made from the earth for a long, long time. In fact, pot making was one of humankind's first inventions, and the durability of fired clay remains one of the best kept records of the beginning of culture. Obviously, no one can precisely pinpoint the exact circumstance where clay was pushed and shoved into a usable form. But it does seem quite plausible that creatures with a maturing intelligence at some point hungered for a better way to bring water into their mouths without cupped hands and a wet chin; all it took was one inventive tribesman to connect the logic of a water holding object like a sea shell or a ram's horn to hand-building a rough replica of a functional container. The earliest known ceramics date to about 10,000 BC in parts of Asia, with other evidence from the Middle East dating to about 6,000 BC. All of the initial work was earthenware with no glaze. Many of these early vessels had the texture of basket weave embossed in the surface, a tradition that artists continue to utilize even now. As the clay expanded slowly into different directions and more realistic inventions were discovered, glazes were added to give this earthenware a distinctive appearance, practicality and longevity.

For centuries, pots were made by hand with rolled coils and fired on the ground in bonfires. And then somewhere along the line, about 4,000 BC, hand-building took a quantum leap to the mesmerizing spinning top of a wet potter's wheel that changed the nature of ceramics forever. In the beginning stages of production, potter and artist could affix his mark under a fine jug of olive oil or a cooking crock, but the opportunities and motivation for self-expression were limited. But as the medium matured and traveled beyond utilitarian borders, artists creatively explored this material's potential in a variety of forms and expressions. Today, artists following some of the same basic traditions founded thousands of years ago are going far beyond initials on the underside of a pot.

Peggy Greenfield is a ceramic artist with a deep respect and understanding of the history of clay. In a solo exhibition at the Liman Studio Gallery in Palm Beach, Greenfield displayed an exciting array of hand-built sculptures that have found a delicate balance between the old and the new.

In her series of wrapped figures, the artist takes snippets of the past reminiscent of Egyptian tomb figurines and brings them into the twenty-first century with a newness that keeps her work fresh and invigorating. In Waif with Banded Cowl, 2006, Greenfield has pinched together a convincing young figure hiding under a long drape that is patched and buttoned, pseudo-sewn and sliced, and painted with earthy stains, complementary oxides

131

and harmonic glazes. In this series, the artist seems to capture a moment of integrity and warmth with an almost invisible contrapposto stance. This series celebrates the great history and tradition of creating figures out of clay that may go all the way back to biblical mythology, where our own shape purportedly was formed with handfuls of clay.

Another series, which may have gotten its inspiration from an industrial glove form, commemorates the tradition of crafting parts of the body into storytelling platforms that are both serviceable and whimsical. Among the most memorable works in this lively exhibition are a series of ceramic hands and connected forearms that serve as a kind of canvas for decorative patterns, which recall early decals that were transferred to window surfaces and craft projects. In this impressive line-up, Greenfield takes a hybrid clue from a mix of surrealism, pattern and decoration and post-Pop imagery and makes it fit naturally like a kid glove. In these standing up right hands that seem to reach for the stars, intimate vignettes appear along the arms, which float upwards to the fingers all neatly covered with transfers of flowers and other related objects. In the work Green Thumb, Greenfield has used the clay from mother earth within a double metaphorical context, covered like a New England garden with a rainbow of flowers. This sculpture might serve as the Academy Award prize for superior gardening in a supportive role, complete with a painted green thumb.

Peggy Greenfield seems to enjoy looking back at contemporary history to blend in the old with the new. In a series that is the sleeper in a wide awake show, the artist has meticulously recreated a children's building block set like those used to the learn the alphabet, the results of which are handsome and witty. In one small block, measuring four inches square, a monkey image has been transferred and then aged and sanded to lend a convincing patina. Florida flamingoes frolic in the Intracoastal beneath a checkerboard pattern that adds just the right balance of simplicity.

This unique transfer procedure is a result of trial and error in the studio, where this artist is pushing creative barriers in ceramic art. Greenfield's signature work is her celebrated robes, where she received her first real recognition. These objects, which appear in different contexts throughout art history, are dramatic and full of symbolism. During the artist's laborious investigation, an evolution of singular techniques began to emerge that are now identifiable trademarks on their own.

A series of black stoneware forms with a spiritual essence were on concurrent display at the Paul Fisher Gallery, West Palm Beach, where they complemented new glass works on view by Dale Chihuly. In this fascinating installation, Greenfield confronts the visitor with a group of gravestone-like shapes that stand at attention like a Chinese honor guard. Here in a minimalist-inspired composition, these pieces have a common denominator of simple outlines, a deep black, harmonious color and hand-embellished textural surfaces that seem like curious hieroglyphics. Memories is the title of this collection of seventeen stoneware works, measuring from approximately six to twelve inches high. These striking objects evolved from the artist's slim, slab built vessels that she has been creating for years. The pieces also play with the traditional pottery concept that clay is for building utilitarian "pots." But these sealed vessels fool the eye and present only a slightly expanded silhouette of their useful cousins without an entry or exit. In addition to a contemporary homage to ancient tradition,

Peggy Greenfield, *Green Thumb*, ceramic with fired glaze transfer images, 14 in. x 6 in. x 3 in. © Peggy Greenfield. Courtesy of Paul Fisher Gallery, West Palm Beach

the artist seals each separate work to contain its secret history. The imprinted abstract textures in squares or circles represent one's own experiences, whether monumental or trivial. The smooth "roads" down the middle of each piece reflect the infinite paths we follow. Greenfield enjoys the challenge of stimulating the viewer to think about their own histories and backgrounds, and to escape their real worlds by exercising imaginations and recollections. It is clearly evident that process is integral to the artist's work, but at the end of the day, it is Greenfield's informed imagination and her willingness to explore risk with the nuances of her art that ultimately guide her hands to form a three-dimensional language that is all her own.

Jim Leedy, *Untitled Stilted Vessel*, 1953, low-fired stoneware with resin glazes, 9 in. x 6 in. © Jim Leedy. Courtesy WeissPollack Gallery

Jim Leedy

FIRE IN A BRICKYARD

One of the benefits of the Palm Beach Contemporary art fair held in the Palm Beach County Convention Center is that you can expect the unexpected. The Jeffrey Weiss Gallery showcased the splendid ceramic work of Jim Leedy, a legendary figure whose work on view was surprisingly fresh and inspiring and for many a real eye opener.

Almost every professional artist who has gained a measure of success and personal satisfaction can point to a moment in their early childhood when an influential spark of experience, encouragement and one's home environment propelled them in a comfortable direction packed with destiny. Jim Leedy's maternal influence began, ironically, before he was born, in a womb with a view to the outside world nourished by his mother's overwhelming desire to eat clay. In rural Kentucky where he was born, and in adjacent states, some folks were said to have a taste for the rich dark earth, which possessed qualities of sustenance and appeasement for an appetite that could not be satisfied with standard fare.

Getting close to the earth is a primitive impulse that early cultures instinctively worshiped. The mud people who populated remote tribes in Africa literally covered their entire bodies with clay as a way of connecting to the earth and the raw natural beauty of its brown tones. Even the Old Testament in Genesis portrays man's beginnings as sculpted from earthen clay, purportedly shaped in God's image. Man was then brought alive with breath warm like a late summer's wind that acted as a catalyst for existence. Since the beginning of mankind, the earth's soil has been his foundation for growth and survival. Seeds dropped into the ground would later provide a continuing cycle of life. So it is not surprising that early man began to fashion instruments out of clay that held water and food and continued his mystical attachment to the earth. Later, the Egyptians formed miniature human images out of fired clay to help carry them comfortably into the afterlife. For centuries, utilitarian vessels made from clay were produced by a multitude of cultures — both prehistoric and sophisticated—and almost always were decorated with a simple engaging design whose natural qualities would last forever.

As a boy, James Allen Leedy was brought up in Kentucky, Virginia and Montana with roots deeply implanted in rural America. He surprised his parents with a drawing of a dog before he was a year old. With a mother's gentle touch of encouragement and an intuitive desire to create things, he was destined from birth to become an artist of international renown.

As luck would have it, the artist grew up near a clay pit and brick factory that allowed the small boy an unusual opportunity to fire his handmade objects. The smell of the earth and the flames from an industrial kiln warmed his heart and the aesthetic senses that would continue building throughout his life.

Like most young artists, Jim Leedy moved around a great deal, observing life and finding his direction. He spent a tour of duty in the Korean War as a photojournalist; his encounters with tragedy and social conditions as seen through a camera lens would influence his motivation and vision forever. Like the youthful good luck of finding a "studio" facility in his own neighborhood, he was also fortunate to follow his passion and inquisitive disposition to New York at the beginning of another important genesis: the postwar New York School. In the dusty downtown loft studios of Manhattan, as early as 1950, Leedy recognized that material mastery could lead to considerable breakthroughs that would allow him to begin making a unique path into the history of contemporary ceramics.

The excitement of the Abstract Expressionist challenge to convention seduced the young Leedy with its freewheeling visual poetic style and endless possibilities. The multi-talented artist jumped into this newly formed fraternity by creating his own competent singular canvases, where occasionally he added clay fragments to the surfaces, predating Julian Schnabel's technique by about thirty years. Two hundred years after Conrad Link (1730-1793) fashioned a two-foot high multiple-figure group in porcelain called Victory of Beauty Over Envy, Jim Leedy discovered that by creating stoneware sculpture in carved sections he could produce clay works of great height and visual impact. Ceramic artists like Michael Lucero and Robert Arnson arrived at this construction discovery only years later. It's important to realize that Leedy's earliest stacked totems were at the time unprecedented in American ceramics for their height, which must have created a mysterious curiosity that became a pioneering icon.

Even with the propulsion and centrifugal force of a new brand of painting, Leedy's true calling in ceramics persuaded him to apply the basic concepts of Abstract Expressionism to clay. His historic innovations in ceramics as early as 1953 were molded by his continuing friendship with Peter Voulkos and Rudy Autio and regular discourse with downtown painters who celebrated spontaneity and subjectivity. It was also fueled by his investigative studies at Columbia University in European and Asian art history—an unusual but beneficial decision. His graduate work with James Fitch and Meyer Schapiro introduced him to both western and European traditions. Splicing these valuable academic experiences together with the vitality of the new epicenter of the art world, coupled with hundreds of hours spent at the Metropolitan Museum of Art, prepared Leedy with a cultured eye and a confident response to the art of the day.

The icing on the cake, like a soft pastel slip on a teapot, was meeting two legendary personalities at the Cedar and Dillion bars, Willem de Kooning and Franz Kline. The remarkable combination of these early encounters propelled Leedy into exploring his true love, ceramics, with the gifted sense of an abstract thinker and the intellect of an art historian. Although Leedy still continues to paint beautiful pictures that are on a par with others of his generation, his ceramic plates and vessels are to this day remarkable works of clay sculpture.

Leedy is absolutely the finest living abstract ceramicist on the planet. A statement so laudatory requires some convincing arguments and observations, which in his case are easy to make. Take for example Slab Vessel and

Abstract Expressionist Shang I (1953), both hand built low-fired stoneware with a resin glaze. These two works are so engaging and fresh that fifty years after their creation the objects remain dazzling sculptural compositions. They are full of beautiful twists and turns and integrated color that is somehow magically combined so that the material and the design become one. An intelligent argument can be made on these two pieces alone that Leedy will continue into this new century and beyond as the de facto Picasso of ceramic art. He's an artist who has crossed all boundaries in his search for elegance, experimentation, riveting formations and engaging color harmony.

Following this logic further, one needs to carefully examine his series of simple raku-fired round shaped stoneware, which seems to have gelled in the mid-1960s. These works are amazing in their stylistic conformity, which has remained consistent for nearly forty years. Expressionist Plate with Blue X (1969, Philbrook Museum of Art), demonstrates the singular skill of an artist who on a rough clay surface gives a hierarchy of painters like Guston and Brooks an honest to goodness run for their money. Untitled Plate (1993), only 21 by 29 inches, displays an expansive design activity that is more engaging than a Motherwell or a Miro and is miles ahead of most production by non-narrative painters of the eighties and nineties. Stilted Abstract Expressionist Plate (1953, pit-fired earthenware), equals in inventiveness and vitality any color field painting, from Frankenthaler to Rothko to Morris Louis. Throw in the singular texture, the porcelain-like cracking and a sandy swirling surface spinning like a Frisbee into outer space and there isn't really anything more you can ask for.

Now at the very height of his illustrious career, the former baby with clay dust near his crib continues daily to explore the open-ended dimensions of his honorable career brick by brick with a calm, comforting energy that has persuaded art historians and critics that he is the absolute genuine article—a national treasure and a cause for continued anticipation and celebration.

Jim Leedy,
Stilted Abstract Expressionist Plate,
1953, pit-fired earthenware,
13 in. x 12 in. x 4 in.
© Jim Leedy.
Courtesy WeissPollack Gallery

137

Craig Bone

BONES TO PICK

Long before the footprints of Cro-Magnon man began to make curious impressions in the moist, rich soil of central Africa, a virtual wandering universe of paw prints crisscrossed the continent in a never-ending pattern that still remains today. As the evolutionary ladder continued to strengthen and spread in all directions, individual species developed into distinct categories. It's hard to imagine that the bloodlines for all this activity began with a single cell that split apart and wiggled around for centuries, until appendages appeared that helped propel small creatures out of the primordial ooze and onto the beach.

This slow process of evolution continued quite nicely as nature streamlined itself into practical, utilitarian and ambulatory shapes covered with fur, which produced amazing speed for a quick escape or a sneak attack. Different animal groups banded together to maintain safety, especially in numbers, as they migrated in search of nourishment. Animals definitely and defiantly ruled the earth. The proud king of the jungle with his shiny regal robe and beautifully proportioned body constantly surveyed his subjects with a confident stare.

As mankind followed his distant relatives' lead and inherited instincts to survive, it was only a matter of time before he went beyond the safety of a cave and out into plain view of the dangerous open skies. Later, after substantial trial and error, certain plants and small animals were identified and passed along as ready made food sources that sharpened the skills of hunters and gatherers. And so, perhaps it was inevitable that humankind eventually discovered an inner creative force that allowed a limited intellect to represent itself as a primitive albeit recognizable interpretation of life. In some early groups, particularly those found in protected caverns in the south of France, it appears that individuals with inventive instincts were able to "capture" their intended victims with repeated charcoal images scratched into rugged surfaces. These first preferred subjects of early man have continued throughout art history to provide us with an exciting visual record of man and beast.

At an early age, Craig Bone, a native Rhodesian now living in the United States, was mesmerized by the exotic animals that shared the African landscape with him. The artist has since carried on the respected and enjoyable tradition of replicating nature and wild creatures onto stretched canvases and multiple prints. In his exhibition at IAG Galleries in Naples, Craig Bone presented a breathtaking array of animals that honor the ongoing beauty of beasts in their natural habitat. He raised the artistic bar even higher with his intimate studies of large elephants, whose stare becomes almost hypnotic. In this latest series covering bold new ground, the artist has come up close and personal while communicating with one of the most fascinating and intelligent creatures on earth. Successfully placing a profile of a five ton animal on a five pound canvas is at the very least a challenge, but here it seems more like a labor of love. Perhaps it is the remarkable familiarity of the artist with beasts from the wild that has made these hyper-realist works so believable. In the large-scale painting, Outside View, the artist has taken a mighty subject and gently pulled it into the picture plane to increase the drama and illusion of an animal that seems to have almost come to life. By positioning the elephant in the center of the canvas, he is able

Craig Bone, *Outside View,* 2007, original oil on canvas, 71 in. x 27 in. © Craig Bone. Courtesy of IAG Galleries, Naples, Florida

to utilize a large brown eye at the top center of his composition that immediately becomes a focal point.

Is this handsome elephant that never forgets trying to communicate with his gaze? A further study allows the viewer to wonder if the expression is of sadness or a gentle reminder of his strength and power. In another painting, Mr. Bone steps up to the bat with an even more severe cropping design where no hint of the environment can be seen. Here the artist concentrates upon the eye of an aging elephant that is framed by a gray-brown pattern of textured skin, reminiscent of a drought stricken former lake. Horizontal lines etched deep into the elephant's skin begin to form a natural plaid pattern that connects with even longer vertical lines that set up a rather contemporary design. In another painting from this new closer than close series, the single eye of a zebra peers out as it watches for danger. Black and white bands of stripes and patterns are utilized in this work that has an almost dizzying effect on the observer. The remainder of the exhibition demonstrated a kind of encyclopedic documentation of the artist's mainstay subject matter of jungle cats ready to pounce when the time is right.

Craig Bone insists on camping out in the wild, waiting patiently for the opportune moment where he can snap a photograph at close range for reference later on. His notebook is like a da Vinci code for artists in the jungle, with quick gestural sketches and notations of backgrounds and times of day. In his Coral Springs studio, Bone reassembles his visual research like a storyboard for a motion picture. Generally, he will begin with a wash of sky that will act as a dramatic backdrop for his parade of untamed beasts. After the sky has its first coat and a foreground begins to take shape, the artist goes through his inventory of photographs to reconstruct a meandering herd from memory. In some cases, particularly for clarity and compositional improvements, Bone will rearrange the original scene, bringing some of the animals closer to the foreground while separating others for an unobstructed profile that adds a better dimension to the painting's structural elements. After deciding where each subject should be placed, the artist outlines an image from a photograph he has taken. This technique allows him flexibility in his decision-making process, as the working sketches can easily be moved or repositioned entirely without having to scrape off a painted area and start over again. And so, at the end of the day, whether it be sitting on a sturdy cypress branch high above a gator's smile or bracing for a gray elephant's threatening charge, Bone's extraordinary passion and lifelong dedication for documenting the wild becomes a visual gift for all of us to ponder and enjoy.

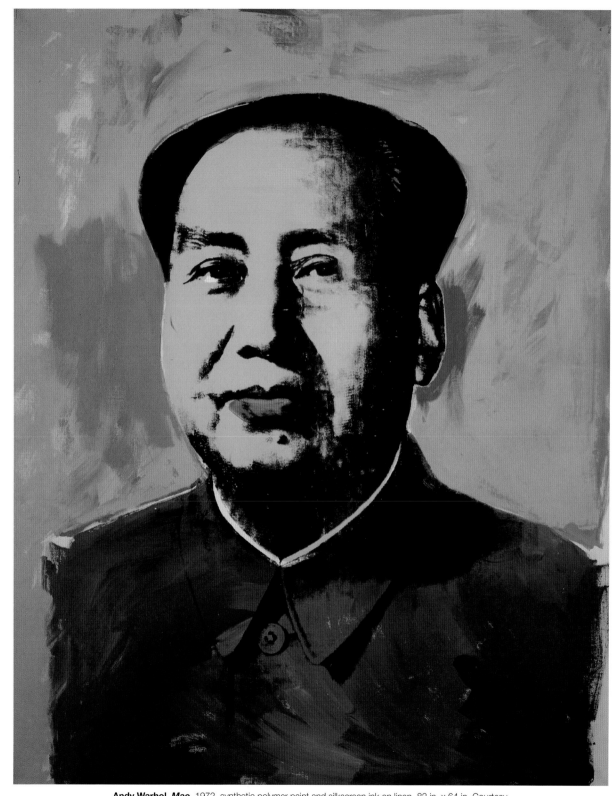

140

Andy Warhol, *Mao*, 1972, synthetic polymer paint and silkscreen ink on linen, 82 in. x 64 in. Courtesy
The Stephanie and Peter Brant Foundation, Greenwich, Connecticut. Courtesy L&M Arts, New York

Andy Warhol

CHINA SYNDROME

Long after Andy Warhol's tragic death his reputation as a genius inventor in the context of contemporary art continues to grow stronger, just as his work continues to break auction records. As a multi-talented artist he had an insatiable appetite for exploring objects and images with a variety untouched in the history of art. As Warhol made the transition from being a member of a Pittsburgh working class immigrant family to an aspiring artist studying commercial art, he gathered his resources and supported his burning ambition by moving to New York City to begin a successful career in magazine illustration and advertising. From the very beginning, he showed a unique singular style in his whimsical ink drawings of shoes created in a loose, unregistered and cavalier-ish manner that became the foundation for greater things to come.

For a decade in New York City his inherent talent and fervent determination made him a much sought after contemporary illustrator, which was both flattering and motivating for a young man who was enamored with city life. By the early 1960s, Warhol began to transform his commercial career into the riskier but far more exciting contemporary art world. Perhaps taking a cue from the reproduction process that brought his illustrations into the homes of millions of Americans, he switched from early canvases embellished with brushstroke drawings of common objects to a manufactured silk screen process to continue with the tradition of mass production. He became comfortable and proficient at recreating massed-produced items that you might discover in a grocery store aisle or a photograph from a tabloid newspaper. His vociferous appetite for making more art faster propelled Warhol to begin his own art factory, complete with art workers engaged in making prints of portraits, shoes, films, books and just about anything else that interested him at the time. He was clearly the boss and chairman of the board, but he relied heavily on other opinions and advice. He loved American culture and Americana, particularly celebrity images that he brought to life from common newspaper clippings that he would retool and spit out with his own Warholian thumbprint.

With all of the banal images that Andy Warhol decided to magically transform on canvas, it was his portraits of famous people that seemed to get under his skin and over and above the appreciation of most people on the street. The concept of making a portrait from a photograph that you didn't actually paint was, to say the least, revolutionary, and in that context misunderstood. While you could recognize an image of Elvis or Jackie or

Marilyn, for many people these simple portraits of personalities were difficult to accept as art. As the works gained notoriety and acceptability, Warhol devoted much of his time to rounding up live subjects who would serve as rich patrons for portrait commissions, including Mick Jagger, Bridget Bardot and Michael Jackson. Around the time that he founded Interview magazine he became fascinated with clipping newspaper images of anything that attracted his attention, including car wrecks, electric chairs, race riots and even the FBI's most wanted faces.

As the Cold War dragged on into the 1970s, Richard Nixon, the avowed Red-bating, anti-Communist, conservative Republican, ended up being the first American political candidate who could dare visit Red China without political fallout and injury to his high-ranking position. Tricky Dick Nixon made the headline of the year when he announced that he would travel to visit Chairman Mao in Beijing in 1972. Andy, like the rest of America, was mesmerized by the news flashes and the infamous Associated Press photograph of the stone-faced chairman of the largest populated country in the world. So, it wasn't a surprise to Warhol's inner circle when Benday images blown up from the daily news were used as a new, provocative series of dramatic and controversial portraits. Warhol, who was fascinated and hypnotized by celebrity and socially powerful imagery, was undoubtedly drawn to this taboo subject because of the extraordinary media attention devoted to the opening of diplomatic relations with the People's Republic of China in the early 1970s. His irreverent and complacent attitude toward China's totalitarian propaganda became transparently apparent on the surface of his silk screen paintings. Chinese Communism was rigid, strict, uncreative and unforgiving. On the other hand, America and its community of artists were inventive, open-minded, flashy and free to go in any direction they wanted. Therefore, the ironic visual chemistry of the straight-laced, balding cruel dictator of the so-called Cultural Revolution as portrayed by a flamboyant, wigged, gay liberal artist, who depicted Mao in wild splashes of color, including red rouge and a feminine blue eye shadow, twisted Communist banner propaganda into a capitalist advertising media tool that was sold and traded in a frenzy on the international art market. Warhol, with his bizarre combination of garish colors and intentionally misprinted scarlet lip gloss, created a kind of passive monster in a square frame who became an imprinted prisoner for the entire world to ponder. Always keen for new and provocative subject matter, the developments of American foreign policy presented Warhol with a garish head on a platter. After the historic meeting between Nixon and Chairman Mao Tse-tung, a new era of diplomacy and a new icon for the artist recognizable to millions became perhaps the most controversial and maybe the most memorable of all portraits in the twentieth century. Warhol swiped his image of the stoic leader from the cover of Quotations from Chairman Mao Tse-tung, which was produced a million times over for the largest red state in the world. He went on to create multiple versions of Mao, screen printed onto canvases of various sizes that became increasingly painterly. This gestural quality with an Abstract Expressionist background, an art form that would have been deplored by Lenin and Stalin, was the final twisting curve ball made in China that the young boy from Pittsburgh would use for a career home run. The stark, repetitive profiles, which have now inherited over time a kind of mesmerizing gravitational pull, have aged gracefully into a beautiful iconic series that are among the artist's best work. Utilizing eccentric or unusual raw material for canvases became a Warholian trademark. A hammer and sickle, simple shadows, an electric chair, a dead body

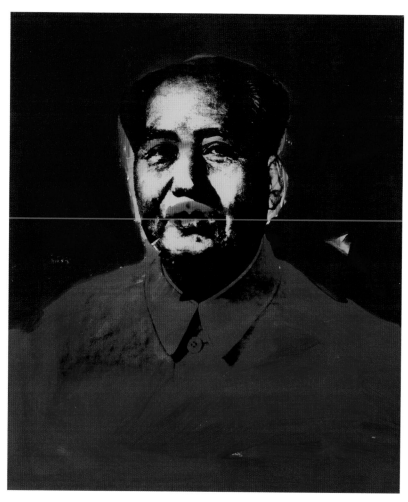

(hanging out of a car door) and a host of other images were pure artistic fodder for a man who could put his distinctive spin on literally anything. But it is the portraits, among the hundreds of examples he scalped from day to day life, which seem to carry the longevity characteristics that immortalize not only the subjects but the works of art themselves.

This exciting period from arguably one of America's greatest artists of all time was the focus of a comprehensive survey of these legendary portraits of one of the dominant political figures of modern history. The exhibition at L&M Arts in New York City coincided with the thirtieth anniversary of the Chairman's death and the fortieth anniversary of the Chinese Cultural Revolution. Remarkably, over fifteen Mao paintings were on view, offering a rare and broad representation that allowed one to compare numerous variations open to the artist's seemingly controlled and repetitive working method. A fully-illustrated catalogue modeled on Mao's famous Little Red Book accompanied the exhibition. This clever facsimile of the infamous 'Little Big Book,' which was held high in the air, arms fully stretched, by millions of chanting Chinese, became a literary symbol of an oppressed society. Warhol, like most of his odd subjects, crossed a mysterious border and manipulated a foreign image to finally set it free.

Sue Williams

LINE DANCE

The work of Sue Williams at the Palm Beach Institute of Contemporary Art in a show subtitled A Fine Line is fresh and inventive and curiously hypnotic. Williams' first critical attention came during the early 1990s, when she presented highly charged, deliberately coarse and ridiculously witty works about the plight of women. Her pictures were part autobiographical (she had been a battered woman), part satire, part release and part sunny departures from the darkness of an abusive relationship.

After having a secret peek-hole sense of this artist's trials and tribulations with pathetic men, a viewer of her early primitive restroom wall-like drawings on canvas or paper begins to intuitively sense the comforting release making these images must have offered the artist. Many Americans eventually find an outlet for their personal anxieties with trips to the golf course or bowling alley, a favorite fishing hole or observing a stockcar race. Artists generally find salvation through their work and the contemplative isolation and satisfaction of the studio.

In Williams' case, dealing with past abuse became more healing through a mockery of comic, left-footed depictions of sexually charged situations. Close-up and purposely crude renditions of naughty and vulgar situations helped the artist escape. For most of us, therapy generally depends on repeating an exercise — physically or mentally — and then exploration. Jumping out of one's psychological skin by drawing and making light of past horrors becomes curative. For example, contemporary comics are just now finding ways to interpret the Taliban debacle with wit as a healing escape. Art school students find daily repetition on a sketchpad calming and indeed superior to any other method of developing personal style and direction.

The early works of Sue Williams remain both idiosyncratically goofy and unnervingly desperate, even embarrassingly revealing. But like building a strong, concrete foundation, they were necessary exercises in developing maturity and panache and even visual elegance. The long and ambitiously introspective serpentine road of Williams gradually brought her to a very different metaphorical immaculate surface. For the most part she dropped narration and plunged full speed into free flowing, dancing and wonderfully poetic and dazzlingly beautiful abstract pictures.

144

Perhaps the most exciting development within the artist's large scale white-based canvases is that the overall compositions and color juxtapositions are completely new — that is, there are no other look-alike sisters, or for that matter, brothers, relating directly to her creative efforts. To be sure, there are distant Abstract Expressionist cousins, which pioneered and parlayed gestures and paved the way for non-narrative, fearless artists like Williams.

The inventory of mid-career examples of her metamorphosis is rich with consistency and completely satisfying with a singular style of flowing, colorful abstraction, along the lines of de Kooning, Pollock, Morris Louis or early Joan Mitchell. More importantly, Sue Williams has invented a new visual vocabulary through hard work, repetition and loose pattern, which is rich in abstract painted lines but still somehow retains an undercurrent of sexuality. When you toss out the secrets and overlook any connotations other than strict non-narrative gestural surfaces, what's left is very likely some of the most handsome, charismatic and starkly beautiful paintings created in today's art world.

Vickie Wulff

A WULFF IN SHEEP'S CLOTHING

Despite being relatively unknown, Vickie Wulff's mysterious and eccentric paintings, exhibited at Gallery Merz in Sag Harbor, New York, should convince the art community that without a doubt she is one of the finest mature painters in America.

Wulff is a prime example of why we need to keep our eyes open for unique talent outside of a fashionable circle, away from the mainstream and not necessarily showcased in the pages of art publications.. One wonders how many truly gifted artists are out there totally committed to their work and creating astonishing and fascinating pictures without regard for what the critics and the art market consider fresh, inventive and commercially viable. There is a certain unique character that is undeniable in the work of so many of these visual artists, who generally keep their cards close to the chest and consequently close to their heart, as they channel an inner spirit of creativity that manifests itself on the surface of a stretched canvas. Those who are fortunate enough to be born with a gift of expression and are able to harness their innate ability, often bring with them a desire to stay far away from the ordinary—out in the woods and out of the "loop." There they concentrate on what they naturally do best without much regard for anything else but basic survival. Harold Shapinsky, the late Abstract Expressionist, toiled away for over forty years in the shadow of the Flat Iron building in New York City, right under and above the noses of the art establishment.

Wulff began to impress fellow students and faculty at the Rhode Island School of Design in the late 1960s with her unconventional style and notoriety as one of the college's most talented graduates. After receiving her master's degree, she solidified her technique at the legendary Slade School of Fine Art in London and then returned to Manhattan to continue painting small narrative works. Soon afterwards, a small band of serious supporters helped her get by with occasional purchases and large quantities of encouragement. For the next twenty years she exhibited almost nowhere, preferring to reserve her energy for developing paintings and investigating the endless subjects floating around in her head. But like many artists who grow older and wiser, the reality of finding a way to survive led her, like Susan Rothenberg, to consider a medical avocation - as a nurse by day in a white woolen outfit with a red cross - and as a painter in an apron by night. Gradually the work took on an undeniable polished presence that has remained consistent with every finished product. Recently, the artist was discovered by the John Simon Guggenheim Foundation, receiving a grant that has allowed her to recharge and flourish. Group shows at the National Academy of Design and at Lincoln Center in New York drew attention from all the right places, and word seems to be finally spreading in the proper directions that will allow her to concentrate fully and exclusively on her painting.

The work titled If Walls Could Talk is a memorable example of the artist's understanding of the grand elements of contemporary picture making at its best. Greeting the viewer in a ballroom lit by levitating green crystal

chandeliers, is a beautiful woman who gracefully and literally blends into a pink background like a spirit making a brief appearance at a Waldorf séance. Her delicate arms disappear like a fancy fragrance into the atmosphere while two scratchy figures outlined in red begin to arrange their table. This highly idiosyncratic composition recalls the best hybrid elements of a surrealist's doctrine with the convincing narration of a two-dimensional storyteller.

Medici Garden (2003, 30 inches x 24 inches) is a landscape with legs that keeps generating interest as the viewer dives deeper into the surface. In typical fashion, Wulff has layered a crazy quilt of underpainting that acknowledges a joyful diffusion of pigmented oil. The sky is represented by a simple horizontal purple wash that doubles as a backdrop for a silhouetted Payne's Gray grove of organic forms. The foreground supports a few tall cypress trees that cast refined shadows of unusual character and variety. The trees follow a pyramid walkway that sustains a vanishing point alongside a country house. The combination of tree shapes and manicured grounds against the geometry of a built environment is just the right juxtaposition.

Rome (2003, 30 inches x 24 inches) crosses an invisible line between reality and decorative fantasy. In this modest canvas the artist has constructed a hanging lamp that would make the Fortuny family jealous. This cascading object, with tentacles reminiscent of an aging octopus in a tuxedo, seems to absorb whatever dares to pass by. The whitewashed background is fully integrated into the fixtures and grand entrance of an ancient hallway. Nearby, a champagne fountain balances precariously against sections of unassuming black lines.

Each of Wulff's works retains its own independent identity while sharing a strong common denominator of invention. This all over persuasive style has been Wulff's own wonderful singular recipe that has been cooking on simmer for nearly forty years. Now things are heating up. This is serious, consistent picture making at the highest level.

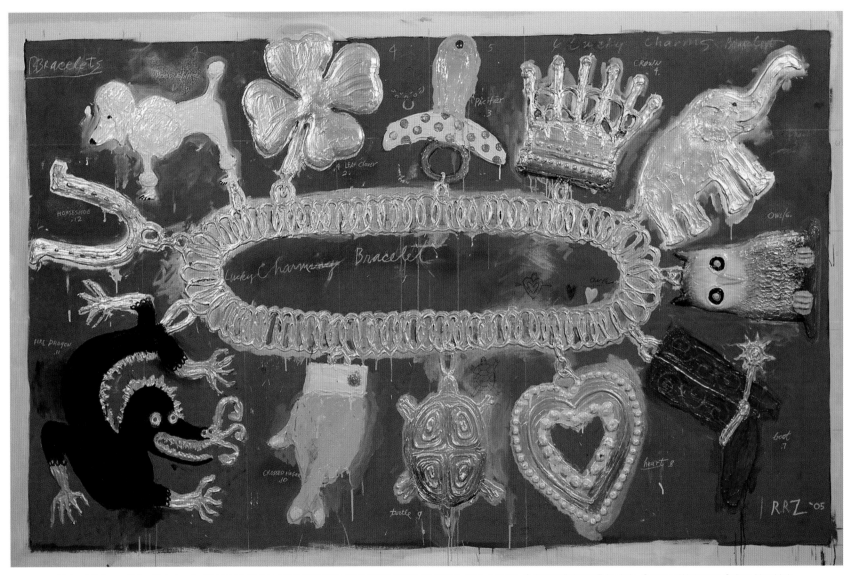

Robert Rahway Zakanitch, *Lucky Charm Bracelet I (Cross Your Fingers),* 2005, acrylic on canvas, 61 in. x 100 in. © Robert Rahway Zakanitch. Courtesy Werkstatte Gallery, New York

Robert Rahway Zakanitch

CHARM SCHOOL

Robert Rahway Zakanitch's exhibition at Manhattan's Spike Gallery was chock full of sweet little images collected over the years that brought us a sense of joy and of renewed optimism. His unusual collection of painted subjects laid down on primed canvas all originate from individual charms that one can find attached to a bracelet that sparkles and dangles like a silver trout line seeking attention in murky water. Traditionally, single charms were often collected thematically until they told a well-rounded and colorful story, often referring to one's personal interests, hopes and fears. The Mexican milagro is a popular charm in the shapes of individual body parts. A broken arm requires a small, quaint aluminum cast of an appropriate appendage to soothe the soul. With a migraine, you select a head to pin on a wall or wear on a bracelet. The shapes are inherently handsome and simple and relatively easy pickings for an artist's interpretation. Charm bracelets, made popular in the late 1960s and most often worn by young female students, spoke of innocence and adventure. From a roller skate with wings to a well-coiffed standard poodle hanging along side a baby elephant or a polka dot pig, the mission was, as I recall, to collect an array of cute little forms that you could point to with pride and embellish with a story or two. Charms have an eternal quality, particularly connected together, as each object joins hands with the other to portray a common denominator of visual strength. The most exciting charm was the secret heart shape that opened up (with some encouragement) to reveal your own photograph!

Right about the time primitive man started sticking feathers in his hair and colored mud on his face, a practice that is still with us, humankind was also persuaded by some instinctual motivation to weave a vine or palm frond around one's wrist, neck or ankle. Hanging from these organic chains were baubles and bangles made from reflecting gemstones and hollowed out carvings of recognizable subject matter. The waistline had its priority, from discreetly covering one's genitals with a natural slant of fashionable style to systematically displaying a family of shrunken heads on one's hip to ward off evil spirits. These charms were considered to be lucky as well as protective, not to mention banishing fear. Surely there must have been a sense of comfort with these early decorative embellishments that were handed down generation after generation and still offers a measure of familiarity. Now that women and men have discovered the same satisfaction with pierced ears connected to a swinging lure, a tattoo here and there and enough gold chains to make an Aztec priest jealous, we have come a full circle of equality with our ancestors.

149

Robert Rahway Zakanitch has always maintained a rich curiosity about our past and an engaging impulse to incorporate and blend objects of everyday life into his work. As a distinguished founder of the pattern and decoration movement in the early 1970s, he was a big hit with his intoxicating, gorgeous painterly patterns pulled from vintage linoleum and wallpaper borders. His first solo show was in 1965, where he immediately caught the attention of courageous collectors and museum curators. By 1973, he became a household name in America, adored by the French and misunderstood by many. The same year, the Whitney Museum of American Art included him in three separate exhibitions. Zakanitch went on to show at such legendary galleries as Holly Solomon and Robert Miller (1978), Daniel Templon in Paris (1980), Helander Gallery in Palm Beach (1989), Sidney Janis (1990) and Jason McCoy (1994). He then hooked up with the Spike Gallery downtown, where the combination of a beautiful space, a supportive staff and an enthusiastic press response kept him comfortable, productive and seemingly quite happy. Being content and confident with your dealer produces a kind of adult security blanket that stays with an artist in the studio and acts to support creative risks and novel directions, which are obvious by-products in this extraordinary exhibit.

Zakanitch's fresh forward motion retains all of the vision and pioneering spirit from the past while stirring up new images from the present. In his early pictures of meandering repeat patterns that incorporated organic subjects like grapes or flowers, the recognizable narrative was always given a front seat, while the backgrounds with occasional drips and recalculations quietly supported his hybrid composition.

Zakanitch has gracefully carried forward his love of objects with wit and whimsy into a new direction. After gathering together a fine cross section of bracelet accessories, the artist selected singular shapes that could hold a canvas on their own. A small molded dragonfly becomes a forty-eight inch high work complete with a "golden eye" for interlocking. In another picture, a pacifier becomes a huge pop-like symbol of safety and security frosted with a tempting coat of gold. Other towering single shapes of a seahorse, starfish, hair comb and an ice skate spell out an irony of exaggerated size and importance. These works are on a kind of oxymoronic scale, as in 'jumbo shrimp,' which emphasizes the impossibility of gigantic size while celebrating the tiny, illustrated beauty of a dream come true.

In the charm bracelet series, Zakanitch has comfortably woven together on canvas measuring over one hundred inches wide a full display of trinkets attached to a central round bangle that secures the middle ground and allows the attachments to float in space as if they were connected to a mother ship. In this same series, Lucky Charm Bracelet III (Hot Dice) (2005), Zakanitch has compiled images that provide us with a good time: a baseball mitt, roller skates, an opera singer, a pair of dice and a dancing ballerina. Who wouldn't be the most popular girl at Harrison High with this kind of magical lineup?

In another appealing picture, Lucky Charm Bracelet II, the signs of the zodiac are connected to a central infinity shape that inventively presents the well-known astrological symbols, from the scorpion to the bull, into a totally new heavenly atmosphere. To bring clarity to these naturally three-dimensional forms, the artist has discreetly added a sculptural paste onto the original drawings, allowing the objects to pop out with texture and definition. In one work, Seahorse, the centrally located floating equestrian contender has first been built up with a plaster-like material that gives true life roundness to a curved tail. In this work, as in most of this series, Zakanitch adds

pencil-like sketches to the borders that add mysterious clues and word games to the evolution of a completed picture.

Zakanitch, the master at manipulating ordinary forms into a common denominator pattern, is on familiar ground with Musical Charms (2005), where he has recreated a black flea market cardboard display of musical instruments that seems to be duplicated just the way he discovered it, only much larger. Odd combinations of a trumpet, a flute and a harp complement the individual pieces that are part of a nifty orchestra. Zakanitch not only strikes up the band with these instruments of fancy, but also has created an entire choir of talented extras that sings the praises of simple pleasures. Zakanitch proves he can turn literally any subject into a new light with another proportion, and still retain the romance and delight from a time of innocence and charming beauty.

Flashes of Light by Bruce Helander

I sort of fell into the professional art world establishment overnight, so to speak, when I was persuaded to take over as the acting Provost at the prestigious Rhode Island School of Design just prior to my thirtieth birthday. It was like being dropped into the middle of a new universe, with amazing people from all aspects of the then-alien art world orbiting around me. Prior to that, as a graduate student surveying Janson's History of Art and reading Artforum and ARTnews magazines during the late-1960s were the closest I got to learning anything personal about prominent artists. Many of my fellow RISD students and studio mates possessed remarkable vision and an unusual burning ambition: future dealers Mary Boone and John Cheim, musicians and artists Martin Mull and David Byrne, as well as Dale Chihuly, Jenny Holzer, Nicole Miller, Roni Horn, actor Charles Claverie (as Charles Rocket), and quite a few other talented individuals that later became enormously successful and well-known, adding an important down to earth reality that were great examples for me on the front lines of learning and maturing. Except for being an art dealer later on, none of these experiences would lead me into a natural arena for meeting important movers and shakers in the art world as did the position of chief academic officer of an important college of art. It was from this office that a young administrator from the Midwest began to kindle a natural ambition, energize his motivation, practice writing skills, dictate dozens of letters daily and connect in person with the genuine, exceptional visiting players in residence on this respected college campus.

These experiences, along with dozens of others, lent a kind of credible reality to writers and artists that you only knew from a distance, but now could relate to as regular people doing irregular things within their extraordinary careers. A delightful, long-term friendship with Ray Johnson came next with his interactive New York correspondence school and knack for sending creative envelopes to personalities in the art world. Directing the Provincetown Fine Art Workshops for several years (where I discovered that the name of legendary teacher Hans Hofmann was stenciled under each studio chair) on Pearl Street in Cape Cod allowed me to interact with neighbors Philip Guston and Robert Motherwell and other prominent

As Provost of the Rhode Island School of Design at the age of 29, Helander awards Joan Mondale, wife of then-Vice President Walter Mondale, an honorary degree of arts and letters. (Also pictured: left to right, Dr. Lee Hall, President of RISD, Bayard Ewing, Chairman of the Board)

Next to Nicole Miller, after their joint opening to premiere the Helander-designed neckties and other fashion items, at the Palm Beach home of Jane Holzer. To the right of Helander: Jimmy Buffett, daughter Camila Helander with friend, Meagan Mottinger.

Mr. & Mrs. Henry Ford at the first American showing of newly discovered abstract expressionist sensation Harold Shapinsky at Helander Gallery, Palm Beach.

With Robert Rauschenberg at the opening of the exhibition, Chihuly, Rauschenberg, Scanga, in the Helander Gallery, Palm Beach.

With Dale Chihuly at the installation of the Wall of Ice, part of the Chihuly—In the Light of Jerusalem 2000 exhibition at the Citadel. (for review titled Fire & Ice)

Bruce (in original Keith Haring hat) with wife Claudia, as celebrity artist at the Annual "Get Painted!" Artists Ball, Armory Art Center, West Palm Beach, Florida.

artists from America's first art colony. Richard Merkin, the painter, professor at RISD and writer for Vanity Fair (I was fascinated that an artist could write so well and with such informed style), also became a strong influence and a connection to New York that helped mold my perspective on artists and dealers and the major players that constitute the energy and long-lasting influences on the art world. I got to know the components of this community even better as the short-lived publisher of Art Express magazine (1979-1981). New York City, where I lived for a time in the East Village and on Bedford Street in Greenwich Village, and uptown, where I lived for a year in the Dakota and later in the Alwyn Court across from Carengie Hall, the pieces started to come together for me that would build a strong foundation for articulating and examining contemporary art in the nucleus of the art world. After discussions with legendary creatures like Andy Warhol, Robert Rauschenberg, Louise Nevelson, Tom Wolfe and even one night, with Grace Jones and Neke Carson, the excitement of absorbing contemporary life finally sunk in and I made the most of it. New connections, introductions and friends materialized as I opened my second gallery, on West Broadway next door to the Mary Boone Gallery, across the street from Leo Castelli, Charles Cowles and Ileana Sonnabend, whose director, Judith Richardson, later joined the staff of my Palm Beach gallery. And so, looking back, we discovered in our photographic archives, evidence of these influential personalities attending openings and receptions and benefits and dinner parties that attest to the unusual encounters that I have had the privilege to experience and to some of the people who became pals—the human influences that have shaped my thinking, sharpened my creative perspective and ultimately allowed me to become a better artist and a more informed writer. Unearthing the following portfolio of photographs was an entertaining and enjoyable task for Susan Hall, my trusty assistant. Her selections paint a descriptive picture that weaves together the different social aspects of my professional and personal life that I think is worth sharing as a perspective and how my interest of writing about art and artists continued to grow in all directions, until I had enough substantial material to publish a book of my reviews.

Lastly, I would like to thank the photographers for this section; many who are anonymous and whose images were sent to us by friends, others well-known and celebrated. Although we may not be able to credit all contributors—and we apologize for that—I'd like to thank Michael Price, Lucien Capehart, Kim Sargent, Mort Kaye, Amy Arbus, Harry Benson, Beau Solomon and Paul Fisher, among others, for their documentary talents.

Gallery reception for Helander in Southampton, with artists (left to right) David Slater, Bill Drew, Robert Rahway Zakanitch, Helander, Neke Carson and John Torreano.

Helander discussing Yoko Ono's retrospective at the Museum of Contemporary Art (MOCA) in Miami (for review titled The Message is the Medium).

Color-coded gentlemen: with writer and critic Tom Wolfe at Helander Gallery, downtown Manhattan, at the opening for painter Richard Merkin.

With iconic art dealer Larry Gagosian and collector/entrepreneur Howard Gittis, at Amici Ristorante, Palm Beach.

With Dorothy Lichtenstein at the opening of her husband's exhibition, Roy Lichtenstein: Inside/Outside at the Museum of Contemporary Art (MOCA) in Miami (for review titled Four Degrees of Separation).

With the late, great art dealer, Leo Castelli, at Helander's opening in the Peder Bonnier gallery, 420 West Broadway.

Discussing de Kooning with Mr. and Mrs. Julian Schnabel at a reception in Denise Rich's Manhattan apartment.

With Donald and Melania Trump, at their Mar-a-Lago home in Palm Beach, during the Rush Philanthropic Arts Foundation event, "Art for Life Palm Beach."

With longtime assistant and executive secretary of twenty-five years, Susan Hall, at the opening of his "Love Letters" exhibition at the Norton Museum, West Palm Beach.

Famed Beatles' photographer, Harry Benson, shoots Bruce Helander at Worth Avenue's oceanfront view; Helander wears his trademark bowler and official Palm Beach tie produced for Nicole Miller.

Out-muscled by a huge Botero bronze at the Marlborough warehouse (Brooklyn), with Marlborough Gallery (New York City) director, Michael Gitlitz.

Helander and Baby Jane Holzer in the front row of the Nicole Miller runway show with Helander (wearing his own Nicole Miller design, "License to Thrill" bowtie).

Giving a comprehensive explanation to then New York City mayor, David Dinkins, of works at the inaugural opening of the Helander Gallery in Manhattan (1991).

Next to a stylish redhead and Fred Schneider, singer with The B-52s, during Todd Oldham's opening at the Helander Gallery (New York).

At a "hat party" given by James Rosenquist in his Aripeka, Florida home.

Todd Oldham with actress Susan Sarandon and her children, and Oldham's partner, Tony Longoria, at the POWARS benefit, Helander Gallery, New York.

With Jane Holzer at the opening of Helander's retrospective exhibition at the Museum of Art/Fort Lauderdale.

With Ivan Karp, founder of O. K. Harris Works of Art gallery, in Palm Beach, while attending the grand opening of the Helander Gallery on Worth Avenue.

At a party post-Marisa del Re Gallery opening for Helander, hosted by collector/socialite Judy Green in her Park Avenue apartment, with Bobby Short at the piano and Chuck Mangione on trumpet.

With David Byrne of the Talking Heads, on Collins Avenue, Miami Beach, prior to Byrne's concert.

With influential critic and curator Robert Pincus-Witten, at the inaugural opening of the Helander Gallery in New York.

At a reception in the Pierre Hotel, with hosts Annie and Michael Falk, sponsor Dan Aykroyd, actor Marjoe Gortner, Nicole Miller and Helander, wearing his 'On the Road' tie.

With late photographer Horst P. Horst, at a reception for the watercolors by his partner, Valentine Lawford.

Helander (upper left), at the Stage Delicatessen, offers a toast to David Hockney and friends, Callie Angel (Whitney Museum of American Art), Frank Stella, Paul Bartel and Paul Fisher.

Dennis Oppenheim, *Safety Cones,* 2007, blaze orange cast fiberglass. Three elements, 20 ft. X 9 ft. x 9 ft. each.
Installed at SCOPE Miami, December 2007, Art Basel Miami. Courtesy of the artist & Eaton Fine Art, Inc., West Palm Beach, Florida
(see page 76)

At the end of the day and at the end of the road, Dennis Oppenheim's Safety Cones gives the viewer that "Honey, I Shrunk the Kids!" feeling, with a brilliant scale reversal of a recognizable common object, its plasticity grounded in Pop Art symbolism.

ACKNOWLEDGEMENTS

This book is dedicated **to my wife, Claudia**, constant companion, motivator and studio assistant, who has been by my side for eleven years and who is a late night sympathetic listener for my last draft review notes in bed and who often pushes me to finish an editorial deadline as the last possible minute approaches. Her natural beauty and talent remain an inspiration to me every day.

And to those individuals who provided input, perspectives and encouragement along the way:

To my high school English teacher, who repeatedly said I was hopeless as far as composition was concerned—but that something had to be in the way—and encouraged me to persevere no matter what, to later discover that I am severely dyslexic (like the majority of male artists) and that there were ingenious ways to circumvent this inconvenient learning disability.

To my publisher, Brenda Star of StarGroup International, who stayed with me over the past three years to assemble this ever-expanding book, and to her associates, with a special acknowledgement **to Mel Abfier**. **To Susan Hall**, my trusty assistant and editor for the past twenty-five years, for her intelligence, dedication and managerial skills that keep the Helander Studio moving forward in all directions on a daily basis. Susan has been chiefly responsible for editing literally hundreds of my reviews over the last ten years, and is confident enough to suggest valuable, nuanced changes that help connect my personal observations while always keeping me grammatically correct. **To Audrey Diamond**, who first hired me to begin writing reviews for her magazine nine years ago, because without her confidence in my judgment and monthly assignments with accompanying deadlines, other priorities would have taken over and I'd just have a collection of undocumented memories to piece together. **To Jed Perl**, whose 1990 review in The New Criterion, "Successes," on my uptown show at the Carlo Lamagna Gallery was a spark that was implanted permanently in my psyche, which connected the joys of art-making with the satisfaction of art-writing and the responsibility and rewards of keeping your eyes open. **To the late, great Henry Geldzahler**, who patiently tutored me in the elementary facets of creating art reviews, and **to Amy Fine Collins** (now contributing editor to Vanity Fair) who accurately described what I was doing in my first review in Art in America (1989). To my first partner in the gallery business, **John Rubinstein**. **To Blake Byrne**, the celebrated Los Angeles collector and longtime friend, whose kindness, financial support and remarkable consideration of my career has no equal. **To Jane Holzer** and **Beth DeWoody** of New York and Palm Beach, **Sydelle Meyer** of Palm Beach and **James Pappas** of Boston, who regularly motivate me to keep accepting challenges and whose appreciative awareness of what I do as an artist and critic keep me going. **To Brian & Joan O'Connell** and **Eric & Lucinda Stonestrom**, for their additional support. **To Gilbert Brownstone**, who may be one of my best fans, for writing the introduction and **to Bonnie Clearwater**, for constantly opening my eyes with her curatorial genius at the Museum of Contemporary Art (MOCA) in North Miami, and who, with her husband, **James Clearwater**, (Grassfield Press) published my first book, Curious Collage, and penned the foreword to this book. **To William Warmus**, for "diving into" my background and developing an insightful introduction. **To Paul Fisher**, my best friend and colleague, who I have traveled with round the world—Venice, London, Dubai, Paris—together gathering images and editorial information with determination and spirit. **To friends Todd Oldham and Tony Longoria**, who connected with me early in Palm Beach and at New York flea markets and gallery

openings and shared and promoted a remarkable, fresh, idiosyncratic vision and lifestyle surrounded by unique design that offered me an enjoyable road to travel. **To Nicole Miller**, for her confidence in my designs and for her loyalty. **To Amy Cappellazzo** for her guidance while at PB/ICA (now at Christie's). **To Virginia Heckert**, now at the J. Paul Getty Museum, for her insights on contemporary photography. **To Dan Ellis** of Look Interactive, our hot shot in-house designer, whose past work for the Museum of Modern Art and the Whitney led us to acquire his unique talent for our own studio projects, for his patience throughout with literally hundreds of changes and adjustments on this project.

Thanks to all of the museum personnel, gallery directors, artists and studio staff for their cooperation and encouragement during this project—special mention to the following individuals and institutions that provided valuable assistance and support:

Tony Berlant, Jacqueline/Tony Berlant Studio, Artists Rights Society, New York, Michael Gitlitz/Marlborough Gallery, Ms. James McKee/Gagosian Gallery, Leila Saadai/Exhibitions Director for L&M Arts, Italo Scanga Foundation, Andy Warhol Foundation, Museum of Contemporary Art (MOCA), North Miami, Kipper Lance & Alexia Davis/Public Relations for Norton Museum of Art, Barbara O'Keefe/Coral Springs Museum of Art, Bashar Alshroogi/Cuadro Fine Art Gallery, Dubai, UAE, Ken Clark/Chihuly Studios, Wendy Williams/Managing Director for Louise Bourgeois Studio, Leonard Perlmutter/Classic Gallery, Deborah Murry/Stygian Publishing Co. (LA), Bernard Jacobson Gallery (London), Paula Poons, Francis Morris/Senior Curator, Tate Modern, London, Meg Blackburn/Museum of Modern Art, Shelley Lee/Estate of Roy Lichtenstein, Heather Sullivan/Edward Thorp Gallery, Dan Parker, Studio Manager/Julian Schnabel, Alex Zachary/Gavin Brown's enterprise, Heather Palmer, Research & Archives/PaceWildenstein, Antonio/Sonnabend, Chris Burnside/Cheim & Reid, Dawn Ahlert, Assistant/Buck-Butterfield, Inc., Arij Gasiunasen/Gasiunasen Gallery, Peter Goulds, Lisa Jann/LA Louver, Shoshana Wayne Gallery (Santa Monica), Eaton Fine Art, ULAE, Gallery Paule Anglim, Ellen Miller/Miller Block Gallery, Ginger Cofield/James Cohan Gallery, Sperone Westwater, Caitlin Shey/Friedrich Petzel Gallery, Robert Miller Gallery, Alex Gruen/Charles Cowles Gallery, Damien Hirst, Betsy Senior/Senior & Shopmaker Gallery, the Appleton Museum, Ocala, Museum of Fine Arts, Boston, Grey Art Gallery, Lennon, Weinberg, Inc., New York, Palm Beach Institute of Contemporary Art, Museum of Art, Fort Lauderdale, Julie Green/David Hockney Studio, William Wegman, Ariel Dill/William Wegman's studio, Christopher Baer/Ben Brown Fine Arts (London), Gallery Merz, Sag Harbor, Reneé Giovando/Yellowstone Art Museum and Leonard Nimoy.

Learning to See--An Artist's View on Contemporary Artists from Artschwager to Zakanitch has been made possible in part by the New York Foundation for the Arts.

And finally, to all those folks who continually send announcements and catalogs for our consideration, and to the many talented artists we have covered and to those who also deserve to have their reviews reprinted again in this book, but space limitations did not allow.

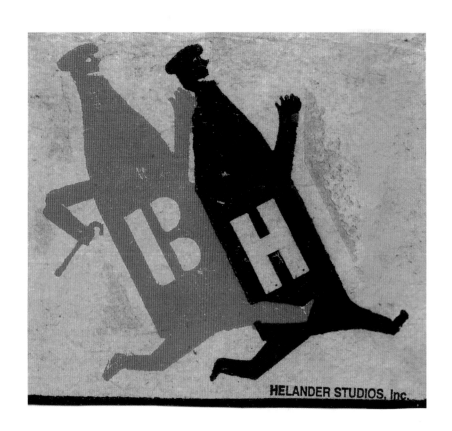